Photographica

Photo

PHOTOGRAPHS BY
Matthew R. Isenberg and *Charles Klamkin*

graphica

A Guide to the
Value of
Historic Cameras
and Images

Charles Klamkin
with Matthew R. Isenberg

FUNK & WAGNALLS
New York

Designed by Folio Graphics

Manufactured in the United States of America

Library of Congress Cataloging in Publication Data
Klamkin, Charles.
 Photographica: a guide to the value of historic cameras and images.
 Bibliography: p.
 Includes index.
 1. Photography—Apparatus and supplies—Collectors and collecting. 2.
Photographs—Collectors and collecting. I. Isenberg, Matthew, joint author.
II. Title.
TR6.5.K58 770'.75 77-2849
ISBN 0-308-10298-3

1 2 3 4 5 6 7 8 9 10

3|29|78
Review copy

Contents

Photographica

1

Building a Photographica Collection

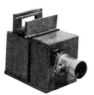

The art or science of photography is almost 150 years old, but it is only within the past several years that the collection of its artifacts has become a widespread and well-organized pursuit. There is very little evidence of many private collections being formed in the late nineteenth and early twentieth centuries, although about a dozen major museum collections of photography had been established in the United States, England, France, Germany, and other European countries.

One of the most important private collections in existence prior to World War II belonged to an attorney, Gabriel Cromer of Paris. This collection was sold by his widow in the latter part of 1939 and was spirited out of France in about sixty huge cartons just ahead of the German occupation. Purchased by the Eastman Kodak Company for approximately $10,000, this rich and vast treasure formed the nucleus of the George Eastman House collection in Rochester, New York. Formally opened in 1949, the International Museum of Photography at George Eastman House expanded its holdings to include not only cameras, photographic equipment, motion-picture equipment, and films and images but a comprehensive research library as well.

A few private collectors, perhaps influenced by what they had seen at the Eastman House or the Smithsonian Institution or collections abroad, began actively to collect photographica shortly after the Eastman collection became available for public inspection. The term *photographica* encompasses all photographic equipment, including cameras, lenses, developing equipment, photographic images important by reason of their contribution to the art or their historical content, viewing devices, projectors, Union cases, and photographic literature and other associated ephemera.

By the early 1970s a half-dozen collecting and photo-history associations had been formed (presently there are almost twenty), and many journals devoted to the subject of photographica and its collection and preservation began to be published. All were aimed at a collector audience. Photographica was rapidly assuming the dimensions of a full-scale collecting hobby.

Most of the collectors in these groups were drawn to photographica by the mystique of the photographic image and the ingenuity that man had used to capture it. They were intrigued, also, by the vast impact photography has had on the arts, science, medicine, and graphic reproduction, both in print and in motion pictures.

There are purists in every collectible area who search for the old, the rare, or the items that represent significant advances in the field. However, there are others who are attracted by the profit potential as soon as it appears that any collecting hobby is going to expand into a widespread competition for scarce, desirable objects. In photographica, there are the collectors who are drawn by reports of the discovery of a group of seven daguerreotypes in a flea market that were bought for $18 and of which six were later sold to the Library of Congress for $12,000. They learn from one another of the very real possibility of having a New England farmer pull out of a barn attic a dusty, cobweb-covered small wooden box that proves to be a pre-1850 American daguerreotype camera. This is an actual discovery by a New Jersey collector visiting a Connecticut farm, and the camera, reportedly purchased for a

few dollars, was eventually sold to a buyer who happily paid several thousand dollars to add it to a collection that previously contained no such treasure.

In another category are the collectors whose primary endeavor is to build a collection that reflects the development of a particular aspect of photography or, more ambitiously, to provide a comprehensive overview of the history of the art. Among these specialists there are those who collect only Leica cameras and accessories; Kodak cameras from 1888 to the present; detective, spy, or other cameras used for taking pictures surreptitiously; cameras and equipment used for taking and viewing pictures in stereo; and the panoramic cameras capable of photographing extensive landscapes or large groups of people in a single exposure. A major group of collectors eschews the hardware entirely and seeks only photographic images such as daguerreotypes, ambrotypes, tintypes, the cases in which these were displayed, and stereo views.

Presently, one of the most rarefied heights of photographica is the collection of the cameras, equipment, and ephemera associated with the birth and infancy of photography. This is a period of roughly twenty-five years from 1839 to 1865 and includes, of course, daguerreian cameras, their stands, plates, preparation and developing apparatus, and similar equipment used in photography's next technical advance, the wet plate.

Of the museum collections, only a few can make any claims to be comprehensive in their coverage of the entire field of photographica. Obviously, the number of private collections in this category is even fewer. In the United States, however, the collection that comes closest to this objective is owned by Matthew Isenberg and is located in his two-hundred-year-old house near the Connecticut River in the town of Hadlyme, Connecticut, north of Saybrook.

Using the Isenberg collection, we will trace much of the history and development of photography through the nineteenth century and up to the present, beginning with such prephotographic items as an eighteenth- century camera obscura.

The Isenberg collection of photographica is distinguished for a number of reasons, the first of which is the breadth of the collection. It encompasses prephotographic and early daguerreian items as well as quite recent collectibles. The second reason is the depth: over four thousand items, including variations within types, or models plus the accessories and the original literature pertinent to many examples. A third criterion by which the collection may be judged is the rarity of many of the items: many pieces are either unique or one of the only two or three examples presently known to exist in the world. Quality is a fourth criterion, and most of the collection can be considered to be in either mint or near-mint condition. Dozens of items retain the original packaging and are enhanced by advertising material, instruction manuals, or descriptions and references contemporary with the commercial introduction of the item.

In addition to the above, the Isenberg collection includes a historically important and comprehensive library. Besides scores of recent or long-out-of-print books on every aspect of photography, there are several complete runs of British, French, German, and American photographic journals. Where original material has not been available for purchase, arrangements have been made to photostat thousands of pages of data in libraries in this country and abroad to aid in the research in dating and identifying rare items. The collection is certainly as comprehensive and rich as almost any in existence, and its orientation to the history of photography as shown through its artifacts makes it especially significant.

Most pertinent for other collectors and photographic historians, the current value or price of hundreds of the most important items in this collection will be given. These prices will surprise many experienced collectors and perhaps will discourage some beginners. They will cause some collectors to reevaluate their holdings and upgrade the estimates of many of the photographic objects they own. In other cases, these values may compel a collector to reassess the method by which he or she is

collecting and the objective he or she wishes to achieve.

The decision to publish these values was not made in an effort to upgrade or add status to the Isenberg photographica collection. It has already achieved worldwide recognition as one of the best collections in or out of most museums. The values are cited to place the collecting of photographica in proper perspective and to establish a rational basis for collectors to buy and sell. A collector may read volumes or discuss endlessly the rarity, mystique, or significance of a particular camera or piece of photographic ephemera, but its real value for most, unfortunately, is the price someone is willing to pay.

With that fact in mind, the Isenberg collection has been evaluated in terms of age, mystique, quality, rarity, and significance. The prices are also based on the current marketplace, auction results, and the offerings of merchandise received almost daily both from dealers and other collectors.

With the growth of interest in photographica has come a parallel growth in the value of the collectibles. Just one item, the Giroux camera from the Cromer collection, will serve as an example of the value received by George Eastman House back in 1939 and how values have escalated in the past forty years. The Giroux camera was the first commercially produced camera, introduced a few days after Daguerre's disclosure of his process on August 19, 1839. It was designed by Daguerre and bore his signature attesting to its authenticity, and the seal of Alphonse Giroux, Daguerre's brother-in-law, who supervised the camera's manufacture.

It should be pointed out that fewer than two dozen of these cameras are known to exist, none in private collections, and that since World War II none has been offered for sale either by auction or privately. George Eastman House's three Giroux daguerreotype cameras, one of which is now at Kodak-Harrow, England, are presently worth over $100,000 apiece. These, along with an original sensitizing kit, were only a small part

of the thousands of items acquired in the Cromer transaction. The purchase price included important cameras and other photographic equipment, literature, hundreds of daguerreotypes, and immensely valuable early paper images which came to Eastman House. Items collectible at the time of World War II for a few dollars are now worth $500 to $1,000 and more.

It was not until 1969 that Matt Isenberg took any interest at all in collecting cameras.

Within a few months, Isenberg purchased four or five Leicas, and while doing research on the camera and the man who designed it, he became caught up in what is known among collectors as the "Leica mystique." He learned, for example, that the Leitz factory designed a machine to test the durability of the shutter and film-advance mechanism of their cameras. After hundreds of thousands of exposures and windings, the machine broke down while the camera under test was still functioning perfectly.

Within the next two years, Isenberg looked at many important private collections and bought or traded for more than two hundred Leica cameras and countless esoteric Leitz lenses and assessories.

Late in 1970, Isenberg was able to acquire one of the most sought-after Leica items, a Compur B Leica. Purchased for $1,000, it is now worth close to five times that amount.

It was following the 1970 Rochester convention that Isenberg made the decision to put all of his energy and most of his resources into assembling as complete and comprehensive a total photographica collection as possible. In the next five years, he made numerous trips outside the United States to study the great private and museum collections in England, France, Germany, Japan, the Middle East, South America, and behind the Iron Curtain. During the period from 1971 through 1975, he acquired over four thousand items.

Since 1974, however, the emphasis of Isenberg's collecting activity has shifted from the general to the period representing roughly the first twenty-five years of the history of photography. To other collectors he

defines the area of his interest as being anything "through the Civil War," or photographica up to 1865. None of this equipment can presently be purchased in volume at bargain prices. Whether it be a daguerreian or wet-plate camera, equipment for preparing or processing the sensitized plates, or any related ephemera, much of it commands prices well into the thousands of dollars. To be a customer for this type of merchandise requires more than money. It calls for an appreciation of the various types of craftsmanship that distinguish an American from a French daguerreian camera and a knowledge of whether a lens could really have been made as early as the camera with which it is being offered. There is even the possibility of counterfeiting as a cautionary influence.

These things and scores of other small but significant details, such as whether a metal part exhibits traces of hand filing or machine finishing, must be studied before a collector writes the check for a fresh acquisition. In evaluating a camera of this early period one might consider the man who designed it. Did he copy another camera, or does the camera in question have some original refinement? The amount of care taken in its construction, the way it was used by the photographer, its present condition, and its lack of careless or sometimes too careful restoration must also be taken into account.

Each of the major categories of photographica is strongly represented in this collection. Each has been a challenge to research, locate, and secure. In respect to early Kodaks, for instance, the Isenberg collection contains not one, but three of George Eastman's first commercially successful roll-film cameras. The importance of this one aspect of the collection will be discussed more fully in a later chapter devoted to George Eastman and the impact of the Kodak camera on making photography available to a huge popular market.

We have already mentioned that the Leica portion of the collection is especially strong and is probably among the ten best in North America. The early development of cameras specifically constructed for color

photography is very well represented in the collection and will be described in its own chapter. A separate section of this book will deal with the cameras and equipment used to make and view stereo photographs. These early American and European stereo cameras are exceptionally rare and are among the most costly and historically important items in the collection.

Also well represented are the detective and other cameras used to take photographs unobtrusively as well as the early and later subminiature cameras and other oddities. The twentieth-century cameras primarily from Germany and Japan that Isenberg refers to as "black-and-whites," the Ermanoxes, Contaxes, Super Ikontas, Robots, and others are all represented, too.

The image and case portion of the collection is small but choice. A constant program of weeding out and upgrading has brought the selection of images to the point where the work of many important early daguerreotypists is represented as well as historically significant landscapes and gold-mining and architectural studies. The thrust in this area has been to secure the best quality rather than sheer numbers. Many examples of Isenberg's image collection have appeared in major books on photographic history. Another part of the daguerreotype collection has been lent to the United States Information Agency and has been on tour in Russia.

Although the collection does represent a substantial investment of money and effort, that is not the full explanation of its importance. It should be emphasized that while Isenberg was buying photographica, he was also studying the subject with other advanced collectors and museum experts. He spent endless hours with the noted collector Michel Auer of France, conducted continuing talks with the curatorial staff of George Eastman House and other museums throughout the world, and constantly added to his own reference library. This is the only way any fine, specialized collection can be built with the expertise to make it significant. Dollars, while necessary to pursue any important

collecting hobby, cannot by themselves create the critical eye and refinement of taste needed to assemble any collection of true quality.

Some collectors jealously guard every scrap of information that comes their way, but this is not true of Matt Isenberg. He is in contact with collectors from all over the world and freely shares information, advice, and expertise. In the following chapters, he will share his knowledge with us.

Prephotographic, Daguerreian, and Wet-Plate Equipment

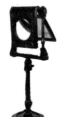

Almost every treatise dealing with the origin and development of photography begins with an illustration and discussion of the devices used to collect and focus an image. The apparatus usually referred to as the forerunner of the photographic camera is the camera obscura. The camera obscura consists of a box with a lens at the front end which projects an upside-down image on a plain, flat surface. The earliest type of camera obscura used a pinhole for a lens until optical lenses became available in the sixteenth century which provided a brighter, sharper picture.

A camera obscura could be as large as a room in which a number of people could view an outdoor scene projected on the rear wall. Smaller, more portable models, perhaps only a few inches to a few feet long, produced their transient images on a sheet of ground glass or similar semitranslucent material. These were particularly useful to artists, who were able to trace the projected images and required far less skill and time than sketching the same scene would have demanded.

Cameras obscura made for artistic purposes or sold as novelties were produced in quantity through the end

of the nineteenth century. These later models were factory-made, lacked careful cabinetmaking, and employed lenses fitted in metal mounts. The camera obscura in the Isenberg collection is a late-eighteenth-century French example distinguished by a lens mounted in a handmade wooden cell. The front ring of this wooden lens mount or cell is different from the more frequently seen types in that it is slotted or milled rather than smooth. This camera obscura focuses by means of a sliding box-within-a-box, and foreshadows the system employed by Daguerre in his first photographic apparatus. Other prephotographic devices in the collection are the *vue d'optique,* the camera lucida, and the tent camera obscura.

Louis Daguerre is universally credited with being the first man to fix or permanently record an image by

1

Two prephotographic viewing devices.
Left: Camera Obscura, French, late eighteenth century. Value, $4,500.
Right: Tent form camera obscura. Value, $200.

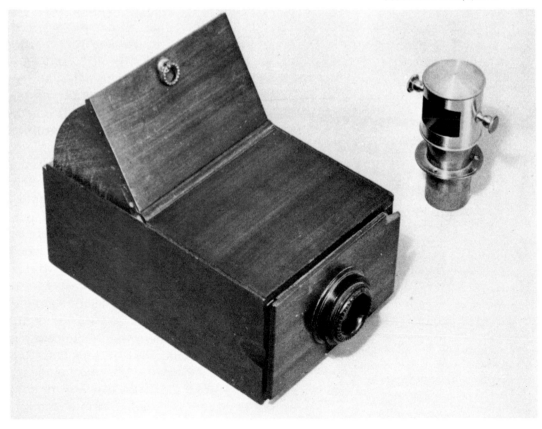

2

Close-up of handcarved wooden lens mount of French camera obscura.

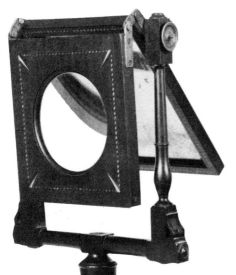

3

Vue d'optique, lens and mirror, artist's device to direct an image to a surface where it could be viewed in greater detail with a pseudo-three-dimensional effect. French, late eighteenth century. Value, $200.

means of light acting on a sensitized plate by what could be considered a commercially feasible procedure. In this effort he was preceded by such earlier workers as Wedgwood, Niépce, Bayard, and Fox-Talbot, who had successfully recorded images a number of years prior to the 1839 disclosure of Daguerre's process. The difficulty with the product of his precursors was that their images generally lacked definition and required such long exposure or development as to make their processes impractical.

In regard to the original Giroux Daguerre camera, Eaton Lothrop remarks in his book *A Century of Cameras:* "Because this camera was the first model commercially manufactured, it is the most important camera throughout the whole history of photography." The Isenberg collection does not contain a Giroux camera, and to the best of our present knowledge, neither does any other private collection. Matt Isenberg agrees with Lothrop's assessment of the significance of the camera, and to him it is still the ultimate challenge to the collector: a sort of photographic Holy Grail. He believes that a complete Giroux with label, seal, and Daguerre's signature intact would be worth well in excess of $100,000.

4
Description of Gaudin camera appeared in this French pamphlet which claimed that daguerreotype equipment was "at last perfected."

The earliest daguerreian camera in the collection is actually a complete daguerreian processing outfit contained within the body of the camera itself. This is an 1841 camera designed by Alexis Gaudin and built in Paris by N. P. Lerebours. The lens on this Gaudin is exactly like examples in other collections except that it is not marked *Lerebours A Paris*. This leads Isenberg and other experts to believe that it was of quite early manufacture and possibly a prototype. There are four variable f/stops on a disk fastened to the front of the lens, and a black cloth attached to the top of the camera which acted as a shutter. The cloth was lifted to begin the exposure and dropped over the lens when enough time had passed to complete the picture-taking operation. Within the camera box were stored two plate holders, extra plates, an iodine-sensitizing box, and a mercury-fuming box to develop the plates.

Isenberg purchased this Gaudin from a French collector who bought it about ten years ago in the Paris flea market for $100. Its current value would be about $12,000, in view of its age and the fact that it is the earliest example of a self-contained outfit.

While most readers of this book could be expected to be familiar with the daguerreian photographic pro-

5
French daguerreian camera
(1841) designed by Alexis
Gaudin. Unique for its time
because complete process-
ing outfit was contained
within camera box. Front
view shows lens with four
adjustable f/stops and black
cloth which acted as shut-
ter. Value, over $12,000.

6 Rear view shows camera
open and compartments for
storing developing ma-
terials.

7
Close-up view of cabinet
latch showing hand-cut and
-filed brass fittings.

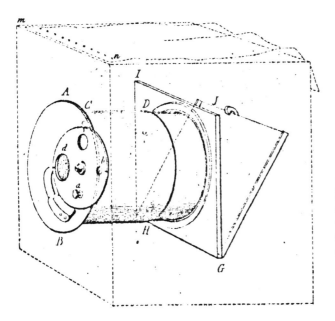

cess, it might be instructive at this point to summarize the process for those who are not. As described by Daguerre in his August 1839 manual, a silver-coated copperplate was polished repeatedly with pumice and oil, washed with dilute nitric acid, and heated, washed, and polished again. Later, workers added a final buffing with high-quality rouge and other polishing agents. Next, the plate was placed face down at the top of an airtight box containing iodine crystals and exposed to the iodine vapor until the plate assumed what Daguerre described as a "bright golden yellow color."

The plate was now ready for an exposure that initially could take up to a half hour. This time was reduced to seconds as chemicals such as bromine and certain chlorides added to the iodine were found to increase the sensitivity of the plate dramatically. After exposure, the plate was placed, again face down, at the top of a box containing, according to Daguerre's instructions, two pounds of mercury. The mercury was heated by an alcohol lamp to a temperature of about 170 degrees Fahrenheit, at which heat the mercury gives off a vapor that combined with the exposed silver

9

Cover page of early English edition, published in September 1839, of Daguerre's manual in which he disclosed his photographic process. Value, $1,000.

10

Two boxes containing one-sixth-size daguerreotype plates. Manufacturer's label on box on right indicates that it was made prior to 1849, when company changed its name to Scovill Manufacturing Co. Value, $250 to $400 each.

AN

HISTORICAL AND DESCRIPTIVE ACCOUNT

of the various Processes

OF THE

DAGUERRÉOTYPE

and the Diorama,

By DAGUERRE,

Painter, Inventor of the Diorama, a knight of the Legion of Honour, and a Member of several Academies.

LONDON,

Mc LEAN, 26 Haymarket;—NUTT, Bookseller, Fleet Street.

1839.

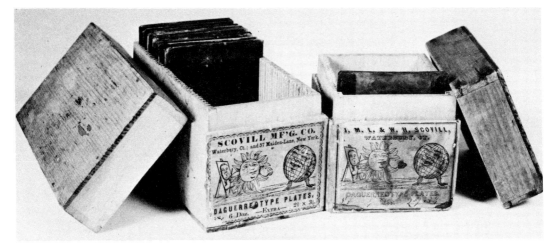

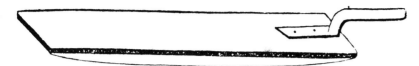

BUFF STICKS.—*Fig. 25.*—These are usually from one to three feet in length, and about three inches wide—some think two and a half sufficient. The underside, which is convex, is covered with a strip of finely prepared buckskin, or velvet, well padded with cotton or tow.

11

Description of plate buffing stick from Snelling's 1850s photographic manual.

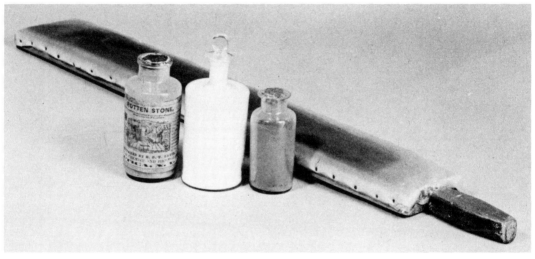

12

Plate buffing stick (value, $350) and some of the polishing materials, including rotten stone, tripoli, and pumice.

13

Polishing rouge made about 1853. Label on side of box bears testimonial by J. Gurney, noted New York daguerreotypist. Value, $300.

14

American iodine-sensitizing boxes. Box on right can be masked to fit ninth-, sixth-, or quarter-size plates. Value, $1,000 each.

15

Excerpt of 1843 letter written by New York City daguerreotypist to a neophyte worker in Savannah, Georgia, describing his methods and equipment, including a sketch of his iodine box.

to form an image. Next, the silver plate was washed in a salt solution or, preferably, sodium hyposulphite, commonly known to photographers as "hypo." This treatment removed the unexposed silver iodide and caused the image to remain relatively permanent. About a year later, in 1840, it was found that gilding the finished silver plate in a bath of gold chloride increased the contrast of the image and made it less susceptible to damage by exposure and oxidation. To protect the surface of the daguerreian plate further, a sheet

of glass was placed over the image, separated by a mat, and its edges sealed in as ideally airtight a manner as possible.

This short account of the daguerreian process should also note that each step had to be accomplished by trial and error before the process was mastered. The tedious polishing was extremely critical, as was the proper degree of sensitization, the length of exposure, and how long the mercury vapor should be allowed to react with the exposed plate. The purity of the chemicals was also a factor, and the time of day or season of the year had to be taken into consideration in respect to exposure times. When we contrast this process with the present simplicity of taking photographs with carefully standardized manufactured materials, it can be seen why photohistorians maintain an enormous respect for the early workers in the field.

16
American *(left)* and European *(right)* mercury-fuming boxes for developing exposed daguerreian plates. Values: left, $1,200; right, $2,000.

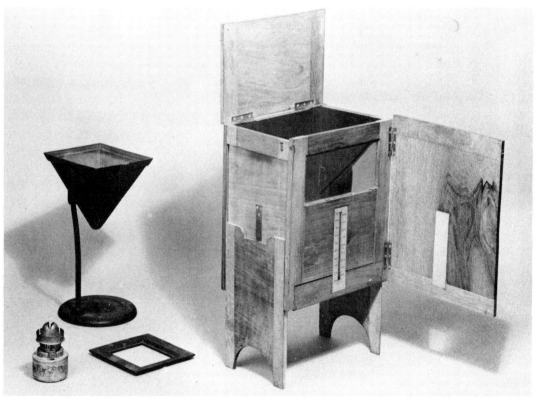

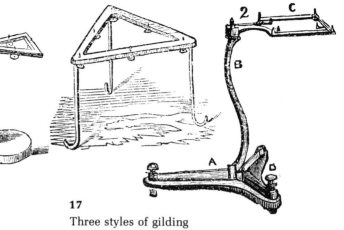

18

Gilding stand for quarter-
plate daguerreotypes.
American, c. 1845. Value,
$400.

One of the few reproductions in the Isenberg collec-
tion is a 1956 limited edition of a Voigtlander & Sohn
all-metal daguerreian camera. Resembling a telescope,
the camera was first produced by this famous Vienna
optical firm in 1841 and made a picture on a circular
plate approximately 3¾ inches in diameter. The cam-
era was the first to use a relatively fast lens designed by
Professor Josef Petzval. Although about six hundred of
these cameras were originally produced, the only ex-
ample on permanent display is in the Deutches Mu-
seum in Munich, West Germany.

The 1956 version was made by the same Voigtlander
Company to commemorate its two-hundredth anniver-
sary, and two hundred copies were produced. Most of
these went to museums around the world, and the fact
that very few have found their way into private collec-
tions makes it a desirable and valuable photographic
item. Collectors in both Europe and the United States
cannot understand why so few originals have surfaced
in the past 136 years. Six hundred were made, and, be-
ing of all-brass construction, the camera was extremely

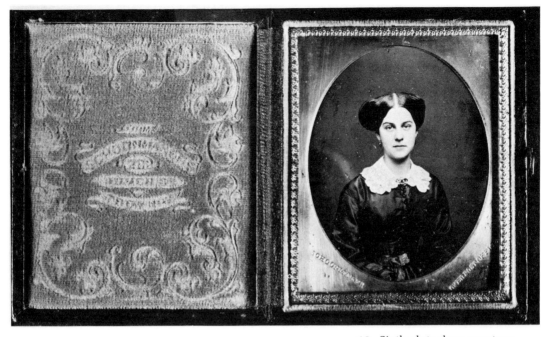

19 Sixth-plate daguerreotype mounted in a leather case. Photographer's name, Schoonmaker, of Troy, New York, and his location, "over the post office," is stamped into the mat inside the frame. Made around 1855. Value, $40.

THE

HISTORY AND PRACTICE

OF THE

ART OF PHOTOGRAPHY;

OR THE

PRODUCTION OF PICTURES THROUGH THE AGENCY OF LIGHT.

CONTAINING

ALL THE INSTRUCTIONS NECESSARY FOR THE COMPLETE PRAC-
TICE OF THE DAGUERREAN AND PHOTOGENIC ART,
BOTH ON METALIC PLATES AND ON PAPER.

BY HENRY H. SNELLING.

ILLUSTRATED WITH WOOD CUTS.

New York:
PUBLISHED BY G. P. PUTNAM,
155 Broadway.

1849.

20
Manuals describing the photographic process, such as this 1849 publication, were indispensable to early workers and are of interest to today's collectors.

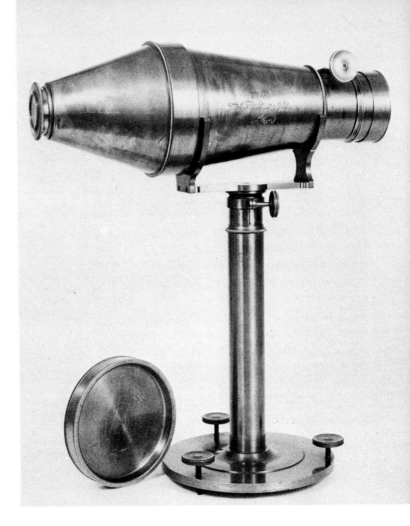

21
A copy of 1841 daguerreotype camera made by Voigtlander & Sohn of Vienna around 1956 to mark the two-hundredth anniversary of the founding of the company. This copy is one of approximately less than two hundred made. Like the original, it is all brass and has an f/3.4 Petzval-type lens. This replica is now worth $2,500.

durable and not subject to the rot and other deterioration a wooden camera might experience. Also, the camera was probably imported into the United States in the early 1840s by the Langenheim Brothers of Philadelphia, Pennsylvania, who were the American distributors of Voigtlander lenses and other photographic equipment.

A recent addition to the collection is an American quarter-plate daguerreian camera which is judged to have been made between 1841 and 1843. It is a sliding box in a box of typical American construction, lacking the refinement of cabinetmaking evident in European models of the same and somewhat later periods. Of particular interest is the lens, which is similar in size, design, and shutter mechanism to the one used on the

original Giroux Daguerre camera of 1839. While the lens bears no markings, it may be a French import or more probably an American copy, fitted to an American-made box.

A lens of this type is described in a letter owned by Isenberg written in February 1843 by a daguerreotypist in New York City to a neophyte photographer in Savannah, Georgia. The New York worker describes his apparatus as "a camera of rosewood with a screw to adjust the focus and furnished with two acromatic [sic] lenses and one plano three inches [in] diameter." This letter is a treasure to photohistorians, as in four closely written pages the writer describes his methods, materials, successes, and failures, and assesses the work of such noted contemporary daguerreotypists as Plumbe and Chilton.

Two quarter-plate daguerreian cameras with chamfered edges represent an American type of the late 1840s. One, 12¾ inches long, has a mahogany-veneered body and a mirror to right the image projected on the ground-glass focusing screen. The shorter version, 10½ inches long, is made of rosewood veneer and lacks a righting mirror. Both cameras have two top-opening

22
American quarter-plate daguerreotype camera, c. 1841–43. Sliding-box type with 4-inch-diameter lens. To control lens aperture, paper stops were inserted between the sections of the three-element lens. Lens and shutter similar to type used on original Giroux daguerreotype camera. Value, $12,000.

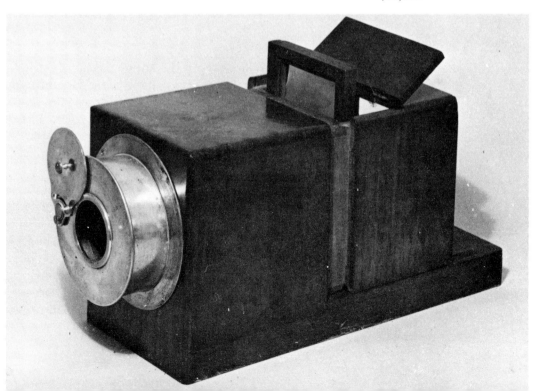

23

Original broadside advertisement for itinerant American daguerreotypist of the late 1840s. Value, $150.

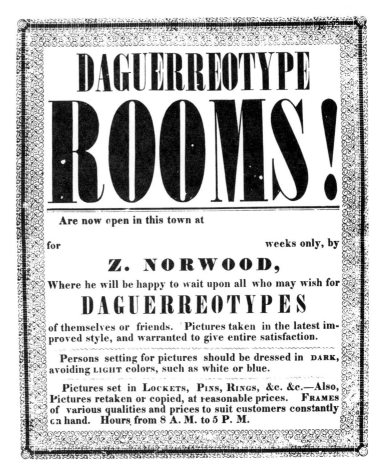

DAGUERREOTYPE
ROOMS!

Are now open in this town at

for weeks only, by

Z. NORWOOD,

Where he will be happy to wait upon all who may wish for

DAGUERREOTYPES

of themselves or friends. Pictures taken in the latest improved style, and warranted to give entire satisfaction.

Persons setting for pictures should be dressed in DARK, avoiding LIGHT colors, such as white or blue.

Pictures set in LOCKETS, PINS, RINGS, &c. &c.—Also, Pictures retaken or copied, at reasonable prices. FRAMES of various qualities and prices to suit customers constantly cn hand. Hours from 8 A. M. to 5 P. M.

doors through which the focus can be adjusted by moving the frame holding the focusing screen within the outer box and for inserting and removing the plate holders. There is no manufacturer's name on either lens. An engraving of an identical type of camera appears in Humphrey's *A Manual of Photography,* published in the early 1850s.

An improvement on this style of camera was achieved by the American firm of W. & W. H. Lewis. Their patent, dated November 11, 1851, describes a camera very similar to the solid-box chamfered-edge type in which the front and rear halves of the box are connected to one another by an adjustable leather bellows. Focusing is accomplished by moving the rear section back and forth along a single track in the base.

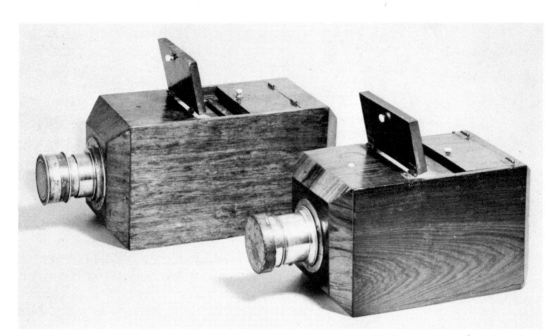

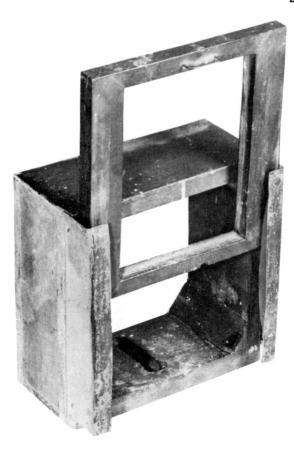

24 Two quarter-plate American chamfered-box daguerreian cameras, c. 1848. Focus and plate changing were accomplished through the top by lifting hinged lids. Camera on right has rosewood-veneered body; camera on left is finished in mahogany veneer. Neither lens has a maker's name. Value, over $5,000 each.

25 Inner box accommodated daguerreian plate holder and moved within camera body to focus image.

Once the focusing was satisfactory, the rear section was locked in place by means of a round, knurled nut which took up on a bolt that passed through an open slot and which ran along the center of the base. The front of the camera containing the lens was fixed rigidly to the base.

This focusing arrangement was a great deal more flexible than working the focus within an enclosed box and permitted the focal length to be extended to a degree that made the camera practical for close-up work such as copying paintings, printed material, and other daguerreotypes. The patent, in addition to the bellows arrangement, also described an improved plate-loading system. Instead of having the ground glass and plate holders inserted and removed through hinged, top-opening doors, the Lewises illustrated an opening at the side of the rear section through which this operation could be accomplished with a push-pull motion. Examples of the Lewis-type cameras with the opening at the side are seldom found, although the Isenberg collection does contain one half-plate Lewis camera employing this system. The collection also contains several other Lewis types, including three quarter-plate models, two half-plate models, and two of the only complete full-plate Lewis daguerreotype cameras in the world.

In 1852, the Lewis Company passed into the hands of Gardner, Harrison & Co., and then in 1853 to Palmer and Longking, which continued to manufacture the identical Lewis camera through 1857. Cameras made by the Lewises were unmarked, but Palmer and Longking used a metal die to impress their trademark into the wooden surface of their cameras and other photographic equipment. In the collection are Palmer and Longking quarter-plate and half-plate daguerreian cameras and an iodine-sensitizing box marked in this manner.

Another type of American camera made in the late 1840s through the 1850s was the sliding box-in-a-box which focused the image in the same way as the camera obscura or the Giroux daguerreotype cameras. The improvements were top-opening lids for the insertion

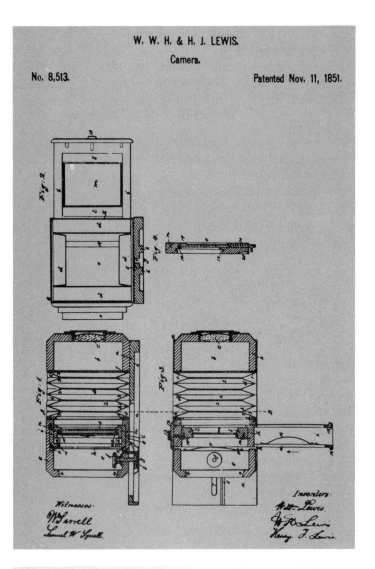

W. W. H. & H. J. LEWIS.
Camera.

No. 8,513.

Patented Nov. 11, 1851.

26
Patent issued November 11, 1851, to W. & W. H. and H. J. Lewis describing their bellows-type daguerreian camera.

27
This photograph clearly shows evolution of chamfered-edge daguerreian box camera into the Lewis type in which front and rear sections are connected by flexible bellows.

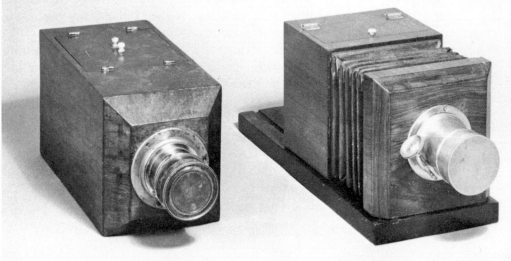

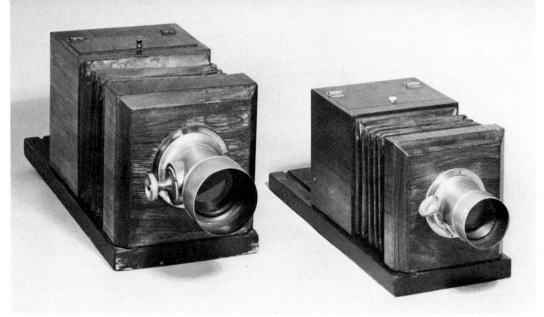

28

Half-plate (*left*) and quarter-plate (*right*) Lewis-type cameras, American, mid-1850s. Value, $5,000 to $6,000 each.

29

Rear opening of Lewis type cameras showing the track along which this section of camera was moved to focus on ground-glass screen, and knurled knob used to lock this section in place.

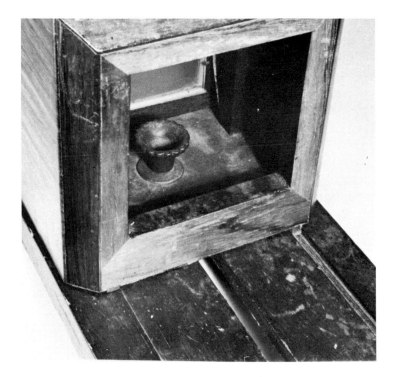

30
Quarter-plate Lewis-type camera with dark slide which covered daguerreian plate holder, partially removed.

31
Quarter-plate Lewis-type camera of the mid-1850s mounted on a tripod of the period. Value of tripod, $1,000.

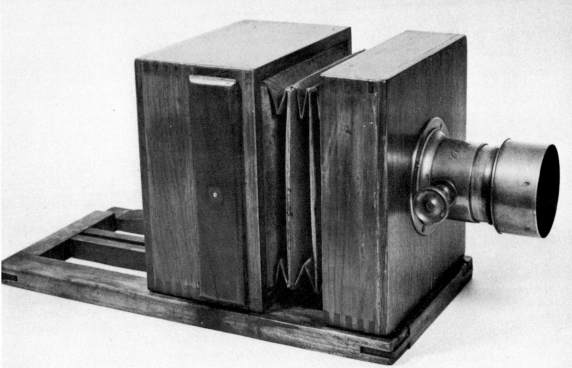

32
Half-plate camera built with Lewis's 1851 patented push-pull, side-loading plate-changing system.

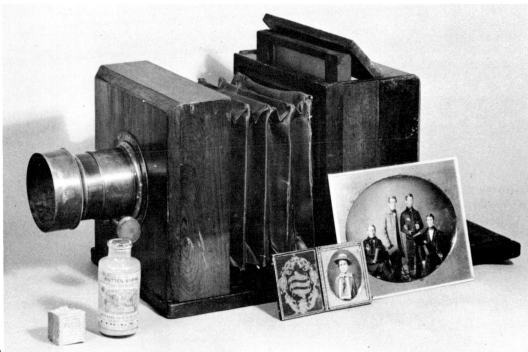

33
The world's only known full-plate Lewis-type daguerreian camera. Large image shows 6½-by-8½-inch full-plate daguerreotype contrasted with more common sixth-plate size. Value, $10,000.

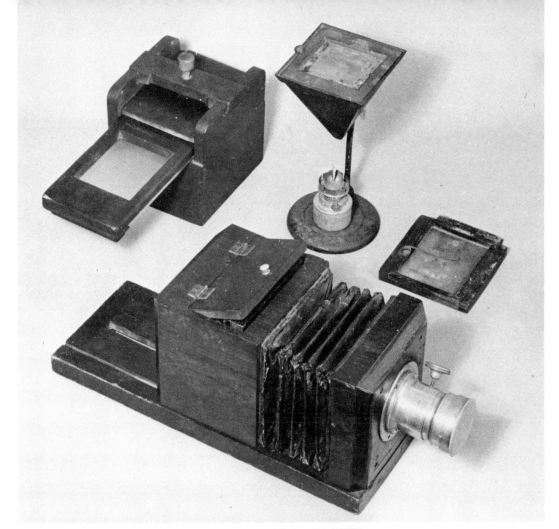

34
Quarter-plate top-loading Lewis-type daguerreian camera made by Palmer and Longking around 1854. Also shown are Palmer and Longking iodine-sensitizing box, American-style mercury-fuming stand and plate holder. Value, $7,500.

35
Palmer and Longking trademark die-stamped into both camera and iodine box.

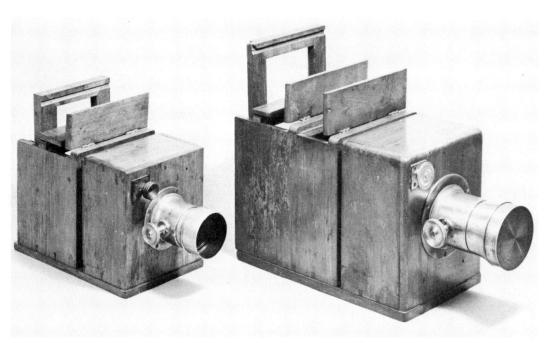

36

Two top-loading sliding box-in-a-box daguerreotype cameras of the early 1850's. Quarter-plate model on left by John Roberts of Boston, Mass. Half-plate model on right by unknown commercial maker. Value, $5,000 to $6,000 each.

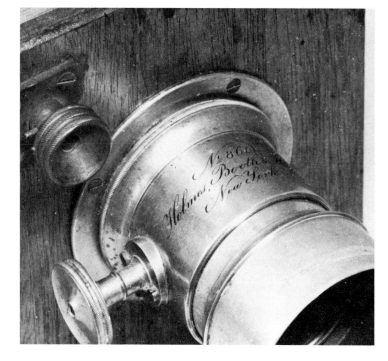

37

Quarter-plate Roberts camera is equipped with contemporary Holmes, Booth and Hayden lens.

of focusing screens and plate holders, a knurled knob at the end of a long screw to move the two telescoping parts of the camera box in and out, and a focusing device on the lens itself. Two American examples of this type in the collection are a quarter-plate camera made by John Roberts of Boston, Massachusetts, about 1853, and a half-plate camera of similar construction. The half-plate model has three doors for plate and screen changing through the top, and the quarter-plate example has two doors and is equipped with a Holmes, Booth and Hayden lens. When the two halves of these cameras and their lenses were fully extended, copies of the same size as the original subject could be made.

An early 1850s English publication, *A Manual of Photography,* by Robert Hunt, illustrates a French daguerreian outfit typical of those used by European photographers at that time. It shows a sliding box-in-a-box camera that is somewhat less intricate than the Roberts type, with a focus tie-down arrangement similar to the Lewis camera. Isenberg owns an almost identical camera exhibiting the precise, elegant dovetailing typical of French workmanship and equipped with a lens made by Lerebours and Secretan of Paris around

38
Engraving from early 1850s English publication, *A Manual of Photography*, by Robert Hunt, showing typical European daguerreian equipment.

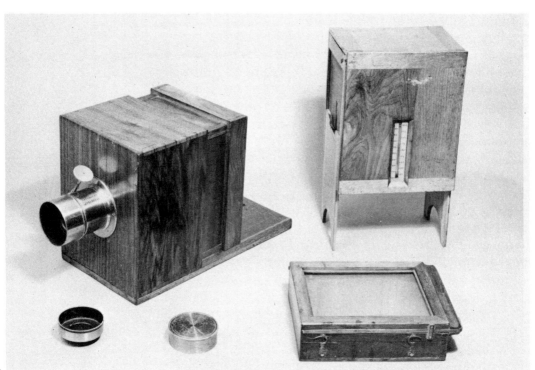

39

French 1840s daguerreian
outfit similar to engraving.
Top left: daguerreian
camera with Lerebours and
Secretan lens; *top right:*
mercury-fuming box; *lower
left:* removable lens stop
and lens cap; *lower right:*
iodine-sensitizng box. Value,
outfit, $10,000.

40

Serial No. 2948 indicates
that this lens was made by
Lerebours and Secretan of
Paris around 1847.

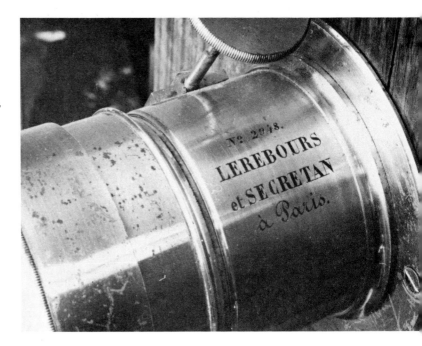

the late 1840s. Along with the camera are a sensitizing box and a folding wooden mercury-fuming box equipped with a thermometer and a ruby window through which the development of a daguerreotype could be observed.

It is important to note that at present there are twenty daguerreian cameras in the Isenberg collection— more than in any other single public or private collection in the world. This accomplishment is all the more remarkable in light of the fact that its first daguerreian camera was purchased in 1972. In that year, he bought a quarter-plate Lewis camera from George Eastman House, which at that time owned three models and could use the proceeds of that sale to buy something they did not own. However, the example bought by

41
Some American-made equipment used in wet-plate photographic process. Clockwise from top left is an 1857 copy of Humphrey's *Photography and Manual of the Collodion Process,* a collodion bottle, plate-dipping tank, developing tray, photographer's journal, and printing frame.

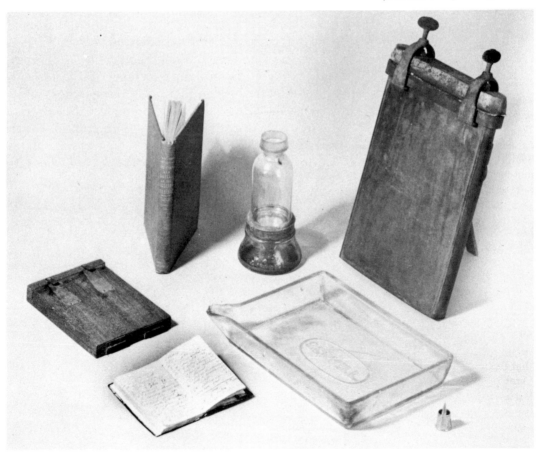

Isenberg is the one that is illustrated in many books as being the classic Lewis-type camera, and is still credited as belonging to George Eastman House when, in fact, it is now on Isenberg's shelf.

The practice of photography evolved in the early 1850s from the positive picture produced on sensitized silver-coated daguerreian plates to the production of a negative image made on a coated glass plate. The primary problem was to find a vehicle which could support the light-sensitive silver-iodide layer and bind it satisfactorily to the glass. At first, albumen secured from egg whites was used, and in 1851 the collodion process was described by Frederick Archer, a British worker. In 1854, James Cutting of Boston was granted United States patents covering the essential aspects of the collodion process.

This method involved the coating of a glass plate with soluble iodide added to nitrated cotton, dissolved in ether and alcohol, and then left to set. The coated plate was inserted into a bath of silver nitrate, forming the light-sensitive silver-iodide surface. This last operation had to be performed just prior to the exposure because once the plate had dried completely, it lost practically all of its sensitivity. While still damp, however, it was almost as sensitive as the daguerreian plates

42

Six American dipping and sensitizing tanks for processing wet-plate negatives. Value, $100 to $300 each.

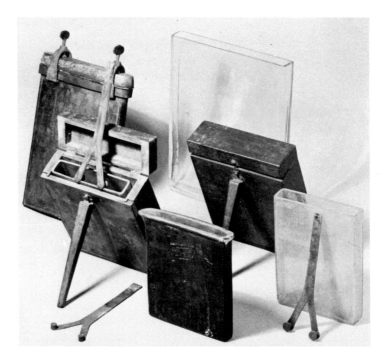

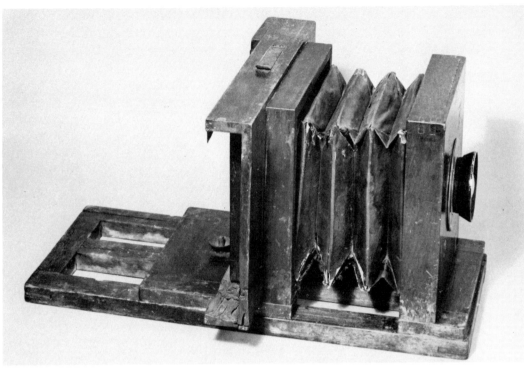

used at that time. Thus, this method came to be known as the "wet process."

The transition from daguerreian to wet plate did not take place overnight, and a camera suited only to wet plates was not instantly available. What did take place is that, as workers began using wet plates, they modified their daguerreian cameras to accommodate the different style of plate holders. Several of Isenberg's earlier cameras, particularly the quarter-plate Roberts and several of the Lewis types, including the Palmer and Longking camera, bear traces of the action of the chemicals used in the wet-plate process.

An 1863 American wet-plate camera in the collection bears the stamp of H. J. Lewis, a son of W. Lewis and one of the holders of the 1851 patent for a camera of their design. It is very similar to the daguerreian style of camera except that the back of the camera to the rear of the bellows is made so that a wet-plate holder could be inserted at the rear from the side. Isenberg has

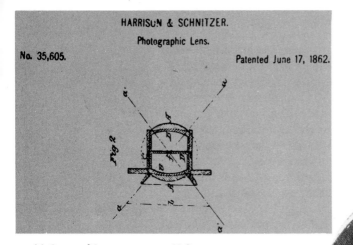

44 Copy of June 17, 1862, U.S. patent for Harrison and Schnitzer wide-angle lens. Referred to as "globe" lens because of its spherical shape.

45 Harrison and Schnitzer lens with maker's name and patent date embossed on lens retaining ring. Value, $500.

fitted this camera with a Harrison and Schnitzer wide-angle lens. This is the first wide-angle lens to be made and patented in the United States, and the patent date, June 17, 1862, is embossed in the ring holding the front element of the lens.

It is probable that the British developed cameras exclusively for wet-plate photography more rapidly than did the Americans because of patent restrictions on the daguerreotype process imposed solely on the British. A rather sophisticated portable folding wet-plate camera was illustrated in a British catalog published by Griffin in 1852. The components of this folding-style camera in the Isenberg collection are completely removable from one another and bear such refinements as a rising and falling front and provision for shifting the lens laterally. The brass hinges on the collapsible camera box are stamped *P. Moore & Co. Patent.* Although relatively

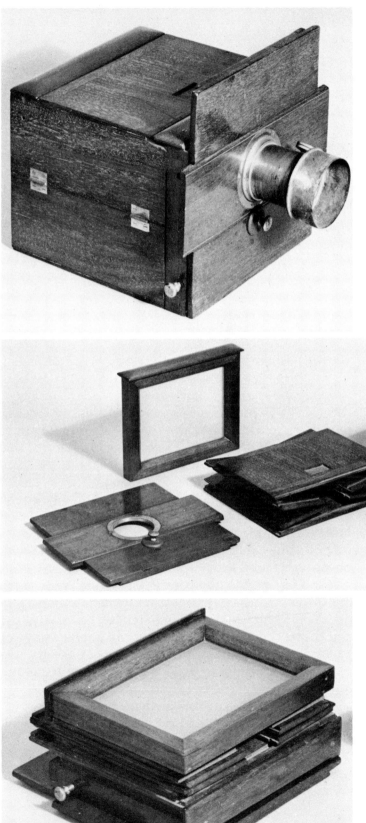

46
British folding-style wet-plate camera of the early 1850s. Camera has a rising and falling front, and lensboard can be shifted laterally. Value, $2,000.

47
View showing camera disassembled into its components.

48
Parts of camera stacked for storage or transport.

PORTABLE FOLDING CAMERAS.

This is a very convenient form of Camera for the traveller or tourist, as it packs up into small compass, and is very light. It consists of a mahogany box, the sides of which fold inwards; is fitted with ground focussing glass, two improved dark slides for sensitive paper, and sliding front; the whole, with the Lens or Lenses, fitted into a deal box, with lock and hinges.

No.	For Views.		Price.			If with second opening and extra front for Portrait Lens, dark box, with inner frames for Collodion plates.		
	Inches.		£	s.	d.	£	s.	d.
1	4½ by	6½	4	4	0	5	10	0
2	6 by	8	6	6	0	7	17	6
3	8 by	10	9	9	0	11	11	0

light in weight for its time, the outfit when disassembled was not much less bulky than the camera was in its ready-to-use condition.

A less elaborate wet-plate camera is an English model of around 1855 which took 5-inch-square plates and is fitted with a French lens made by Derogy. The lens bears the royal cipher of Queen Victoria, which indicates that it was made for British export. The camera is a sliding box-in-a-box that is unquestionably British in its fine dovetailing and carefully made and fitted brass track guides.

During the 1850s, various technical advances and innovations caused an enormous expansion in the use of, and interest in, the photographic process. We have already mentioned the wet plate, which produced a negative from which any number of positive paper prints could be made. Less costly and somewhat less technically demanding, it brought about the decline and eventual demise of the daguerreian process within about twenty years of its introduction.

This period also saw the birth of stereo cameras designed to make two photographs side by side simultaneously and which, when seen through a proper viewer, gave a three-dimensional illusion to a scene. At first, two separate exposures were made on a single

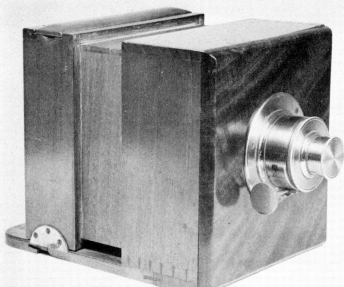

50
British-made camera, c. 1855, for 5-inch-square wet plates fitted with French lens by Derogy. Dovetailing and brass track guides are typical of British construction of the period. Value, $1,500.

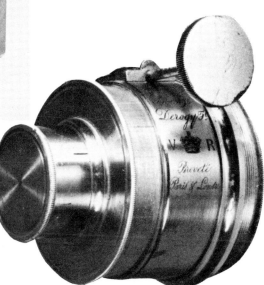

51
Derogy lens with "VR" cipher of Queen Victoria, indicating it was made for British export.

plate by shifting the position of the lens from right to left and masking the plate. Some stereo photographs were taken by two separate cameras mounted side by side. The next logical development was a camera with two lenses and shutters which made possible portrait photographs in stereo and other subjects less static than landscapes or still lifes.

What may be one of the earliest known commercially produced stereo cameras is the J. B. Dancer stereo camera. Made in England in 1856 primarily as a wet-plate camera, it also contains a magazine to hold twelve dry plates and a mechanism for changing the plates after each exposure without removing them from the camera. It is particularly important that this is the first cam-

41

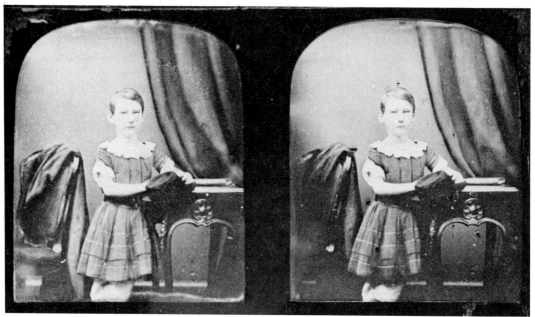

52

Hand-tinted stereo daguerreotype taken by Antoine Claudet, a fashionable French photographer and photographic distributor who worked in London up to 1867. Value, $300 to $400.

era to incorporate such an internal plate-changing device. Matt Isenberg feels that the five-figure price he paid to an American dealer for this camera was fair, even though he knew that the dealer had bought it for only $300. The only other known example is on display in the photography collection of the Science Museum in London, England. In respect to mystique, rarity, and historical significance, it is one of the crown jewels of the collection.

There are two other fine British stereo cameras in the collection of the same period as the Dancer. One is marked *Murray and Heath/43 Piccadilly/London*. It was made to take wet plates and is equipped with a consecutively numbered matched pair of Ross lenses. This is a more common type of stereo camera, which was made in England for about twenty years. The other is an especially beautiful J. H. Dallmeyer stereo camera made about 1860. It could be claimed that no other camera in the entire collection exhibits so high a degree of craftsmanship in cabinetmaking and the precision with which the brass fittings are made and applied. Each of the slots of the brass wood screws on either

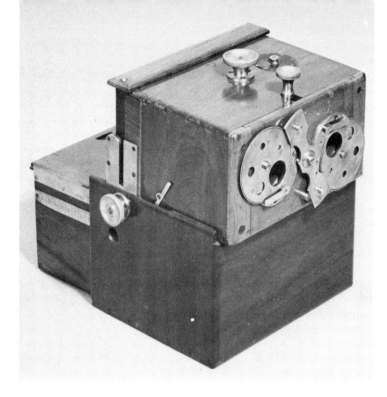

53

J. B. Dancer's stereo wet- or dry-plate camera. Probably the first commercially produced camera of this type. British, 1856. Upper section could be used separately. Lower section is a magazine for twelve dry plates which could be changed without removing them from chamber. A Dancer camera similar to this was sold at a Christie's auction in London on October 5, 1977, for $36,750.

54

Rear view of Dancer stereo camera components. At right is the camera portion with stereo septum and plate holder. Dry-plate magazine storage and changing units are at left.

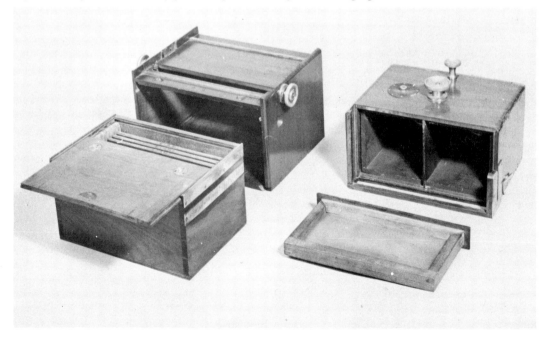

side of the camera body is perfectly aligned in a vertical position. There is an "in" joke among collectors who claim that Dallmeyer's workers must first have inserted the screws and then cut the slots.

A very fine French stereo camera made by Koch in Paris about 1857 has two rather unusual features. First, the panel on which the pair of Jamin lenses is mounted is tamboured so that the degree of stereo separation can be adjusted for close-up or distant subjects. This adjustment itself is remarkable for stereo cameras of this period, and the method of accomplishing it is particularly elegant. Second, when the doors covering the lenses at the front and the ground glass at the rear are closed, the camera can easily be carried about by means of the handle fitted to the top.

It is instructive to compare the cabinetry of the French Koch stereo camera with the British Murray and Heath and the Dallmeyer we have previously discussed. While all three exhibit a very high order of workmanship, precision, and finish, the collector and historian should know how to distinguish one style from the other, even though a camera may lack any

55
Murray and Heath English stereo wet-plate camera made in the mid-1850s and equipped with a pair of matched lenses made by Ross. Value, $3,500.

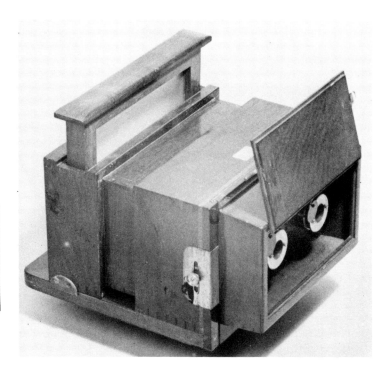

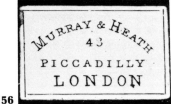

56
Inlaid, engraved ivory maker's mark as it appears on camera.

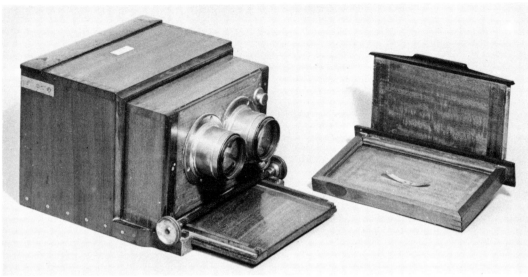

other evidence of the country of its origin such as a manufacturer's or lens maker's mark.

The most reliable point of reference is the dovetailing at the top and sides of the camera box. French dovetailing is bold, with wide triangular cuts; while the British style is much more delicate, with the dovetails narrow, tapering, and more closely spaced. The brass hardware on British cameras is very carefully fitted and usually recessed so that it fits flush with the wooden body. These criteria hold true not only for stereo cameras of these countries but also for their earlier daguerreian and later single-lens wet- and dry-plate cameras as well.

This European precision can be contrasted with the "primitive" appearance of most early American cameras. It is this simplicity and plain utility that hold a distinct charm for us. Although the Americans did not make so elaborate or well-finished cameras as the Europeans did during the period from 1840 to 1880, their results were consistently equal or superior to British or continental photographers. A stereo camera made by John Stock & Company of New York around 1863 is a good example to compare with the Murray and Heath, Dallmeyer, and Koch cameras.

The Stock camera is a wet-plate camera very similar to the Murray and Heath except that the two consecu-

57 English stereo wet-plate camera made by J. H. Dallmeyer in London around 1860. Some collectors feel that no other camera exhibits such a high degree of workmanship and elegance of detail as this beautifully crafted piece. Note that slots on each of the brass wood screws are uniformly aligned in a vertical position. Value, $4,000.

58
Dallmeyer trademark.

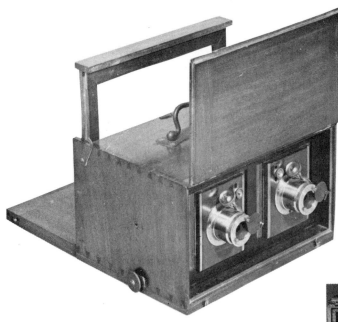

59
French stereo wet-plate camera made by Koch around 1857. Value, $5,000.

60
Front of Koch camera, showing tambour arrangement for adjusting stereo separation of the Jamin lenses.

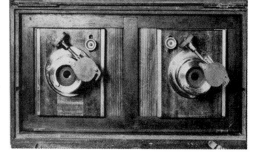

61
Koch camera closed and ready for travel.

62 Koch trademark die-stamped into front lid of mahogany cabinet.

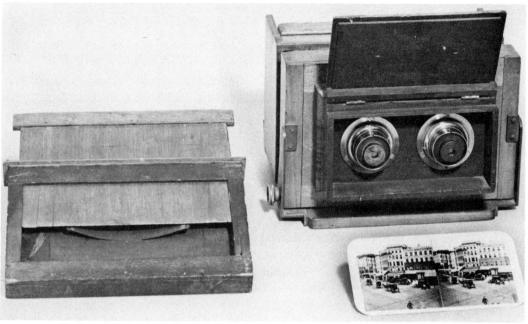

tively numbered Voigtlander lenses have no shutters and the exposure is controlled by simply raising and lowering the wooden door that covers the front of the camera. Dovetailing is rectangular rather than tapered, and the brass and wood have a more coarse and utilitarian appearance. This is the type of camera frequently used by photographers during the American Civil War.

The refinement and widespread acceptance of the wet-plate process, with its capacity for producing paper prints, reduced the cost of having one's photograph taken to an amount much less than the daguerreian method cost. This helped to start the mid-1850s craze of the *carte de visite*. The printed calling card which had been in vogue for many years was rapidly replaced by a person's photograph in the shape and size of the calling card that served the same purpose. This fad brought onto the scene a number of cameras suited to take this size and type of picture. The most distinctive development was a camera that could secure several images on a single plate. This facilitated the production of duplicate prints, since the photographic paper in contact with the negative had to be exposed to sunlight for long periods of time because of its low sensitivity.

63 Wet-plate stereo camera by John Stock & Company, New York City, c. 1863. This type of camera was used extensively by Civil War photographers. Camera is shown with front flap—which acted as shutter—open. Twin Voigtlander lenses. Value, $5,000. Anthony stereo view is 1860s New York City scene.

64
John Stock's trademark stamped into camera's front lid.

65

Post–Civil War *carte de visite* of the photographers Bolles and Frisbie of 3 Bank Street, New London, Connecticut. Of special interest to photo historians is the chamfered-box half-plate daguerreian camera mounted on a ''Jenny Lind'' stand.

Among the earliest American cameras built to take multiple exposures on a single plate is one patented in April 1855 by A. S. Southworth, a partner in the firm of Southworth and Hawes, noted Boston photographers, who sold the rights to Simon Wing of Waterville, Maine, and later Charlestown, Massachusetts. Wing received a patent for his version of this camera on December 4, 1860. This rare Wing camera has only a single lens, but a complicated system of gears and cogs at the rear permits a 6-by-9¼-inch plate holder to be shifted into different positions, allowing up to twenty-five separate photographs to be made on the same wet plate.

This ingenious arrangement was soon superseded by multilens cameras using four, six, nine, and up to sixteen separate lenses, and Simon Wing and his successors continued manufacturing these and other cameras for another fifty years. Among the multilens wet-plate cameras in the collection are a Wing four-tube (or four lenses) of about 1870 with a shutter patented by Simon Wing, and four-tube and nine-tube cameras made by E. and H. T. Anthony in the period between 1870 and 1880.

An especially important multilens item in the collection is the sixteen-lens Roberts camera. It is a clear adaptation of the earlier Roberts daguerreotype cameras of the sliding box-in-a-box design and was used to make miniature tintypes on a single sensitized sheet-metal plate. After the exposure was made, the plate was cut with metal cutting shears into sixteen small tintypes which could be framed, used in jewelry, or mounted in an album.

It should be pointed out that treating a photographic plate with a wet sensitizing solution gave rise to a variety of photographic images. We have already mentioned the *carte de visite* and other paper prints which were printed on photographic paper from a glass negative, and the tintype of various sizes which was made by a direct positive process on a metal base like the daguerreotype, from which copies could be made only by rephotographing an original.

Another kind of early wet-plate image was called the ambrotype. The ambrotype picture was made to ap-

66
Shown on a Wing tripod is this camera patented by Simon Wing in 1860 but also bearing rare impressed stamp *A. S. Southworth's Patent April 10, 1855* and *Wing's Patent Dec. 4, 1860.* Camera could take as many as 25 separate exposures on a single 6 by 9¼ inch plate by manipulating position of plate holder in relation to lens. Value, $5,000.

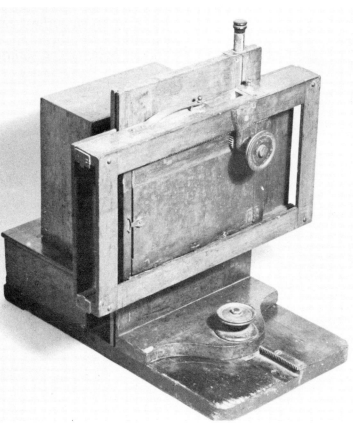

67 Rear view of Wing camera.

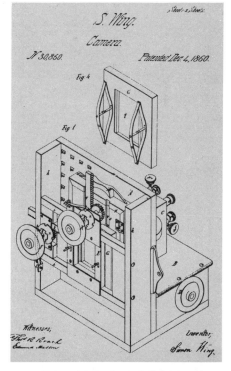

68
Copy of Wing's patent, dated December 4, 1860.

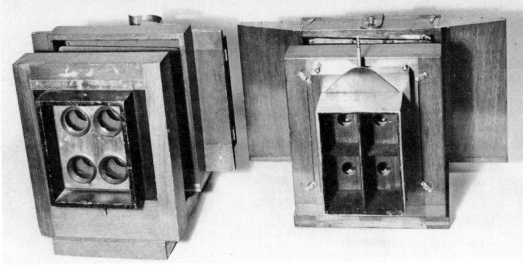

69

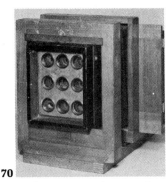

70

pear as a positive image by placing a piece of black cloth, metal, or paper behind a slightly underexposed wet-plate negative. This technique gave the illusion of a positive image. In some cases, the back of the glass plate was coated with a black paint or varnish. These ambrotypes, being glass, were usually protected by frames and cases similar to those used for daguerreotypes. All of the wet-plate cameras and even modified daguerreian cameras could be used to make ambrotypes, tintypes, or paper prints from glass or paper negatives. Only a suitable change in the plate holder for the type of process used had to be provided.

A considerably more portable wet-plate camera was patented in 1864 by Bourdin, a French engineer. His apparatus, named the Dubroni (an anagram of the inventor's name), made possible the sensitizing, development, fixing, and washing of the photographic plate entirely within the camera body. A glass or ceramic container in the camera held a collodion plate to which the chemicals could be introduced or removed in the proper sequence by means of a syringe inserted into the top of the camera. In some models the development could be observed through an amber glass container or through a ruby glass window in models equipped with a ceramic processing container.

The Dubroni apparatus was one of the first attempts to eliminate the need for a darkroom, to make the equipment less cumbersome, and to make the photographic process accessible to a great number of inexpe-

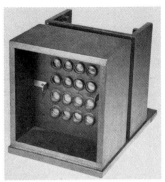

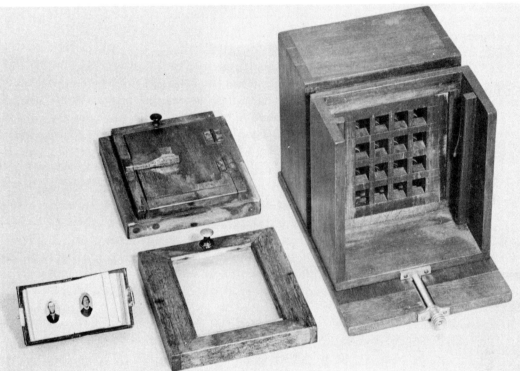

rienced operators. It could be thought of as a wet-plate adaptation of what Gaudin was trying to accomplish with his daguerreian outfit.

Of the two Dubroni cameras in the Isenberg collection, one is complete with its original oak carrying case and has two of the chemical bottles, a funnel, syringe, an envelope containing printing paper, and a glass plate used in the process. In addition, a developed glass negative of a Parisian street scene was found in the camera. A complete Dubroni outfit tends to be nearly double the value of the camera alone.

72
Rear view of Roberts tintype camera showing back divided into sixteen frames, ground-glass focusing screen, plate holder, and typical miniature tintypes produced by this kind of camera.

73

Quarter-plate ambrotype of an American sailor, c. 1857. Ambrotypes were made by placing a negative image against a black background, but lacked the clarity and lifelike aspect of a daguerreotype. Value, $50.

Two Dubroni cameras, one in original carrying case with some of the chemicals required to coat, sensitize, and develop a glass plate. All of these functions were carried out inside the body of the camera. Made around 1867. At the lower right is a circular-shaped negative found with the camera. Complete outfit value, $4,000.

A significant advance in the design of wet-plate cameras was suggested in 1857 by Colonel C. H. Kinnear of Scotland. Kinnear proposed a tapered or cone-shaped bellows which could be folded into a smaller space than the usual rectangular style. By the mid-1860s, Kinnear-type cameras were being made and sold in many parts of the British Isles. The Kinnear-type wet-plate camera in the Isenberg collection bears an inset ivory label indicating that it was sold by Brown in the city of York. This camera, which takes a 6½-by-8½-inch wet plate, can be completely disassembled into practically all of its components and was the precursor of all subsequent folding cameras.

A photo historian is just as interested and enthusiastic about what is referred to as "photographic ephemera" as he is about the "hardware." "Hardware" means cameras, lenses, tripods, viewers, projectors, and the like, while "ephemera" are the manuals, books, broadsides, posters, advertising material, works of art containing photographic references, and the equipment or accessories required to process daguerreian and wet-plate photographs. Images and cases are in a distinct and separate category.

Representative of some of the items of the daguerreian era are American and French iodine-sensitizing boxes, one of which is impressed with the Palmer and

74

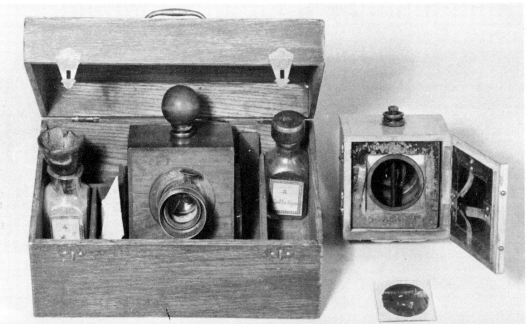

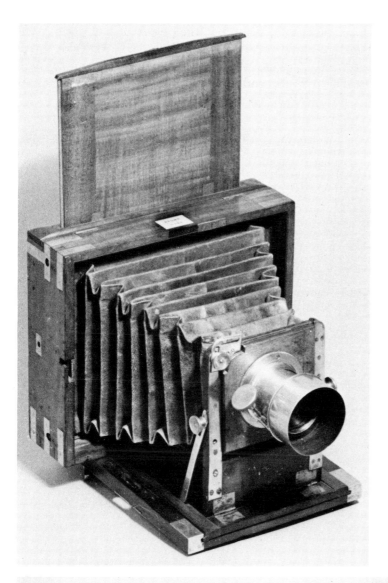

75
An early 1860s
tapered-bellows or Kinnear-
type camera for 6½-by-8½-
inch wet plates exhibiting
typical brass-bound British
construction. Value, $1,000.

76
Camera can be
disassembled into all of its
parts for storage. Forerun-
ner of later folding cameras.

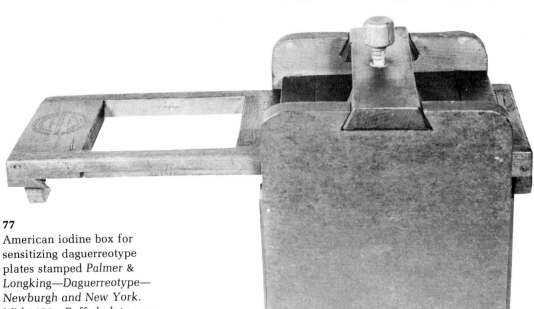

77
American iodine box for
sensitizing daguerreotype
plates stamped *Palmer &
Longking—Daguerreotype—
Newburgh and New York.*
Mid-1850s. Buffed plate was
placed in frame and shifted
to cover the glass jar, which
held iodine crystals. Clamp
at top was provided to
make airtight seal. Value,
$1,000.

78
Coloring box, 1840s style,
for handtinting directly on
the silvered surface of da-
guerreotypes. An outfit ex-
actly similar to this is
shown in an engraving in an
1850s photographer's man-
ual. Value, $2,500.

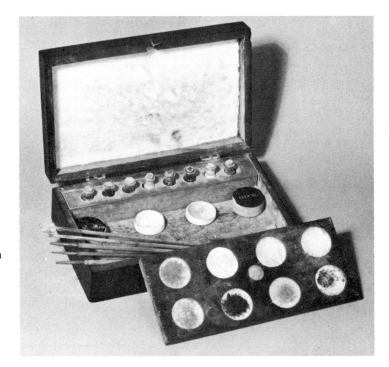

Longking trademark. There are also American and European mercury-fuming boxes and gilding stands. Since the emphasis of this part of the collection is principally on early American artifacts, we find many rare and fascinating objects. One of the most valuable is an 1840s coloring box used to hand-color daguerreian plates directly on the silvered surface. On the lid of this rarity is an old paper label on which is written: "Isaac McNeely's daguerreotype retouching case." This box is identical to one shown in an engraving in one of Humphrey's manuals of the 1850s.

Other important daguerreian tools are buffing sticks and a box of polishing rouge bearing the endorsement of J. Gurney of New York and M. A. Root of Philadelphia, both eminent daguerreotypists of the early 1850s. A bottle containing rotten stone used in the preliminary polishing of a daguerreian plate bears the label of D. D. T. Davie of Utica, New York, who in 1851 became the first president of the New York Photographers Association. It is of special interest because the label has a cartoon depicting Davie's laboratory and shows a camera and a potential sitter rushing in panic from the studio.

Other plate-preparation items are a plate vise patented by Samuel Peck, who is usually associated with the development of daguerreian cases, a Benedict plate vise, and a crimper used to bend the edges of the daguerreian plates so that they could be held more readily in the vise. There are also several boxes of unused daguerreian plates bearing the label of J. M. L. & W. H. Scovill and their 1849 successors, the Scovill Manufacturing Company of Waterbury, Connecticut.

Among the paper ephemera is an 1839 copy of the English edition of Daguerre's description of his process, several daguerreotypists' advertising broadsides and

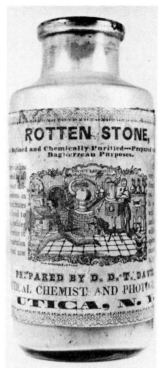

79

Bottle containing rotten stone sold by D. D. T. Davie, an important daguerreotypist working in Utica, New York, around 1850. Cartoon on label depicts client rushing in terror from photographer's studio. Value, $500.

80

Vise to hold daguerreotype plates for buffing by Samuel Peck, maker of early thermoplastic Union case. Value, $300.

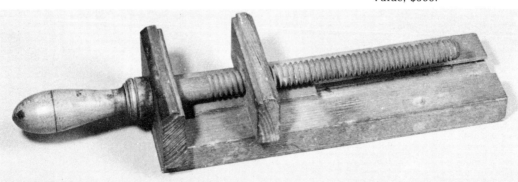

P. H. BENEDICT.
DAGUERREOTYPE PLATE HOLDER.
No. 10,466.
Patented Jan. 31, 1854.

81 Copy of Benedict's 1854 patent for daguerreotype plate holder.

83

Plate bender, or crimper, and an example of Benedict's plate vise. This pair of daguerreian tools is worth $600.

on- | **PLATE BENDER.**—An instrument for turning
ce. | ing down the edges of the daguerrean
all | plate. There are several kinds of these

Fig. 85.

ns, | useful little articles. Fig. 85 represents
the | one of the most simple for turning
nto | down edges for the ordinary plate
vill | block. Fig. 86. is an excellent bender

82 Description of tool to crimp edges of daguerreotype plates so that they could be held more easily in a vise during the buffing operation.

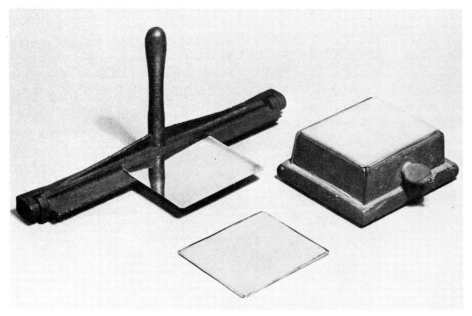

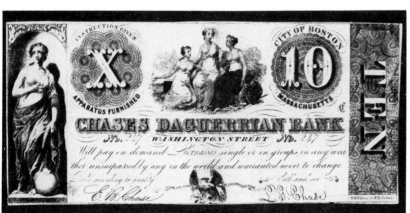

84 Matched pair of consecutively numbered lenses made in the mid-1850s by C. C. Harrison of New York City. These could easily have been used on stereo daguerreotype or transitional American wet-plate cameras. As a pair worth $750, but a wooden camera of the same period would be worth a great deal more.

85
Simulated bank note issued by Boston daguerreotypist as an advertisement. His slogan exhorts customers to "secure the shadow—ere the substance fades." Like many other operators of the 1840s and 1850s, the Chases also sold photography lessons and equipment.

86

Newspaper advertisement for daguerreotypist working in the Williamsburgh section of Brooklyn, New York. He describes his studio and states that he will go to clients' homes to photograph "Sick or Deceased Persons."

87

In the mid-nineteenth century, this New York City hatter offered to install a free daguerreotype of the customer in each new hat that he bought.

88

Box for storage of developed ninth-plate ambrotypes bearing an advertisement for Davis's Traveling Ambrotype Saloon, c. 1860.

89

Flyleaf of intinerant photographer's pocket diary dated April 27, 1862.

90

Entries in April and May of 1862 list ambrotypist's expenses for travel by boat and cost of such materials as glass, silver, mats, acetic acid, alcohol, and varnish.

fliers, and the previously mentioned letter from a New York daguerreotypist dated February 16, 1843. There is also a letter written in November 1850 by S. D. Humphrey on the stationery of the *Daguerreian Journal.*

It might be expected that ephemera from the wet-plate era would be more plentiful since many more photographers, both professional and amateur, were working with the process. This is not necessarily true, as not many developing tanks and trays, plate holders, and dipping rods can still be found.

A particularly nostalgic account of photographic history is contained in a small ledger in which an itinerant photographer made entries concerning his activities in 1862. Inside the cover is the inscription:

> April 27th 1862
> Isaac Finson Brown
> tontogany, wood Co. ohio
> now traveling on the
> ambrotipe boat

The spelling and nonuse of capital letters perhaps reflect the writer's lack of much formal education. The entries list his purchases of acetic acid, 1 ounce of silver, mats and preservers, glass, cyanide, alcohol, and a pint of black varnish. Further entries record his receipts from sitters whose portraits he made in his journey along the Maumee River to Defiance, Ohio, that season. Journals such as the above bring the Isenberg collection into the realm of social and business as well as scientific history and provide the onlooker with a more humanistic approach to collecting photographica.

3

Classic European Cameras

In no other private collection in North America can one find so many rare and important cameras of European manufacture, repre-senting especially the sixty-year span between 1875 and 1935. While Isenberg has been able to acquire many fine items in the United States, some of the most unusual were bought during his frequent trips abroad. This portion of the collection should be of particular in-terest to advanced American collectors, as so few of these cameras are available for study on this side of the Atlantic.

Chronologically, the first camera in this group to con-sider is the Scenographe, patented by Dr. Candèze, a Belgian dentist, in March 1874. The Scenographe was an early attempt to produce a lightweight, compact, collapsible camera. To that end, the body of the cam-era between the front lens mount and the rear plate holder consisted only of a tapered black-silk bellows. When the cloth bellows was extended, it was held rigid by wooden struts at the top and bottom. Although very light, the Scenographe was furnished with a special tri-pod which resembled a cane that came apart to form three legs. The tripod support was needed because the Scenographe was meant to be used with dry plates,

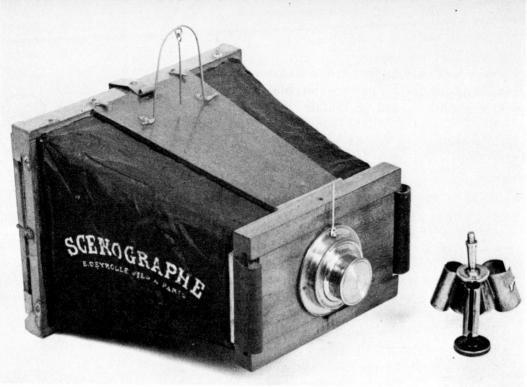

91

The Scenographe, early French folding camera patented in 1874. Bellows is made of black silk. Only example in U.S. private collection. Value, $4,000.

which at that time were slow and required much longer exposures than wet plates. For that reason also, it had no shutter; the exposure was made by removing the cap of the slow, f/20 lens, counting the seconds, and then replacing the cap over the lens. The example in the collection is in remarkably good condition, with the gold stencil on the side of the intact bellows clearly legible; it reads *Scenographe* above *E. Deyrolle Fils—Paris*. Along with the camera is its original carrying case, plate holders, and a tripod socket.

Continuing with French cameras of the 1880s, there is a very simple dry-plate camera which strongly resembles the American-made Walker Pocket camera shown in Chapter 5. The French version has no shutter, and the lens aperture is controlled by inserting disks of varying diameters in front of the lens. Both cameras are rigid wooden boxes, and the focusing on the ground-glass backs was limited to the extent to which the lens could be extended or retracted in its mount.

The Photosphere, patented in 1888 by Napoleon Conti and built by the Compagnie Française de Photographie, is an odd-looking camera that was fairly popular for about ten years. It had an all-metal body, five

shutter speeds varying with the tension on the cocking spring, and used dry photographic plates. The plates were originally loaded in double plate holders, but later a magazine back holding twelve plates was made available. Before it was discontinued shortly after 1900, the Photosphere was offered in three sizes, and a stereoscopic version was also offered in the mid-1890s. In the collection is a single-lens Photosphere with a magazine back, plus the only stereo Photosphere in any U.S. collection.

A very rare and complex camera was invented just before 1900 by Guido Sigriste and manufactured by J. G. Sigriste of Paris. Its special interest for the collector is that it was the first camera designed to take photographs at exceptionally fast shutter speeds. By varying both the width of a slit in a blind or curtain which traveled across the film plane, and the tension of the spring which governed the rate of travel, speeds as high as 1/10,000 of a second were said to be possible. These variables were controlled by setting an arm and a flange on a round dial on the bottom of the camera for the desired slit width and spring tension. The shutter was cocked automatically as each plate in the self-contained film magazine was changed. Just beneath the speed-setting dial is a chart giving suggested shutter settings for various moving subjects. For instance, at the time the camera was made, the shutter speed required to stop the motion of a horse in full gallop was more rapid than for an automobile. While any Sigriste cameras are exceptionally hard to find, included are a single-lens Sigriste and a stereo Sigriste, both of

92
French dry-plate camera of the 1880s has no shutter and used inserts to vary lens aperture. This type of camera is commonly found in Europe and is worth only $400 to $500.

93
Mono and stereo versions of the Photosphere, a popular French camera of the 1890s. Model at left is shown with magazine plate holder. Stereo model is only example in any United States collection. Mono, with plate changing magazine $1,500. Value of stereo version over $6,500.

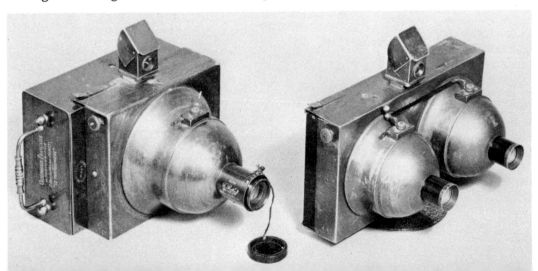

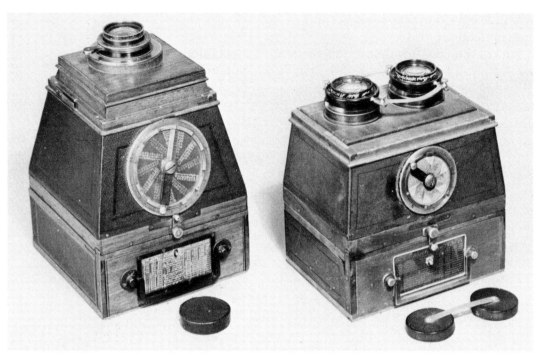

94 French Sigriste camera shown in mono and stereo models. This was the first camera with shutter speeds claimed to be as fast as 1/10,000 of a second. Neither of these cameras is known to be in any other private collection in the United States. Value, $4,000 each.

95 French motion-picture camera of about 1910 is called the Olikos. Instead of using film on reels, the Olikos took eighty-four pictures in sequence on each of twelve glass plates contained in the camera. When developed to a positive, pictures could be projected by opening the camera and placing a light source behind the plates. Value, $1,200 to $1,500.

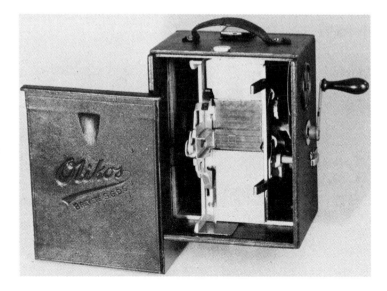

which are the only known examples in a private American collection.

One of the very few items in the collection associated with motion pictures is a weird French movie camera of about 1910 called the Olikos. Apparently the inventor must have felt that movie film wound on reels was unsatisfactory and that multiple images made on glass plates was the only way to go. Therefore, this camera stored a supply of glass plates; seven photographs were made on twelve rows (total of 84) on each of the 2½-by-3½-inch plates. Turning a hand crank moved a portion of each plate from left to right in front of the lens, made the exposure, and advanced the plate to the next frame. At the end of each row, the plate was raised to the next row and advanced right to left. The sequence of movements could be compared to a sheet of paper in a typewriter if the machine could type in both directions. After eighty-four images had been recorded on the exposed plate, it was lifted to a storage area above the lens, and a fresh plate was automatically brought into place from a stack at the bottom of the camera. The elaborate arrangement of ratchets, gears, and cams made a fearful racket as the crank was turned.

After the plates were developed and positive images made—also on glass—the plates were returned to the machine in the order in which they were exposed. At that point, the Olikos could be converted to a projector by opening the back and placing a suitable light source behind the plates. Obviously, this was an extremely complicated and impractical concept, and very few Olikos cameras were made and sold. The camera was a rather rare aberration of an inventive mind.

The Multi-Photo, a French camera introduced in 1924, was an attempt at making a pocket-size camera capable of taking nine images on a single sheet of film, or 108 pictures with a film pack holding twelve sheets. The all-metal body had nine bayonet-mount lens openings into which one or both of the two lenses supplied with the camera could be inserted. The insertion of a lens opened a blind behind that lens while the shutter traveled simultaneously across all nine film chambers. If both lenses were used properly, a stereo photograph

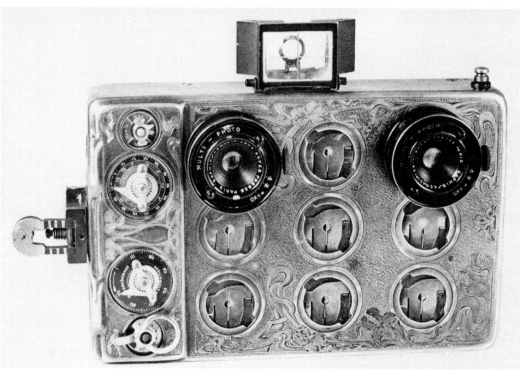

96

Only known example in the United States of 1924 French Multi-Photo camera. It took nine single photos or three stereo and three single pictures on one postcard-size film. This was done by inserting either or both lenses into openings in front of the camera body. Value, $3,500 to $4,000.

97

Portion of catalog page advertising *(left to right)* the Multi-Photo with lenses stored for carrying in alligator case, a rear view, and the two lenses in position for a stereo photograph.

MULTI-PHOTO

Appareil photographique à prise de vues multiples

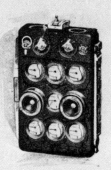

Montrant les objectifs disposés pour la mise en poche ou en sac.

Montrant les cloisons mobiles intérieurement.

Montrant l'appareil les objectifs disposés pour prises de vues.

98

Manufacturer's dragonfly trademark as it appears inside camera body.

would result. This combination of two lenses and nine openings could produce three stereo photographs and three single images or nine separate 1⅛-by-1⅜-inch images on a single postcard-sized plate. Inside the camera the center row of septums, or dividers, could be made wider to allow for wide-angle photographs. The Multi-Photo camera is remarkable for the great technical complexity of the multiple shutter arrangement and the beauty with which its hand-engraved case was finished. The example in the collection is unique in this country and is engraved in a typical Art Nouveau pattern. It is complete with original alligator leather carrying case and manufacturer's catalog and instruction manual.

The Krauss Photo-Revolver was a fairly practical novelty-type camera which first made its appearance in Paris in 1921. Aimed and operated much like a handgun, this compact camera was made in two variations: one held forty-eight individual 18-by-35-mm plates, and the other took roll film capable of producing one hundred pictures of the same size. Both types are in the Isenberg collection and are very similar in appearance except for the winding knob on the right side of the model made for roll film. Presently, less than half a dozen of these cameras have surfaced in America.

Among the English cameras of the latter part of the nineteenth century is a rare Marion's Metal Miniature camera made in London about 1888. This is a relatively early all-metal camera for taking small photographs on 2-inch-square dry plates. The shutter is activated by a simple rubber band. The Marion was available with a wooden carrying case which could be used to support the camera for picture taking or to store it along with twenty-four metal plate holders.

Another English miniature camera of the same period employing a shutter activated by a rubber band is the Demon. First made in 1889, the Demon has an all-metal body and took 2¼-inch-square dry plates. Embossed into the rear panel of the camera is the name *Demon*, the slogan *The Wonder of the World*, O'Reilly's patent number, *10823, W. Phillips Stamper, B'ham* (abbreviation for Birmingham), and across the lower portion, *sole manufacturers The American Camera Co.,*

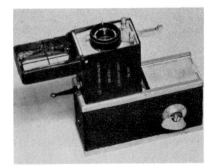

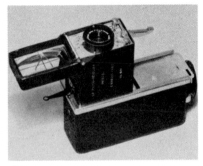

99
Krauss Photo-Revolver was made in France in the early 1920s. Model at top has back for one hundred 18-by-35-mm photographs on roll film, and lower example took forty-eight pictures the same size on individual plates contained in a magazine. Value, $1,500 each.

100

Marion's Metal Miniature, an English camera, c. 1888, mounted and ready to use on its wooden carrying case. Value, $1,200 to $1,500.

101

Rear view showing storage area for camera and plate holders. Camera is original, but case and most of the plate holders are exact reproductions.

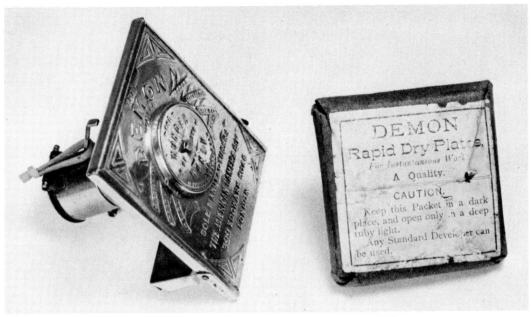

102

All-metal Demon, a British camera patented in 1888, took 2¼-inch-square pictures on dry plates. This photograph shows rubber band shutter-tripping mechanism and a package of plates as they were originally supplied for this camera. Value, over $1,000.

399 Edgmere Road London. No one knows why a British firm using a British design and marketing a British product should have called itself the American Camera Company.

While not a quality product, the Demon was cheap, comparatively easy to use, and the company claimed to have sold a hundred thousand cameras in one year. Today, however, the Demon is a scarce, highly collectible item.

A much more sophisticated English camera in the collection is a brass-bound wooden view camera made in the 1880s by Hare & Co. of London. This is a type first made from the 1870s and which remained virtually unchanged through the turn of the century. It exhibits meticulous workmanship in the application and finish of the brass fittings associated with nineteenth- and early-twentieth-century fine British cameras. The lensboard on the example in the Isenberg collection can be shifted from left to right far enough to permit making stereo views instead of the normal single photograph.

The Luzo is a box-type detective camera first made in London in 1889 and designed to use the newly introduced Eastman roll film. It has a mahogany case, an externally mounted shutter, a waist-level viewfinder, and

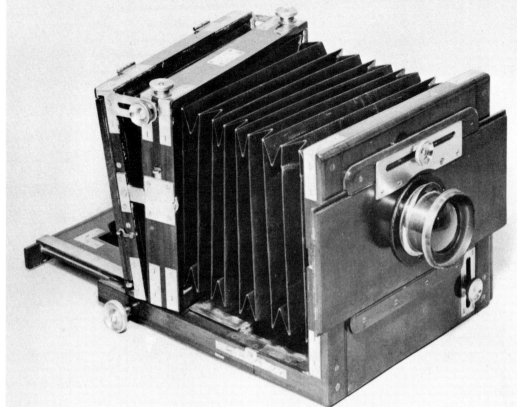

103

A typical British "brass-bound" view camera made by Hare & Company of London in the 1880s. When position of the lensboard was shifted laterally, camera could also take stereo photos. Value, $300 to $400.

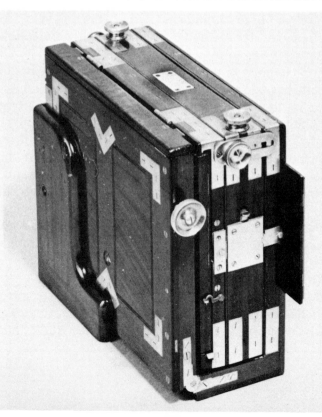

104

Hare camera in closed position. This type of construction remained virtually unchanged in England from the early 1870s through the turn of the century.

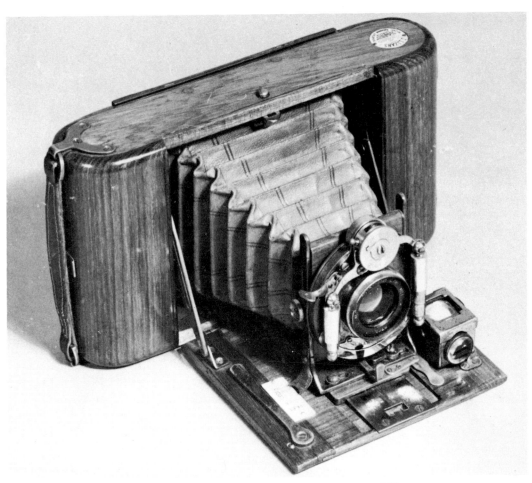

105
An all-wooden body,
roll-film camera made in
Glasgow by J. Lizars around
1905. Value, $400 to $500.

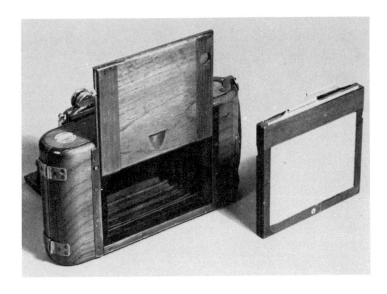

106
Rear view shows optional
plate film back.

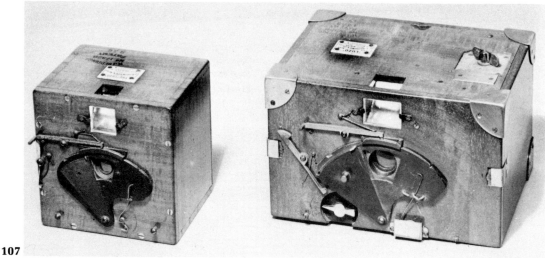

107

The Luzo, a wooden box camera first made in London in 1889. Example at right was made to accept Eastman-style roll film. At the left is unique miniature Luzo made to use single plates. Value, right, $1,200 to $1,500; left, $3,000.

is embellished with typical British brass parts. Designed by H. J. Redding, it was originally manufactured by his employer, J. Robinson & Sons. Redding left Robinson in 1896 but continued to make the Luzo in his own firm of Redding and Gyles until 1899. Of the two Luzos in the Isenberg collection, one is designed for roll film 2⅞ inches wide, while the other is a unique miniature-sized Luzo made to take single exposure plates. Even more fascinating is the fact that this little Luzo came with a leather carrying case which converted the camera into a true detective type.

In the 1890s the London camera makers Newman and Guardia were successful in marketing a folding bellows-type camera called the Nydia. The Nydia held a magazine of twelve dry plates which could be changed inside the camera by manipulating the plate holders by means of a soft leather pouch at the top of the camera. The entire camera—including the leather changing bag, bellows, and supports—folded very compactly into a flat configuration for carrying or storage. The wooden case, metal fittings, and optical parts all exhibit a high degree of careful workmanship.

A relatively late British multiple-image camera is the Royal Mail, made in 1908 by W. Butcher & Company. Sometimes referred to as the "stamp camera," it took six postage-stamp-size photographs on one dry plate by shifting the three vertically aligned lenses from left to

108

Nydia camera made by
Newman and Guardia of
London is a folding camera
which contained a magazine
of twelve dry plates. Plates
were changed by manipulat-
ing them through the soft
leather pouch at the top of
the magazine. Made around
1890. Value, $400.

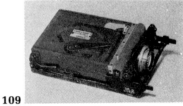

109

Nydia in its closed position.

110

Royal Mail camera made in
England by W. Butcher &
Company in 1908. It took
six postage-stamp-size
photographs on a single
plate by shifting the three
lenses from left to right.
Value, $800.

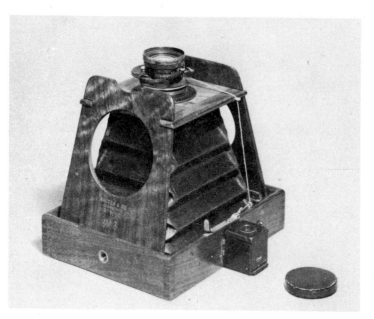

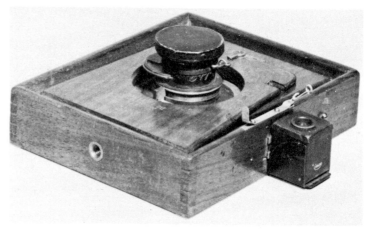

right. The dovetailing on the plain wooden box is
straight, not tapered like earlier British cameras,
although the joints are still closely spaced.

The Swiss were also active in camera manufacturing
around the beginning of the twentieth century, and the
collection contains several significant examples. One
interesting specimen is a Swiss version of the English
Eclipse folding-plate cameras made by J. F. Shew & Co.
of London. The Swiss camera was made or distributed
by Raucher et Cie. in Geneva in the early 1890s and has
the same cut-out wooden bellows supports as the Shew
Eclipse but is not notched for varying the focal length

113
Suter magazine-loading variable-focus box camera made in Basel around 1893. Plates could be changed inside camera body. Value, $450.

of the lens. Lens openings are controlled by an external disk, and the shutter is activated by a string pull.

An important Swiss camera of about 1893 is the Suter, which was made in Basel. The Suter is a variable-focus box-type camera with a self-contained plate magazine. Plates could be changed within the camera after each exposure. The Vega, made in Geneva around 1900, is a book-size folding pocket camera with a bellows that extends, when open, into a fan shape across the back of the camera, much like a fireplace bellows. The Vega used 6-by-9-cm plates loaded into a magazine holding twelve metal plate

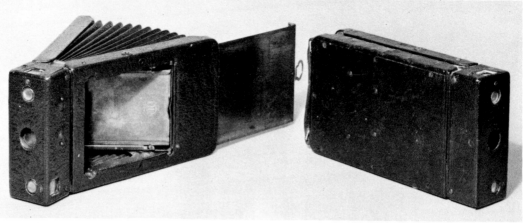

114

Vega, folding bellows
camera, made in Geneva
about 1900. The twelve
plates contained in a
magazine inside camera
body were changed by com-
pressing and expanding
bellows portion of the
camera like an accordian.
Value, $450.

holders. The film plane was across the rear of the cam-
era in front of the bellows. Extending the bellows be-
yond its normal position placed a plate holder at the
film plane. After each exposure, the accordionlike pro-
cess was repeated to store the exposed plate and bring
a fresh one into place.

Access to the film magazine of the leatherette-
covered, aluminum-body Vega was through a dark
slide which ran across one side of the camera.

The reputation of the Germans for the precision and
quality of their optical instruments and cameras is up-
held when we look at a few examples from the period
between the end of World War I and the mid-1930s. To
Isenberg, these years represent a type of European
craftsmanship in camera making that has never been
duplicated. The best of the British cameras were also as
fine, for the British started earlier and continued to
build aesthetically elegant cameras after the Germans
had ceased to do so.

A very fine example of a folding camera is an Erne-
mann made around 1920. This camera has a wooden
body, and the front, which folds down to form the bed
of the bellows, is inlaid with wood in the form of a par-
quet design. As the camera is opened and the bed
comes down, the viewfinder and rear sight swing into
place automatically and also retract as the camera is
closed. The bellows has a double extension, permitting
close-up work to be done.

No better example of the marriage of leather, wood,
and metal in a great German camera could be found

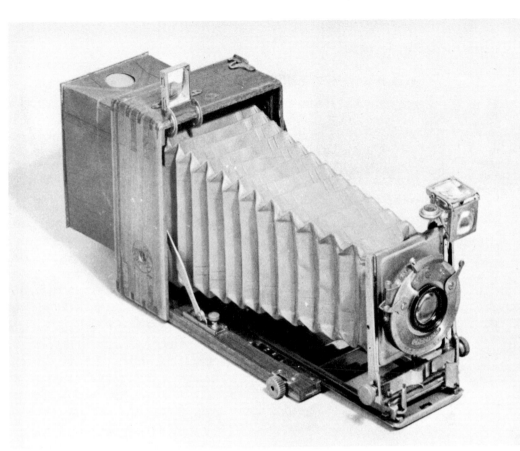

115
Ernemann folding bellows
camera made in Germany
shortly after World War I.
Quality of this wooden-body
tropical camera is typical of
German construction of this
period. Precision detailing
included a viewfinder and
rear sight which swung into
position as camera was
opened, and retracted when
it was closed. Value, $500.

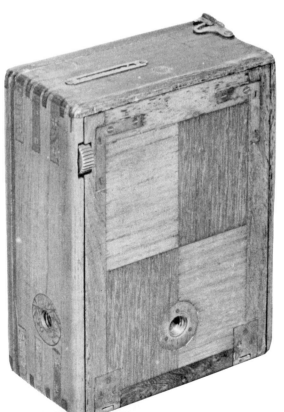

116
Inlaid-wood design on
bottom of camera bed.

than the tropical version of the Clarissa. Cameras made to be used in hot, damp climates were called "tropicals" and were a specialty of both British and German manufacturers. This is no doubt due to the fact that citizens of both countries seemed to have a great urge for exploration and had many commercial interests in Africa and other equatorial areas.

A tropical camera was made with a minimum amount of leather, usually found only in the bellows, to avoid the possibility of mildew. Wooden parts were often made of teak or other exotic hardwoods, and metal parts were heavily plated or lacquered brass. The Clarissa in the collection is a small camera designed for 4.5-by-6-cm dry plates and has a 75-mm f/3 Hugo Meyer lens focusing from 18 inches to infinity and equipped with a focal-plane shutter with speeds from 1/20 to 1/1000 of a second.

In 1924 the Ernemann Company, mentioned previously, brought out a camera that had an enormous impact on the picture-taking habits of photographers everywhere. This camera, called the Ermanox, was a very compact unit originally equipped with an extremely fast 100-mm f/2 Ernostar lens. The first series was made to take 4.5-by-6-cm plates, and the standard lens became the 85-mm f/1.8 Ernostar. In 1925, a

117
Miniature-size German Clarissa tropical camera made for 4.5-by-6-cm plates. Typical of fine German construction in the period between 1910 and 1930. Value, $500.

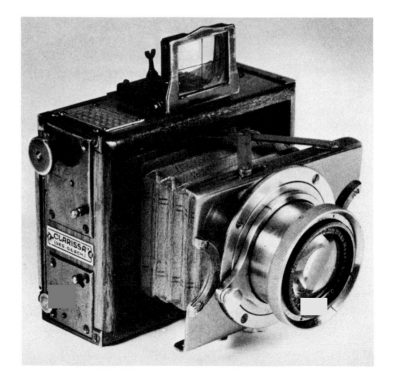

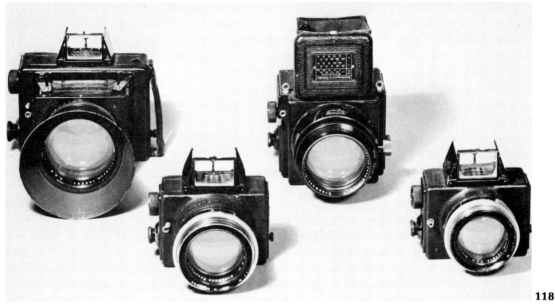

118

larger model using 6-by-9-cm plates was introduced and was supplied with a longer focal length 125-mm f/1.8 Ernostar in a collapsible bellows mount.

This was followed shortly by a single-lens reflex small-format Ermanox with a 105-mm f/1.8 lens. In the collection are these four Ermanoxes, including the very rare original Ermanox with the f/2 Ernemann lens, the precursor of the line that made possible candid photography under previously impossible low-light conditions. This first f/2 model can be distinguished from later models by the fact that the shutter-release button and the cable-release fitting are separate from each other. On the models that immediately followed, the cable-release fitting and the shutter button are a single unit.

There is a group of small folding plate and roll-film cameras which were made most successfully by the Germans in the period from roughly 1910 to the beginning of World War II in 1939. This type of camera is still fairly easy to collect, as hundreds of thousands of them were sold all over the globe. They are appreciated by collectors because of the fine workmanship and simplicity of operation embodied in their design. The manufacturers' names most often associated with this type of camera are Ica, Goerz, Nagel, Nettel, Voigtlander, Plaubel, and Zeiss Ikon.

(1924–28) German Ernemann cameras equipped with exceptionally fast f/2 and f/1.8 lenses that made candid photography practical. *Left to right:* 6-by-9-cm film size with 125-mm f/1.8 Ernostar lens; original model of the series; 4.5 by 6 cm, with f/2 lens; reflex-focusing model with f/1.8 lens; 1926 model, 4.5 by 6 cm, with f/1.8 lens. Value, $800 to $1,200 each.

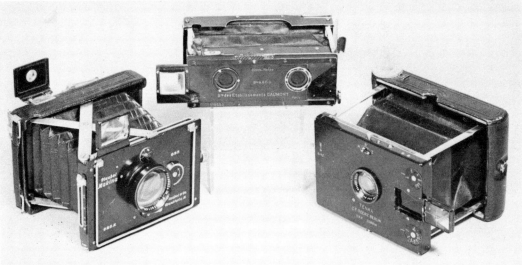

119

Top center: stereo version of French Block-Notes camera made by L. Gaumont et Cie., c. 1904, an early flat-folding-type camera. *Left:* Makina by Plaubel of Frankfurt, popular press type of the mid-1930s. *Right:* Tenax by Goerz of Berlin, c. 1909, German adaptation of Block-Notes design. Value $100 to $200 each.

It was the French firm of L. Gaumont et Cie., however, that introduced in 1902 the Block-Notes camera that became the forerunner of this entire generation of flat-folding precision cameras. The front of the Block-Notes containing the lens and shutter was attached to the rear plate holder by a rectangular, nontapering bellows. The bellows was held rigid when extended by means of four hinged metal struts, one at each corner. By 1904, a stereo model of the Block-Notes camera had come on the market.

Before 1909, the Goerz optical works in Berlin offered the Tenax, a flat-folding pocket camera for 4.5-by-6-cm film, with a slightly tapered bellows and straight metal supporting struts at the corners which folded with a scissorslike action when the camera was collapsed.

In the 1920s, Plaubel of Frankfurt, Germany, produced its Makina line of folding cameras, also with an uncovered front which pulled straight out. Makinas were made for plate film holders, although, as for most cut-film cameras of this period, roll-film backs made by other manufacturers were available. These Makinas were produced for 4.5 by 6 cm and 6-by-9-cm cut film and were useful to press photographers because of the very fast f/2.8 and f/2.9 lenses which were available with the camera. By 1932, Plaubel had miniaturized the Makina concept and was making the Makinette, a

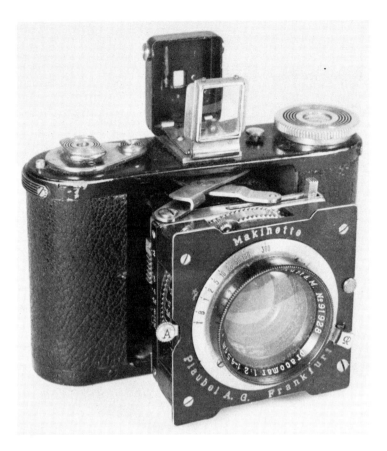

120
Makinette by Plaubel of Frankfurt, Germany, c. 1932. Compact folding camera with f/2.7 lens, 1 to 1/300 of a second Compur shutter. Made sixteen 1¼- by-1⅝-inch pictures on 127 roll film. Value, $150.

compact, pop-out, front-folding camera taking sixteen 1¼-by-1⅝-inch pictures on a 127 roll film. It was equipped with an f/2.7 lens and a Compur shutter with speeds from 1 to 1/300 of a second.

Similar to the Makinette is the Pupille, made in the early 1930s by the Nagel works in Stuttgart. Like the Makinette, the Pupille used 127 roll film and had the same Compur shutter. It differed in that, instead of being a bellows type, the lens and shutter were mounted in a helical barrel which screwed out from the camera body. The Vollenda, also made by Nagel, used the same film size, 127, but was a drop-front folding bellows camera. This design was the basis for most of the Kodak Retina line of 35-mm cameras which first appeared late in 1934 after the Eastman Kodak Company purchased the Nagel operation. The Pupille and Vollenda cameras in the collection are a good deal more valuable than they would be ordinarily, since they are both fitted with f/3.5 50-mm Leitz Elmar lenses. This is

121

The Ica, a diminutive leather-covered aluminum-body German folding camera made in the early 1920s. Measuring only 1½ by 2½ by 3½ inches when closed, the Ica took a 4.5-by-6-cm photographs on single plates or could be fitted with twelve-exposure plate magazine shown at bottom of photograph. Value, $150.

122

Two compact 127 roll-film cameras made in the early 1930s by the Nagel works in Stuttgart, Germany. *Left:* Pupille, shown with accessory range finder. *Right:* Vollenda, forerunner of later line of Kodak Retina cameras. Both cameras fitted with Leitz f/3.5 50-mm Elmar lenses. Elmar lenses make these cameras worth $400 to $500 each.

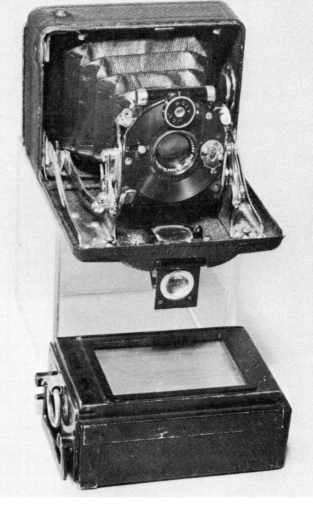

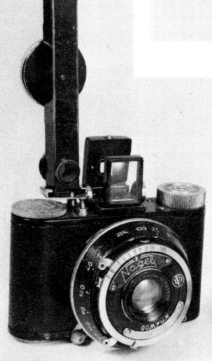

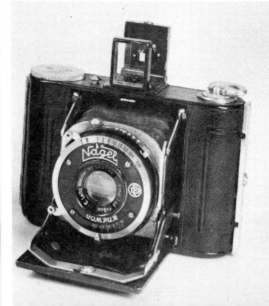

one of the few instances of Leitz lenses found on non-Leica cameras.

The year 1926 marked the merger of the German camera-making firms of Contessa-Nettel, Ica, Goerz, and Ernemann with the Carl Zeiss lens-making company. The resulting conglomerate was called Zeiss Ikon, and many important cameras from that time onward, such as the Contax, Ikonta, and Super Ikonta, were products of that combined technology. In 1930, Zeiss Ikon produced the Kolibri, a leather-covered, metal-body compact camera which took sixteen pictures on 127 vest-pocket-size roll film. It is usually found fitted with a Zeiss Tessar f/3.5 lens and a Compur shutter and was intended to compete—unsuccessfully, as it turned out—with cameras using 35-mm film.

The Voigtlander Prominent, a larger-format 6-by-9-cm camera of about 1932, has been called an "ugly duckling" by Eaton Lothrop, but to many collectors it is the epitome of German folding cameras. At the touch of a button, the front dropped down and the bellows and lens mount slithered out along its track, carried by a chain-link drive. The camera was equipped with a precision range finder and a built-in extinction-type exposure meter that some collectors feel required a degree in physics to operate. The lens was a Voigtlander f/4.5 mounted in a Compur shutter.

123
Kolibri, by Zeiss Ikon, Dresden, c. 1930. All-metal vest-pocket-size camera for sixteen exposures on 127 film. Furnished with handsome form-fitting leather-covered case. Value with case, $225.

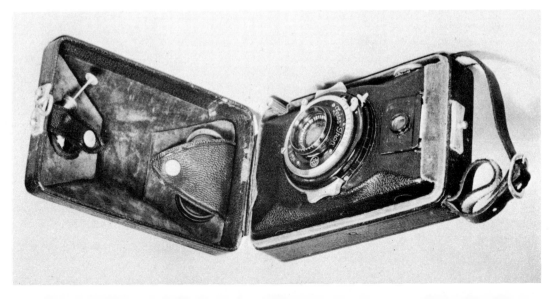

124

Prominent, made by Voigtlander in Braunschweig, c. 1932. Some consider this to be the ultimate German folding roll-film camera. It had a coupled range finder, built-in exposure meter, and provision for eight or sixteen exposures by inserting suitable masks. Value, $350.

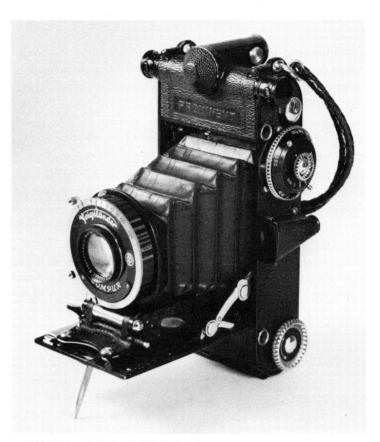

125

Three Zeiss Super Ikonta roll-film range-finder folding cameras from Zeiss Ikon. Very popular in the 1930s. Value, $100 to $150 each.

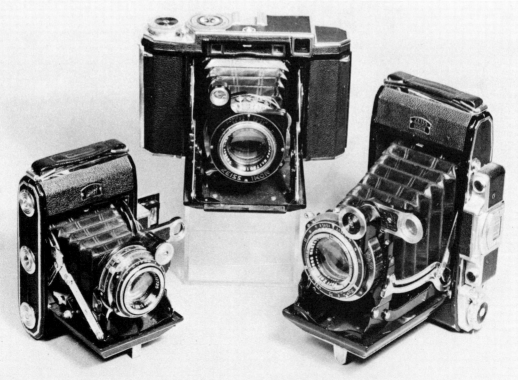

While folding roll-film cameras were still enjoying some degree of popularity in the 1930s, Zeiss Ikon was producing its line of Super Ikonta cameras. These were beautifully made, with excellent Zeiss Tessar lenses and Compur shutters. The four Super Ikontas offered a range of picture size from 1⅝ by 2¼ to 2½ by 4¼ inches, depending on the number of exposures made on the 120 roll film. All Super Ikontas had coupled range finders, and the Super Ikonta BX was equipped with a built-in exposure meter. In retrospect, cameras such as the Voigtlander Prominent and the Zeiss Ikon Super Ikontas were elegant photographic instruments that were relatively popular in the 1930s but came too late to stem the tide toward the more versatile 35-mm cameras.

4

George Eastman and the Eastman Kodak Company

The Kodak camera has had such a vast impact on the growth of photography that any reasonably representative collection cannot be considered complete without including examples of the Eastman Company's earliest models. Some collectors feel that Kodak history is so important that they have confined all their efforts to this one area, to the exclusion of any other photographic material. There is one collector so dedicated to the pursuit of Eastman products that in collecting circles he is referred to as "Captain Kodak."

In spite of the competition among Kodak specialists, Matt Isenberg has been able to assemble a set of the first series of Eastman Kodak box cameras. This group of seventeen cameras is one of only three complete runs known to exist in a single collection, public or private, including George Eastman House. In addition, the collection includes most of the other significant and most-sought-after Kodaks of later production.

To put the Kodak portion of the collection in proper perspective, we should first discuss the background of George Eastman and learn more exactly what his contribution was to photography. In 1877, a friend sug-

gested to Eastman, then a young bank clerk in Rochester, New York, that he become familiar with the art of photography. This was to be in preparation for a projected trip to Santo Domingo, where Eastman thought he might invest in some land. His interest in the Santo Domingo adventure waned, but his involvement with photography did not. He found that working with the collodion wet-plate process was messy and time-consuming, and he began to look for a simpler, more efficient method.

At that time, progress was being made in England in coating glass plates with a sensitized gelatin emulsion which could be used in a completely dry state. One major drawback of the dry plate was that it required far longer exposures than the wet plate. The complete lack of stability and reliability was another disadvantage. After long experimentation carried on in his spare time, Eastman found that he could produce extremely sensitive dry plates by the simple expedient of letting the plates age, or ripen, for several days after they had been coated.

His success became known among other amateurs and a few professionals, and Eastman was asked to supply his plates to them. By late 1878, he had entered into an agreement that gave the photographic supply house of E. and H. T. Anthony the right to distribute his plates to their clientele. By 1880, Eastman had started a

126
Pre–World War I Kodak trade sign. Black-painted glass with gold-foil large letters and red-painted small characters. Size, 36 by 15 inches. Value, $200.

factory, and the following year he gave up his position at the bank to devote his full time to the manufacture of the Eastman dry plate.

Although this business was a success, Eastman began to look for a means of making photographs on a flexible film that could be loaded in a camera and advanced with each exposure, to free the photographer from the weight and bulk of glass plates and the nuisance of changing them for each picture. At first a coated paper roll was devised, along with a roll holder patented by Eastman and a co-worker named William Walker. The Eastman-Walker roll-film holder was made initially in sizes suited to the larger professional cameras then in use.

Securing a positive print from the paper rolls was a very complicated process which involved developing the film, transferring the gelatin emulsion to a glass plate in the same manner as a decal is applied, and using that plate as a negative to make a positive print. Even so, Eastman saw the possibility of expanding the market to nontechnically oriented amateurs by loading the paper rolls in a compact camera that could be used by anyone.

Therefore, in July 1888, Eastman began producing for sale a camera with the name of Kodak, for a mass market. The camera was only 6¾ inches long, 3¾ inches high, 3¼ inches wide, and weighed only 1 pound, 6 ounces loaded with a roll of paper film that had a capacity of 100 circular photographs, 2⁹⁄₁₆ inches in diameter. Later on, improvements in film technology expanded the capacity to 150 exposures. The camera sold for $25 and included a leather carrying case.

When a hundred photographs had been taken, the customer returned the camera to the factory. The Eastman Dry Plate and Film Company would then develop the film, make and mount the prints on stiff paper, and return the prints and the camera with a fresh roll of film for a charge of $10. Photography had now become available to everyone, and Eastman capitalized upon the simplicity of his system with the slogan "You press the button, we do the rest."

It must be remembered, however, in the context of the late 1880s, that $25 was a lot of money. For the

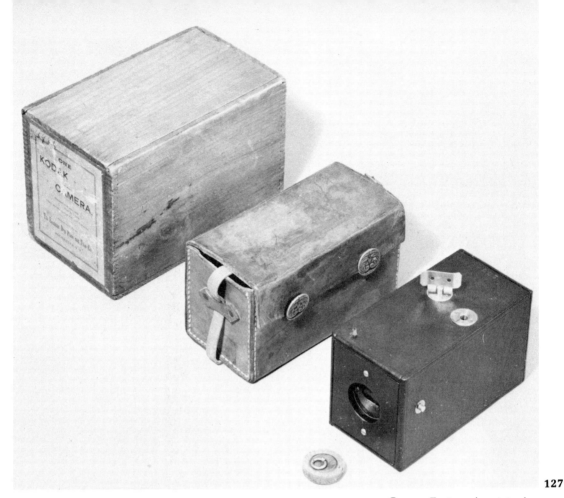

127

George Eastman's original
Kodak camera, introduced
in 1888. Shown also are
wooden shipping container,
leather carrying case, and
original Kodak camera
identified by two brass
screws on front of camera.
Present value of this outfit
which sold in 1888 for $25
is $4,000.

average workingman it probably represented at least
two weeks' wages, and spending it on a camera then
might be compared to the purchase of a moderate-sized
color television set by today's consumer. Even so, ap-
proximately 5,200 of the introductory models were sold
before it was superseded a year later by an improved
model of the same size, named the No. 1 Kodak.

For the collector, and especially the Kodak special-
ist, it is the first, or "original," Kodak that possesses the
greatest significance and mystique. It can be distin-
guished most readily from its later successors by the
presence of two brass screws on the front panel, one
above and one below the lens opening. The shutters on
the entire first series of Kodaks had to be cocked by
means of a string which protruded from an opening at

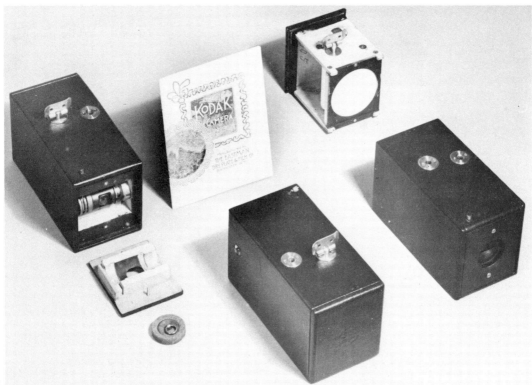

128

Three original Kodaks with camera at right shown with roll holder removed.

the top front of the camera. Also, each camera was furnished with a felt plug which permitted time exposures to be made if the single shutter speed was too short for the available light. All of the Kodak box cameras (except the Kodet) made up to 1895 had string-set shutters that operated in this manner.

The Isenberg collection contains three original Kodaks, all of which are complete with the leather carrying case, and one of which has the wooden shipping container and accompanying literature. This includes a booklet in which the photographer could note his exposures under varying conditions and compare these with the prints when they were returned. (In the time Isenberg has been collecting, he has owned nine original Kodaks, six of which he has traded for other items he needed to round out his collection.) Presently, an original Kodak is worth $3,000 to $4,000, depending upon its condition and completeness.

The No. 1 Kodak introduced in 1889 had an improved shutter and, except for the absence of the brass screws on the lensboard and the lower position of the

shutter-release button, is practically indistinguishable from the original. This model also sold for $25. Later the same year, Eastman offered the larger No. 2 Kodak, loaded with a sixty-exposure roll of paper film that permitted a 3⅝-inch-diameter circular picture and sold for $32.50. By 1894, the Eastman catalog was offering spools of 100 and 150 exposures. The No. 2 was also the first Kodak to be furnished with an optical viewfinder. Previous models were merely pointed at the subject.

Early in 1890, the No. 3 Kodak, factory-loaded with a sixty-exposure roll of film which produced 3¼-by-4¼-inch pictures, was marketed along with the No. 3 Jr. model, which was 2½ inches shorter and also had a sixty-exposure film capacity. One hundred exposure rolls were available for both models, and later, 150-exposure rolls were made for the No. 3 Jr., and 250-exposure rolls for the No. 3 and No. 4. The No. 3's marked the beginning of the rectangular format, the introduction of a rack-and-pinion focusing device, and both vertical and horizontal viewfinders.

The No. 4 and No. 4 Jr. Kodaks made their appearance about the same time and were identical to the No. 3's except for their larger physical size, which allowed for a 4-by-5-inch picture. Both the No. 3 Jr. and the No. 4 Jr. were made to be used with either roll film or glass plates. All No. 3 Kodaks were priced at $40, and the No. 4s at $50. Optional glass-plate attachments for the

Enlarged portion of a photograph taken about 1890 with a No. 2 Kodak of two women in a Southwestern United States or Mexican desert locale. Younger woman on right is holding an original Kodak camera while older woman at left has the leather carrying case slung over her shoulder.

129

130

Original Kodak (right) compared with No. 1 Kodak (center) and larger No. 2 Kodak (left). The No. 1 and No. 2 Kodaks appeared in 1889. Value, left to right, $350, $1,000, $3,000.

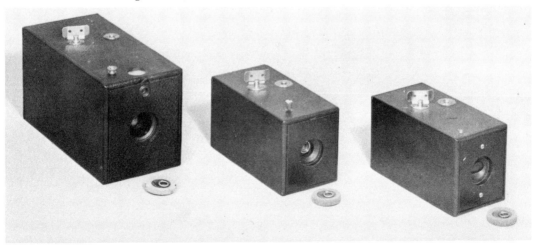

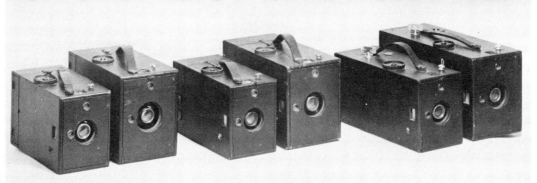

131

In 1890, Kodak released the No. 3 and No. 4 focusing models roll-film cameras. Shortly afterwards an optional plate back was offered. *Left:* No. 3 Jr. and No. 4 Jr. Plate back. *Center:* No. 3 Jr. and No. 4 Jr. Roll back. *Right:* No. 3 and No. 4. Roll back. Value, $300 to $400 each.

132

No. 3 Jr. Kodak of 1890 with roll-film back. Note focusing wheel at top and horizontal and vertical viewfinders. Shutter-release button is on right side of camera body rather than on left in the No. 1 and No. 2.

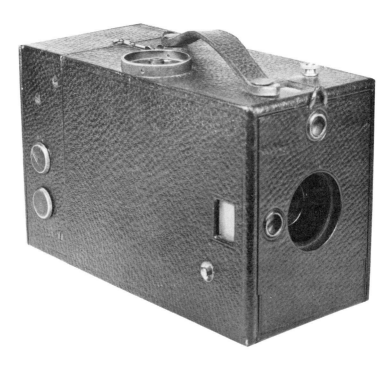

No. 3 Jr. and No. 4 Jr. models were sold for $5, and double plate holders were $1 each. Eastman was trying to preclude the possibility of not being able to sell his cameras and glass plates, which were still an important part of his business, to anyone who did not care for roll film.

A year later, in 1891, Eastman again caused a sensation with the introduction of his much less expensive "A," "B," and "C" series of "ordinary" and "daylight" Kodak box cameras. To crush any competition for the low-priced market, the "A" ordinary sold for $6 and the deluxe, leather-covered daylight model sold for

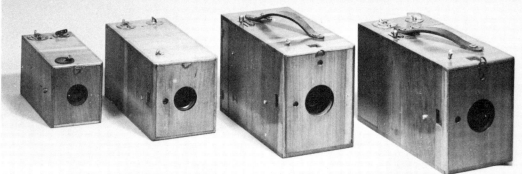

133

In 1891, Eastman marketed his low priced "A," "B," and "C" series Kodaks. *Left to right:* "A" ordinary—no viewfinder, $6 retail; Value, $1,200 to $1,500. "B" ordinary—larger camera, no handle, $10 retail; Value, $750. "C" ordinary—larger camera, with handle and viewfinder, but with cheaper lens, $15 retail; "C" ordinary with roll-film back, $15 retail. Value, $950.

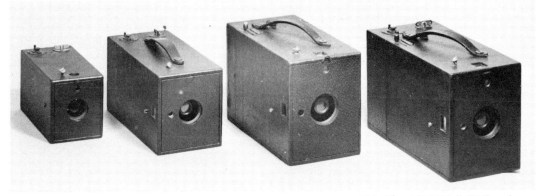

134 The 1891 "A," "B," and "C" series Kodaks were also offered in leather-covered models which could accept the new daylight-loading film rolls. *Left to right:* "A" daylight, $8.50 retail; value, $1,000. "B" daylight, $15 retail; "C" daylight with plate back; "C" daylight with roll-film back, both $25 retail. "B" and "C" daylights worth $300 to $400 each.

only $8.50. Paradoxically, today the "A" ordinary sells for $1,500, while the "A" daylight, originally more expensive, fetches only $1,000.

In appearance, the ordinary differed from the daylight version in only one respect: all of the ordinaries had plain varnished wooden boxes, while the daylight models were leather-covered. The purchase price of the camera included a twenty-four-exposure roll of film which in the ordinary model had to be loaded and unloaded in a darkroom. The daylight, as its name implies, was supplied with a new type of film made with a black cloth leader and trailer which could be loaded or taken out of the camera in full daylight. Picture size for both was 2¾ by 3¼ inches. The "B" series differed from the "A" primarily in the size of the picture, which was 3½ by 4 inches, and it sold for $10 in the ordinary model and $15 in the leather-covered daylight version,

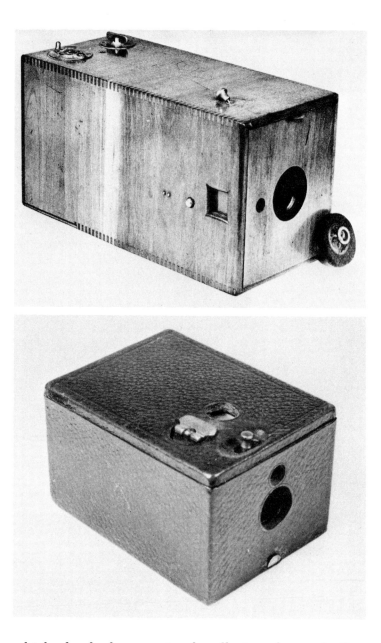

135

The very plain appearance of this "B" ordinary Kodak made it easy to trade a customer up in price to the better-looking, easier-to-use daylight series. String-pull shutter-cocking device at top front of the camera is common to all Kodaks from the 1888 original to these 1891 models.

136

Pocket Kodak cost $5 in 1895 and took a 1½-by-2-inch picture on either roll film or glass plates. Value, $75.

which also had a carrying handle to enhance further the sales appeal of the higher-priced model.

The "C" series, aside from offering a larger, 4-by-5-inch picture, was considerably more technically advanced than the "A" and "B" Kodak. Both the wooden ordinary and the leather-covered daylight "C's" had a focusing lever, adjustable shutter speeds and lens stops, and vertical and horizontal viewers. Both could accommodate glass-plate adapters, an extra-cost accessory. The daylight load capability was nullified in the

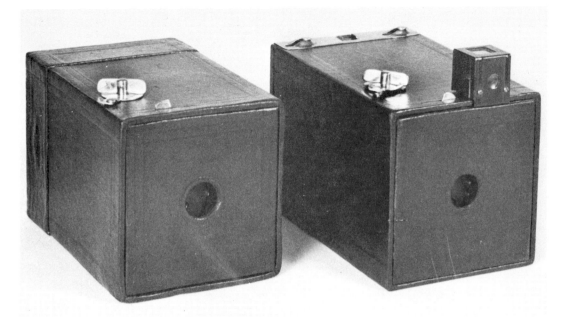

George Eastman captured the juvenile market in February 1900, when he introduced the Brownie, made of cardboard, which sold for $1. Three months later, he brought out the model at the right, which had an improved back and an accessory viewfinder, which sold for 25 cents. Value; left, $400; right, $40.

ordinary model by the insertion at the factory of two permanent wooden spacers in the film chamber. Otherwise, the cameras were structurally identical except for leather covering and one deluxe feature on each of the series: "A" had a viewfinder, "B" had a handle, and "C" had a two-element lens. Retail pricing for the "C" ordinary was $15 and the "C" daylight cost $25.

It should be noted that by 1890 Eastman had been successful in developing and marketing photographic film on a transparent base that was similar to the type of negative material photographers are accustomed to working with today. This film was much less awkward to process than the paper film and allowed Eastman to deemphasize the processing of film at his plants and to concentrate on the manufacture of flexible film, photographic printing paper, cameras, and plates.

The Eastman Kodak Company continued to make box-type cameras for more than sixty years after the introduction of the original and the remainder of the string-set series. Two of the most important were the Pocket Kodak and the Brownie. The Pocket Kodak, though not rare today, was first sold in 1895 at a price of $5. It had a leather-covered wooden body measuring only 2¼ by 2⅞ by 3⅞ inches, and took twelve 1½-by-2-inch pictures on roll film, or could be used with dry plates for single exposures. The Pocket Kodak was the

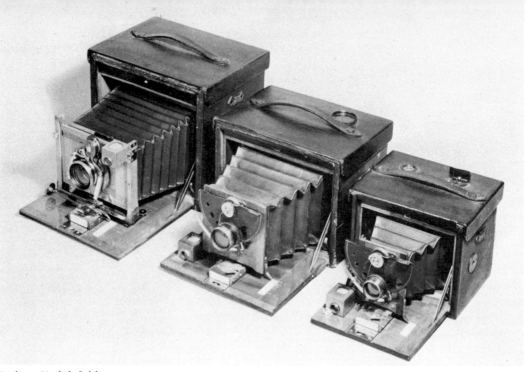

138

Earliest Kodak folding cameras. *Right:* No. 4 Folding Kodak with roll holder, 1890. *Center:* No. 5 Folding Kodak with film back, 1890. *Left:* No. 5 Improved Folding Kodak with Bausch and Lomb lens, 1893. Value $300 to $500 each.

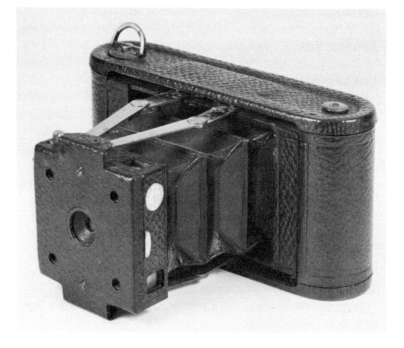

139

No. 1 Folding Pocket Kodak, 1898. First of what was to become a long line of folding Kodaks which were made by the millions in every conceivable combination of film size and lens and shutter options up to the 1950s. Value, $150.

first Kodak to use a red window to read the number of exposures taken. Its small size and low price further expanded the market for cameras and photographic supplies.

The thrust toward extremely low cost apparatus ultimately led Eastman to market the Brownie camera in 1900. This was a box camera constructed of heavy cardboard, and it sold for only $1. The film was sold separately for 10 cents a roll. This camera was designed to tap the juvenile market and succeeded in turning millions of youngsters into avid photographers.

There are several other landmark cameras in the Kodak portion of the collection that should be discussed. Among these are the No. 4 and No. 5 Folding Kodak, which were first made in 1890 and were the earliest folding cameras in the Kodak line. The No. 4 took 4-by-5-inch pictures on factory-loaded roll film, and the No. 5 and later the No. 5 Improved Folding Kodak could be used with 5-by-7-inch roll film or plates. The No. 4 and No. 5 Improved Kodaks were distinguishable by a Bausch and Lomb lens and iris diaphragm shutter. They also had a double swing back, sliding front and drop bed. These cameras were made, with various modifications, up through 1897.

In much the same way that the Pocket Kodak with its $5 price tag affected the box-camera business, the No. 1 Folding Kodak was the fountainhead from which a vast flood of compact folding cameras inundated the world up to the 1950s. The first version of the No. 1 Folding Kodak presents a very plain, unadorned appearance but has one distinguishing construction detail that should make it instantly recognizable to collectors. This is the fact that the metal struts that extend and support the bellows are made of natural, unplated brass. On later Kodak folding cameras, these parts, although still made of brass, were nickel-plated.

Within a few years, the Eastman Kodak Company was selling hundreds of thousands of folding roll-film cameras to a worldwide market of enthusiastic amateur photographers. However, this type of camera was not so well received by professionals or more critical workers. The problem was that they could not be focused precisely using the rudimentary distance scale

140

The No. 4 Screen Focus
Kodak, 1904, for roll film or
plates. Roll-film holder
swung up away from back
so that ground glass could
be used for focusing. Value,
$300.

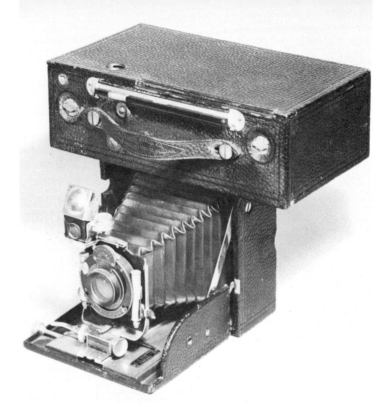

141

No. 4 Screen Focus Kodak
as it appears closed.

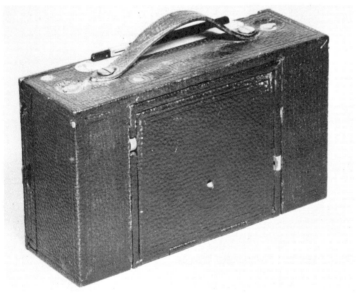

provided, especially when photographing close-up sub-
jects with the longer-focal-length lenses required for a
larger picture size.

To overcome this objection, Eastman brought out in
1904 the No. 4 Screen Focus Camera. This was a fold-
ing camera with a roll-film back that could be swung

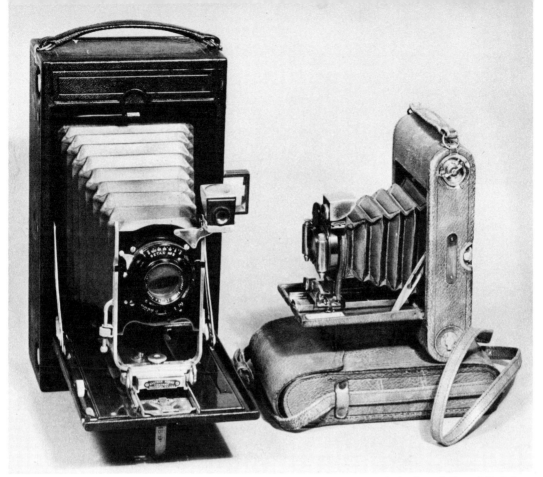

142 *Left:* the 4A Speed Kodak was the only folding Kodak with a Kodak focal-plane shutter. Camera is more than 12 inches long and took 4¼-by-6½-inch pictures on roll film. Made between 1903 and 1914. Value, $350. *Right:* No. 3 folding Pocket Kodak Deluxe, c. 1907. Camera body covered with tan Persian Morocco leather with matching case. Brown-silk-covered bellows, sterling-silver plate for owner's name. Value, $175.

up and over the top of the camera to allow it to be focused with a ground-glass screen. After the focus was made, the ground glass was removed, the film back moved down, the dark slide removed, and the exposure made. For those who still preferred glass plates or cut film, the roll-film back could be replaced with an adapter for plate holders. Eastman was till trying to satisfy the largest possible market.

Another example of Eastman's efforts to make his product universally acceptable was the 3B Quick Focus Kodak. This was a refinement of the popular box-camera style that provided a very simple means of focusing. The distance to the subject was preset on a notched scale at the right front side of the camera, and when a button was pressed, the front of the camera sprung out to the proper preselected distance. This type of focusing arrangement appears to be unique to this

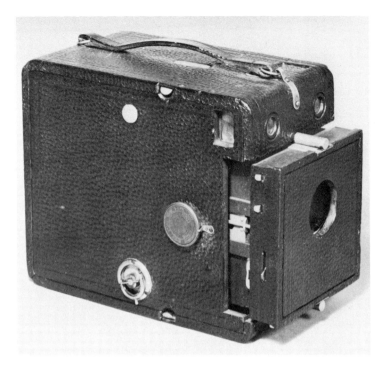

143

Kodak 3B Quick Focus box camera, 1906–11. By pressing button on side of camera, front popped out to preset focusing distance. Value, $80.

one Kodak model, which was made for about five years after its 1906 debut and then was discontinued.

George Eastman was alert to the needs and desires of his customers and went to great lengths to anticipate or fulfill them. In that context there are two types of special-purpose cameras that should also be mentioned. Eastman began making them around the turn of the century, and the first of these was the No. 4 Panoramic Camera introduced in 1899.

A camera which could capture an image encompassing a view of almost 180 degrees was extremely desirable for both professionals and amateurs. Large groups of people, such as a company of soldiers or a school graduating class, could be photographed in a single exposure. Likewise, landscape photographs could be made simply, which for the first time provided the Easterner with an inexpensive, snapshot-type view of the sweep and majesty of the Rocky Mountains, or the Plains dweller with a comprehensive picture of a seacoast harbor. For these reasons, Kodak continued to develop and market the panoramic camera in three other model series up through 1928.

All of the Panoramic cameras used roll film which conformed easily to a curved, rather than flat, film

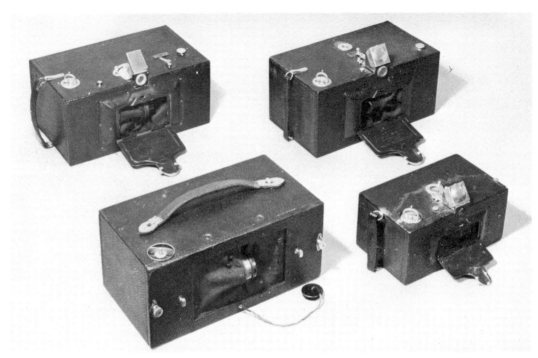

144 A group of Kodak Panoramic cameras for extreme wide-angle photography. *Top left:* No. 3A Panoram-Kodak, 1926–28. Picture size 3¼ by 10⅜ inches. *Top right:* model typical of the later No. 4 B, C, and D series made through 1924. *Lower left:* original Panoram-Kodak, 1899. Picture size, 3½ by 12 inches. *Lower right:* No. 1 Panoram-Kodak, 1900–14. Picture size, 2¼ by 7 inches. Value, $150 to $300 each.

plane and helped to achieve edge-to-edge sharpness. The No. 4 Kodak Panoramic camera provided a 3½-by-12-inch picture, as did the "B," "C," and "D" models made up through 1924. In 1900, Kodak reduced the picture size to 2¼ by 7 inches in its more compact No.1 model. In 1926, the "3A" made its appearance. Using what was then the popular 122 film size, it gave a 3¼-by-10⅜-inch picture.

Stereo photography, which boomed in the mid-nineteenth century, enjoyed a brief resurgence of interest around the turn of the century. Naturally, Eastman capitalized on the demand by producing the No. 2 Kodak in 1901. This was a simple double-lens, leather-covered box camera capable of making two images covering 3½ by 6 inches on roll film in a camera that sold for $15. The No. 2 Stereo was the only box stereo camera made by Kodak. From 1905 to 1910, Kodak offered the No. 2 Stereo Brownie, which was a folding type. Another folding stereo camera, the No. 1, was put into production in 1917, and the last version was discontinued in 1925.

The Kodak portion of the Isenberg collection is very large and ranks among the best anywhere. In respect to the full run of seventeen early string-set Kodaks, the

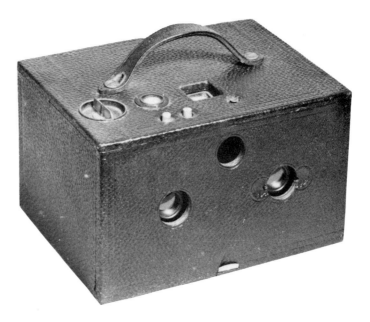

145
No. 2 Stereo Kodak, 1901–1905. This is the first Kodak primarily for stereo pictures and the only box type. Eastman made folding bellows-type stereo cameras intermittently until 1925. Value, $350.

146
The Kodak Bantam Special with its sleek Art Deco aluminum body appeals to collectors even though it is not rare. Made from 1936 to 1940 with Kodak f/2 lens and German Compur shutter. From 1941 until discontinued in 1948, it came with Kodamatic shutter. Camera took eight 28-by-40-mm pictures on 828 roll film. Value, $75 to $125.

collection is extremely valuable. However, in this summary of Kodaks we are limiting our discussion to what are considered the rare and/or significant models. The more common yet still collectible multitude of Folding and Autographic cameras, Brownies, Hawkeyes, Vest Pocket series and many others made in the almost one hundred years the Eastman Kodak Company has been in business must be passed over in this discussion.

In the 1930s, Kodak produced three cameras which definitely belong in any comprehensive Kodak collection. In order of their introduction to the market, they are: the Kodak Bantam Special, issued in 1936; the Super Kodak Six-20, in 1938; and the Kodak Ektra, in

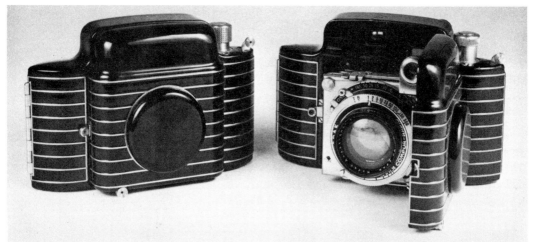

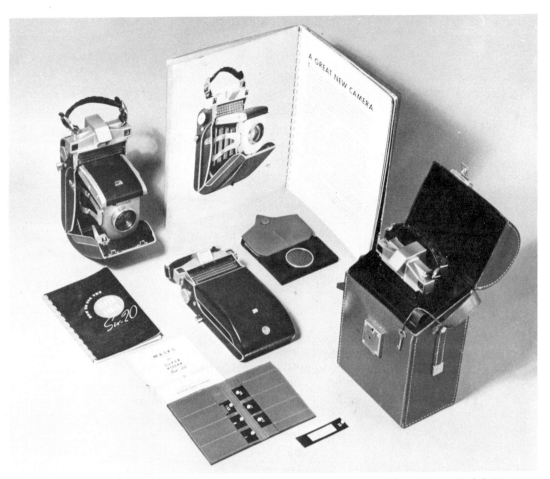

147 Three Super Kodak Six-20s shown with available accessories and carrying case. Made in 1938. This was a folding camera using 620-size roll film and was the first camera to automatically adjust the lens diaphragm according to the amount of light available. Value, $1,000 each.

1941. The Bantam Special appeals to collectors because of the elegance and simplicity of its Art Deco aluminum body, created by the distinguished industrial designer Walter Dorwin Teague. It was equipped with a range finder, a fast f/2 Kodak lens, and, from 1936 until 1940, a Compur Rapid shutter. Since the Compur shutter was imported from Germany, World War II made it necessary to replace it with a similar shutter made by Kodak in the United States—called the Kodamatic. Both the Compur and the Kodamatic shutters had speed ranges from 1 second to 1/500 of a second.

The Bantam Special was made to compete with the influx of German miniature cameras but was at a disadvantage due to the fact that it took only eight exposures on 828 roll film and had no provision for interchangeable lenses of various focal lengths. In the collection are two Bantam Specials: one with the Compur

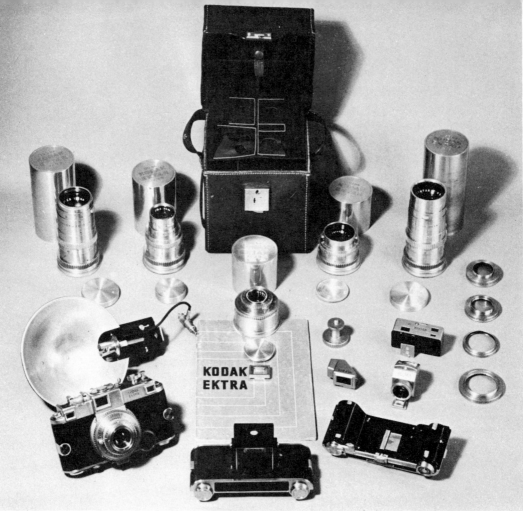

148
Kodak Ektra 35-mm camera was introduced in January 1941 as Kodak's answer to Leica and Contax. Fewer than two thousand were made before World War II halted its production. Shown here is a complete Ektra outfit with all of the accessory lenses, including the rare 153-mm telephoto, viewers, interchangeable film and viewing backs, flash attachment, and carrying case. Value of camera, $350. Complete outfit, $2,000.

shutter, and the other with the somewhat less frequently seen Kodamatic.

The production of the Super Kodak Six-20, first introduced in July 1938 and sold up to 1945, was rather limited. Since less than a thousand were made, it is quite rare, and it belongs on a Kodak collector's shelf as it was the first camera ever to offer an automatic exposure mechanism. This system was controlled by a photoelectric cell which opened and closed the iris diaphragm of the lens according to the amount of light falling on the cell. It is a folding roll-film camera with a coupled range finder and a leather-covered aluminum body, and it made eight 2¼-by-3¼-inch photographs on 620 film. More important than the fact that there are

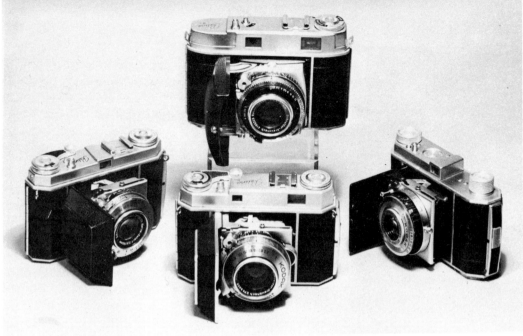

149 Four pre- and post-World War II Kodak Retina 35-mm cameras. The 35-mm film cartridge developed by Eastman Kodak for this line of cameras became the industry standard. Value range, $50 to $150.

three Super Kodak Six-20s in the collection is the fact that it also contains all of the accessories originally offered with the camera. These include the leather carrying case, filters, and a set of masks to be used over the photoelectric cell to adjust its sensitivity to films of different speed ratings and filters of varying density.

In January 1941, Kodak brought out the Kodak Ektra, a 35-mm camera which the company thought could compete with the popular Leica and Contax products. In some respects it was more advanced than the German cameras, in that it offered interchangeable film backs, a provision for ground-glass focusing, and a very accurate wide-base range finder. The standard lens was an f/3.5 50-mm Kodak Ektar. Other Ektar lenses also available were f/3.3 35-mm, f/1.9 50-mm, f/3.5 90-mm, f/3.8 135-mm, and what is today the very rare f/4.5 153-mm.

The Kodak Ektra was manufactured until around 1942, when production was suspended due to World War II. At the end of the war, Kodak determined that in order to resume production of the Ektra on a profitable basis, the camera and standard lens would have to retail for about $750. In view of its prewar price of $304 and the low prices at which foreign cameras

could be imported, it was decided to abandon the line, even though the camera was carried in the Kodak catalog until 1948.

The Ektra in the Isenberg collection is complete with all lenses, accessory backs, special viewfinders, filters, adapters, flash attachment, carrying case, and instruction book. The price a collector should pay for an Ektra today depends upon whether the camera has a working shutter. Many do not have a working shutter, since the camera had one fatal flaw. If the shutter speed was changed before the film was advanced and the shutter automatically cocked, severe damage was caused to the shutter mechanism; and to the best of our knowledge, there is almost no one qualified to repair the Ektra shutter.

Kodak was successful, however, with the Retina line of 35-mm cameras, which were first manufactured in its works in Stuttgart, Germany. Kodak had purchased this plant from the Nagel company in the early 1930s, and the Retina was an outgrowth of the Vollenda camera previously made by Nagel. These compact folding 35-mm cameras were made in as many as forty different models and variations from 1934 to 1958. It is this diversity which makes the Retina attractive to certain collectors who are making an effort to acquire an example of every Retina type.

The Retina line is significant in one other respect that has nothing to do with its collectibility. This is the fact that the twenty- and thirty-six-exposure cartridge for 35-mm film was developed by Eastman Kodak specifically for use in the Retina camera and this cartridge became the standard around which all subsequent 35-mm cameras were designed.

5

Detective, Miniature, and Spy Cameras

 From the time when photography first became a practical process, workers had been endeavoring to make the equipment less heavy and bulky and to make the photographer less obtrusive. All pictures of people had to be statically posed and the sitters made to feel self-conscious. The aim was to develop cameras that did not look like cameras and to make cameras that could be used without a tripod.

The first goal was achieved in 1866 with the French Jumelle de Nicour, a camera which resembled a pair of binoculars with a cylindrical drum mounted above the right-hand viewing tube. *Jumelle* is the French word for "binoculars" and Octave Nicour was the inventor. His design gave rise to a type of camera that has been produced right up to the present time. Although the Jumelle de Nicour is considered the first true detective-type camera, it is remarkably advanced from a technical standpoint. One tube of the binocular viewed the subject, while the other tube contained the camera lens and shutter. The circular drum above the camera portion was a magazine holding fifty 1½-inch-square dry collodion plates. The plates were dropped from the drum into the camera, and after the picture was taken,

150

World's first true detective camera, the French Jumelle de Nicour binocular camera of 1867. One tube viewed the scene, the other was the camera. Drum at top held fifty dry plates. It was used in reverse of the manner in which binoculars are normally held, the eyepiece being the actual camera lens. Value, $8,000–$10,000.

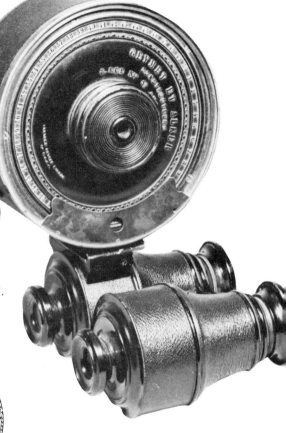

O. NICOUR.
PHOTOGRAPHIC APPARATUS.

No. 71,205. Patented Nov. 19, 1867.

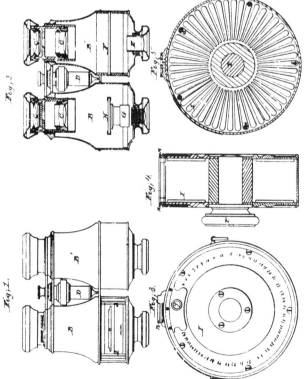

151

Copy of 1867 U.S. patent for the binocular camera invented by Nicour of France. The only three examples of this camera in the United States are in the George Eastman House, Smithsonian, and Isenberg collections.

the exposed plate was returned to the magazine by inverting the whole assembly. Turning a knob on the side of the magazine brought a fresh plate into place, and the camera was righted, letting the new plate fall into position for taking another photograph. In operation, the plate-changing operation is similar to the way in which slides are changed in a modern projector.

A distinct flaw in the Jumelle de Nicour concept which tended to cancel out its convenience and portability was the fact that it could not be used as a handheld camera. The extremely low sensitivity of the dry plates in use at that time precluded instantaneous exposures. The camera was marketed with an ingenious walking stick, or cane, which unfolded to become a tripod upon which the camera was attached backward, as the viewing and taking lenses functioned in the reverse of the normal aspect of a pair of binoculars.

This binocular camera was patented in the United States in November 1867, little more than a year after its French patent date. There is no evidence of its being sold in the United States, however, and the only three known examples in this country are in George Eastman

152

Photo-Jumelle made by Jules Carpentier of Paris, France, was an 1893 adaptation of a binocular camera. Twelve plates were stored inside camera body and were changed with a push-pull maneuver of the camera back. In the foreground is original version for 4.5-by-6-cm plates. The later, 1894, model for 6.5-by-9-cm plates is at the rear. This camera represented one of the first successful attempts at mass production of precision equipment. Value, $150.

House, the Smithsonian Institution, and the Isenberg collection.

Cameras which incorporate the binocular idea were made almost continuously through the nineteenth century and right up to the present. One of the more desirable examples is Le Physiographe, patented in France by Leon Bloch in 1896. This was made in both monocular and binocular versions which could take single or stereo views on glass plates. Of special interest is the fact that the instrument took its photographs at a deceptive right angle to the apparent sector

153

Three monocular detective cameras that took photographs at a deceptive right angle. *Left:* Contessa Nettel Ergo, c. 1924. *Center:* Nettel Argus, c. 1911. *Right:* Le Physiographe, by Leon Block, Paris, c. 1896. Value, $800 to $1,200 each.

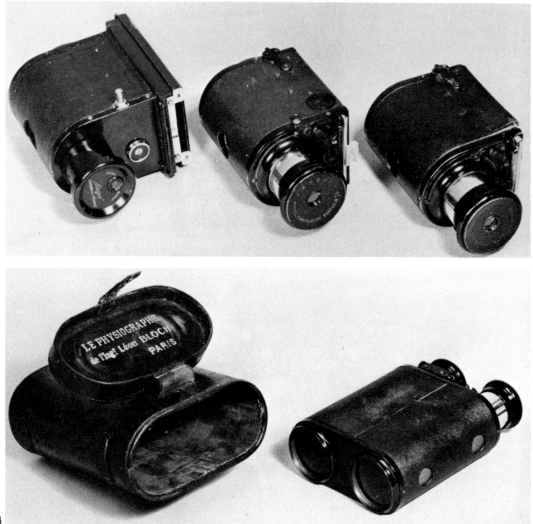

154

Stereo model of Le Physiographe, c. 1896. Value, $2,000.

at which the glasses were pointed. Both the camera lenses and viewing window were inconspicuously placed at the side of the tube rather than at the front. Most of the later stereo binoculars contained a magazine which held twelve plates.

Another camera of the late 1920s, built to look like a monocular field glass but operating on the right-angle picture-taking system, was the German Ergo, made by Contessa Nettel. In appearance and function, it is remarkably similar to the Bloch, which preceded it by thirty years. The same company, Contessa Nettel, also made another camera of this type as early as 1911, known as the Argus.

More modern binocular cameras of the 1950s and 1960s are the miniature Teleca made in Japan, which uses 16-mm film, and the mono and stereo Nicnon, also of Japanese manufacture. The Nicnon is still being marketed today, and among its technical features is a motorized film advance for the 35-mm film it employs.

What is referred to by collectors as the "Leica" of binocular cameras is the German Cambinox, which made its appearance around July 1957 and was distributed in the United States by the Cambinox Division of the Arnolt Company of Warsaw, Indiana. Between the two tubes of the high-quality binocular is a third tube

155
Miniature Japanese binocular camera of the 1950s, the Teleca, uses 16-mm film cartridge. Value, $250.

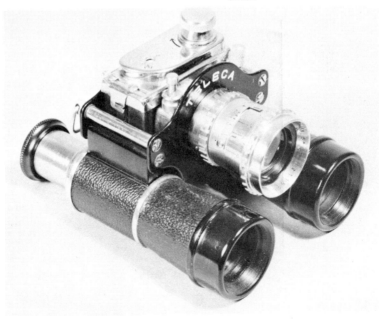

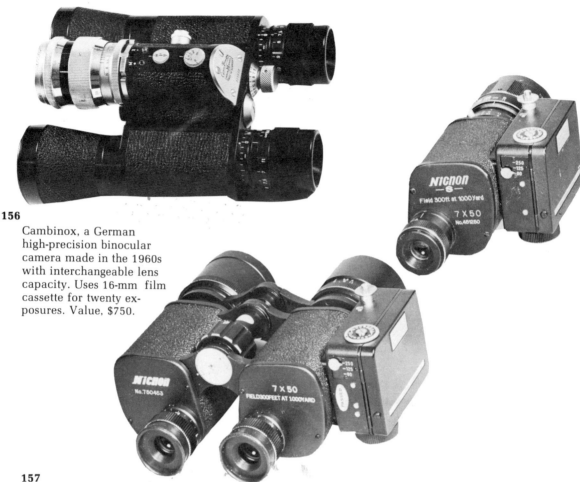

156

Cambinox, a German high-precision binocular camera made in the 1960s with interchangeable lens capacity. Uses 16-mm film cassette for twenty exposures. Value, $750.

157

Monocular and binocular versions of Japanese Nicnon camera of the 1970s has motorized transport for 35-mm film. Value, monocular $250, binocular $400.

which contains a rotary shutter and accepts interchangeable photographic lenses. The camera takes twenty exposures on unperforated 16-mm film loaded in cartridges and even has provision for flashbulb or electronic flash synchronization.

The first camera ever designed to be hand-held was the Schmid Patent Detective Camera. It was patented in January 1883 by William Schmid, an expatriate German who lived in Brooklyn, New York. The Schmid camera was the forerunner of the enormous range of hand-held box cameras and was a direct influence on the development of George Eastman's original Kodak camera. One of the Schmid cameras in the collection is extremely important, as it was bought from one of William Schmid's descendants and was Schmid's personal camera. It was purchased along with the original drawings for the design of the camera and with

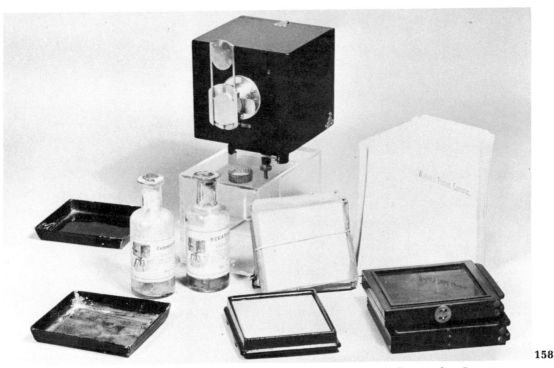

158

Walker Pocket Camera, 1881. Although not a detective camera, the Walker was one of America's earliest dry-plate cameras. Its small size, 3⅝ by 3⅞ inches, makes it an early miniature. Value of outfit, $3,500.

Schmid's correspondence regarding it. It was built at least a year before the patent date and was probably made to submit with the patent application.

One of the differences between this first version of the Schmid Detective Camera and later production models is that its brass carrying handle is mounted rigidly to the top instead of employing the folding type of handle usually found. This prototype Schmid used 3¼-by-4¼-inch dry plates, as did the initial production model marketed by E. and H. T. Anthony. Later variations used 4-by-5-inch plates or could be modified to accept the Eastman-Walker roll-film holder.

Another collector was involved with Isenberg in the purchase of Schmid's camera and collateral material, and each retains a half interest in it. Since neither wishes to relinquish his share to the other, the camera presently spends alternate years in each collection, changing domiciles the first of every January.

One of the best-constructed wooden detective-style box cameras in the collection was manufactured in New York City in the late 1880s by Tisdell and Whittelsey. Inside the finely dovetailed box is a bellows-type camera and storage space for five double plate holders. The release button is made of the same wood

113

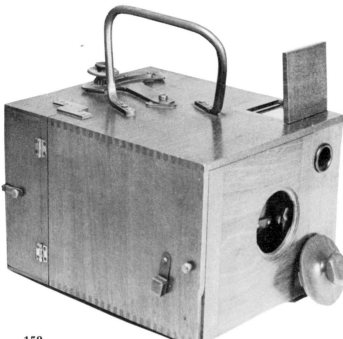

159

This 1882 model of the Schmid Detective camera belonged to the inventor and was purchased with original design drawings and correspondence regarding it. Significance lies in the fact that this was the first camera made to be hand-held. Value, $5,000.

160

Production model of Schmid Detective camera with brass handle on top that was made to fold down. Made around 1883. Value, $3,000.

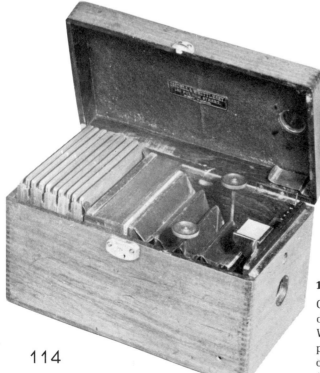

161

Closed view of the Tisdell and Whittelsey, showing wooden release button fitted flush with top. Viewing window is under front flap of carrying handle.

162

One of the best-constructed wooden detective cameras was the Tisdell and Whittelsey, made in New York and patented in 1886. Box held bellows-type camera and five double plates. Value, $1,500.

as the box and was made inconspicuous by fitting it flush with the top surface of the camera.

Among the more popular box-type cameras of the latter part of the nineteenth century was the Anthony Climax camera, distributed by E. and H. T. Anthony of New York. The Climax competed in the marketplace with Scovill's Improved Detective Camera, which was a leather-covered box with the controls for cocking and releasing the shutter and focusing all situated inconspicuously at the bottom of the camera. The camera's function was further concealed by sliding panels

163
Very popular in the late 1880s was this Anthony Climax detective camera, which did not go to any great lengths to conceal its function. Value, $1,200.

164
All operating controls of the Waterbury were located at the bottom of the camera.

165
Improved Waterbury Detective Camera made by Scovill Manufacturing Company around 1890. Value, $650.

which covered the look-in viewing windows. The Climax, however, made no special effort to conceal its function, and its bright brass fittings were in plain view.

By 1902, both Scovill and Anthony found that the upstart Eastman Company had made such great inroads on their entire photographic manufacturing and supply business that they decided to merge. The new firm was named Anthony and Scovill, which was later shortened to Ansco, a trademark which was eventually absorbed into the GAF Corporation.

Another interesting American detective camera is the Hetherington, made in Indianapolis, Indiana, around 1891. It is distinguished by a magazine-load automatic feed plate loading system. After each exposure a turn of a key at the side of the camera drops the exposed plate to a storage area at the bottom of the camera and brings a fresh plate to the film plane. To anyone unfamiliar with the Hetherington, opening the top to gain access to the interior can be quite a puzzle. The release mechanism is part of the spring-loaded

166

Hetherington magazine-loading plate camera made in Indianapolis around 1891. Turning key on side of box dropped exposed plate to bottom of camera and brought fresh plate to the film plane. Value, $650.

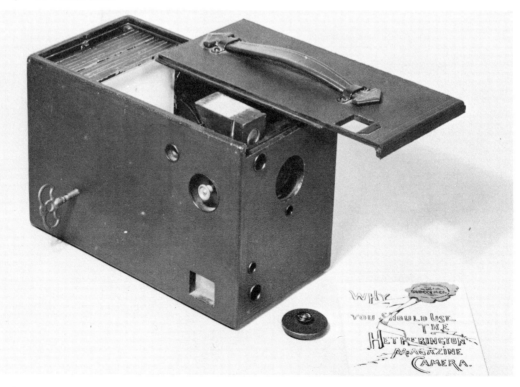

167

Hawkeye Detective and Combination Camera made around 1899 by Blair, successors to the Boston Camera Company. Sold as a detective or view camera, it was available in either plate or roll-film models. Value, $150.

168

Very rare French detective camera called the Velocigraphe. Heavy, leather-covered wooden body with drop-down front panel. Made around 1891. Value, $2,000.

169

Stirn's detective camera, c. 1891, held twelve 6-by-8-cm plates which were changed manually by means of leather changing bag built into camera. Value, $600.

viewing window, which must be pressed down to slide open the lid.

Among the exceptionally rare European detective cameras in the Isenberg collection is a French Velocigraphe made about 1891. This wooden box camera is housed in a heavy black leather case with a leather front panel which is dropped down to uncover the lens and viewing windows. The only other Velocigraphe in

117

the United States is in the George Eastman House collection.

The English miniature Luzo is absolutely unique, being the only one known. Although larger sizes of the Luzo can be found elsewhere, this diminutive model came in a leather detective satchel which also stored extra double plate holders and permitted the shutter to be tripped without removing the camera from the case.

Designers worked continuously to develop cameras that either looked like something else or could be concealed so artfully as to be completely inconspicuous. The Jumelle de Nicour, or binocular camera, was the earliest attempt at the former objective, while the Stirn Vest Camera was a successful effort in the latter pursuit. It was originally patented by R. D. Gray of New York City in 1886, and rights were sold the same year to C. P. Stirn, also of New York. Stirn's brother, Rudolf, began manufacturing their modified version in Berlin, Germany, in the fall of 1886.

The camera as conceived by Gray was a flat, round chamber housing an octagonal glass plate on which six exposures could be made. It was concealed within a

170

Only known example of miniature model of English Luzo camera. Complete with leather case which converts it to detective type. Value, $3,000.

false vest with the lens, plate-advancement and shutter-cocking knob simulating buttons. The shutter was tripped by means of a string which led to a false vest pocket.

Within a short time the camera was modified to use a round plate for six circular pictures, it was made thinner, and the accessory vest was dispensed with as being too bulky. Although marketed under many names, it is most commonly referred to as C. P. Stirn's Patent Concealed Vest Camera. Before it was discontinued around 1892, a great many were sold both in the United States and Europe, and quite a few accessories were offered to its users. Among these were enlargers, circular printing frames, and a wooden case in which the camera could be housed for use on a tripod for time exposures.

There are six Stirn's Vest Cameras in the collection, including a pair of rarer No. 2 or larger-size models. The No. 2 took only four pictures 2½ inches in diameter but was discontinued soon after its introduction as being too large to be successful as a concealed camera. Along with the vest cameras in the collection, there is a round glass plate negative which was used in a Stirn camera on which there are scenes taken in New York City in the 1890s.

171

Six C. P. Stirn's Patent Concealed Vest Cameras, c. 1888. At center in upper row is wooden case which allowed camera to be used on a tripod. Examples at upper right and lower center are the larger and rarer No. 2 models. Value, $800 to $1,500 with case.

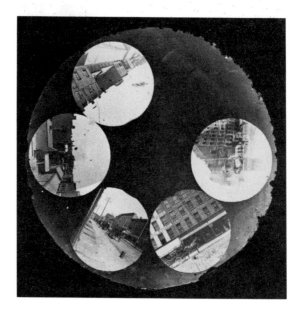

172

Print made from round glass negative found with a Stirn Vest Camera. These are scenes taken in New York City around 1890. Operator evidently failed to advance plate, so last picture is double-exposed and one segment is blank.

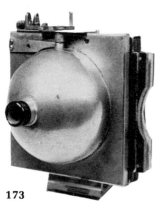

173

Tom Thumb American all-metal miniature camera, made around 1889, used 2⅝-inch-square dry plates and seems to be an adaptation of the British Demon camera and a precursor of the French Photosphere. Value, $900.

A very popular detective camera during the last decade of the nineteenth century was Dr. R. Krugener's Book Camera. Krugener of Germany was an active designer of cameras and photographic apparatus and is probably best remembered for his camera which resembles a small book but was capable of taking photographs slightly larger than 1½ inches square on twenty-four glass plates. The plates were loaded in a magazine and could be changed after each exposure by pushing a rod at the top of the book, or camera. The lens opening was in the middle of what appeared to be the spine of the book. The camera was covered with leather resembling a fine binding, into which was die-stamped *Krugener's Taschenbuch* [pocketbook] *Camera, Frankfurt* and the patent information. In addition to the Krugener Book Camera, the collection contains a French version called the Photo Carnet, made by A. Schaeffer in Paris from the early 1890s and which has the additional feature of a reflex viewer.

The first camera resembling a watch to be made in the United States was the Magic Photoret, patented in 1893. Only 2¼ inches in diameter and ¾ inch thick, the Photoret took six pictures on a special round film sheet. Exposure was accomplished by manipulating the simulated ring and winding stem, and the film advanced to the next exposure by rotating the outer edge of the case one-sixth of a full turn.

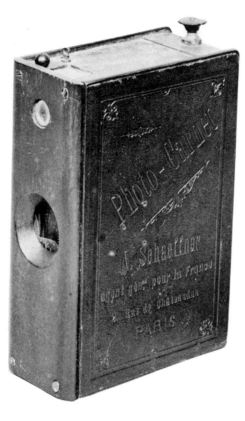

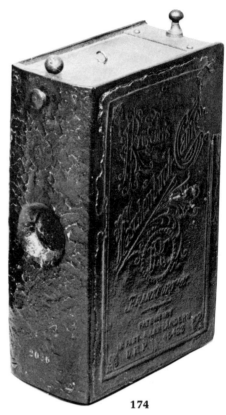

174

The Kombi, a miniature box camera measuring only 1⅝ by 1⅝ by 2¼ inches, was patented in 1892 and manufactured by Alfred C. Kemper of Chicago, Illinois. Its sales were undoubtedly aided by the fact that it was available for sale at the time of the Columbian Exposition held in Chicago in 1893. The camera took twenty-five 1⅛-inch round or square pictures on roll film and could be used as a viewer if the photographs were developed to a positive image. Selling for only $3.50, the all-metal Kombi seems to have been at least as good a value as Eastman's Pocket Kodak, which appeared three years later and cost $5.

Less difficult to find is the Expo camera marketed by the Expo Camera Company of New York City around 1904. This watch-type camera employed a film cassette for twenty-five pictures instead of sheets of cut film. Rarer than the Expo watch camera and its European counterpart, the Ticka, is the Expo Police Camera, which appeared about 1915. This is a tiny metal box-type camera smaller than a package of cigarettes that

Right: Dr. Krugener's Book Camera, a German detective camera introduced in 1889 and sold in the United States by E. and H. T. Anthony. Camera held twenty-four 4-cm-square glass plates. *Left:* French version, called the Photo-Carnet, was improved by addition of reflex viewing window. Value, $2,500 each.

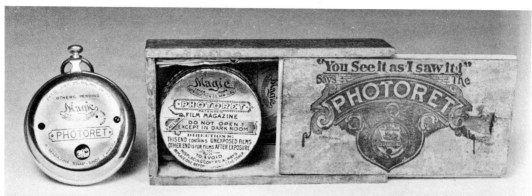

175 First U.S.-made camera to resemble a watch, the Magic Photoret, made around 1893. Took six pictures on a specially cut round sheet of film. Value, $650.

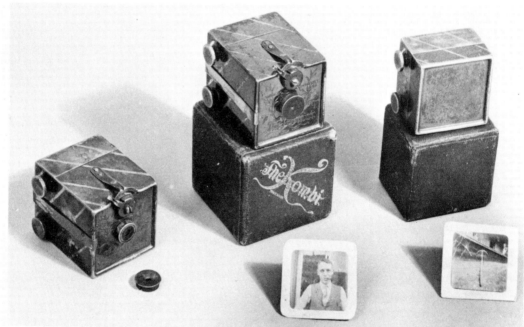

176 The Kombi, a miniature metal-body box camera took twenty-five 1⅛-inch round or square photographs on roll film. Made around 1893. Shown are two Kombi cameras and *(right)* an accessory magazine film back. Value, $150 each. Photographs made with the Kombi show a man with a cigar, and a bicycle.

177

Advertisement, 1890s, for the Kombi from *Harper's* magazine.

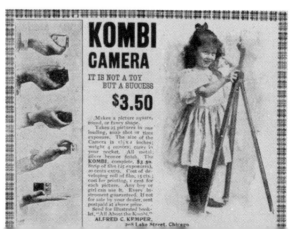

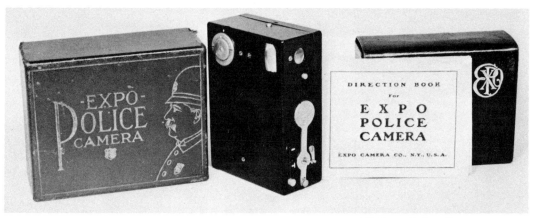

used a twelve-exposure film cassette. The Expo Police
Camera in the Isenberg collection is complete with
leather carrying case, original box, instruction booklet,
and an accessory for enlarging the ¾-by-1⅟₁₆-inch nega-
tives.

A fairly sophisticated type of detective camera was
marketed around 1926 in the form of a lady's makeup
case. Called the Photo-Vanity, the simulated leather
case housed containers for powder, rouge, lipstick, a
comb, and a small Ansco box camera which took 127-
size roll film. A mirror ran across the full width of the
case inside the lid. There is a viewing window at the
end of the case, the lens opening is at the rear just

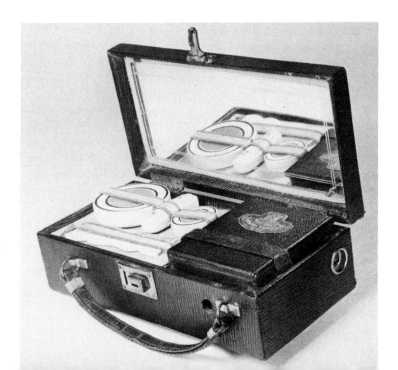

179
Photo-Vanity, c. 1926,
concealed Ansco box
camera for 127 roll film in-
side lady's travel case.
Value, $800.

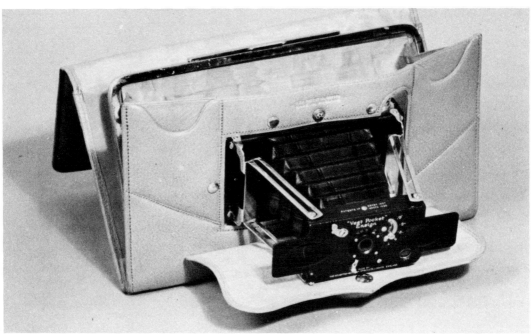

This lady's leather purse contained an English Ensign folding camera which popped out when front flap was released. There are only two known examples of this camera in the United States, the other being in George Eastman House. Made in mid-1920s. Value, $2,500.

Fig. 1.

181

Compass, a remarkably sophisticated British-designed miniature camera made by the Swiss watch-makers, Le Coultre et Cie., c. 1937. Diagram from instruction booklet shows location and function of its many features.

1 Spirit Level.	11 Filter Indication Window.
2 Distance Indicator.	12 Filter Control.
3 Shutter Speed Ring Lock.	13 Instantaneous Setting Arrow.
4 Instantaneous Release.	14 Time Release.
5 Lens Stop Control.	15 Lens Cover.
6 Stop Indication Window.	16 Depth of Focus Scale.
7 Stereoscopic Head.	17 Shutter Wind.
8 Angle View-Finder.	18 Shutter Speed Ring.
9 Camera Foot.	19 Milled Focussing Ring.
10 Lens Hood.	

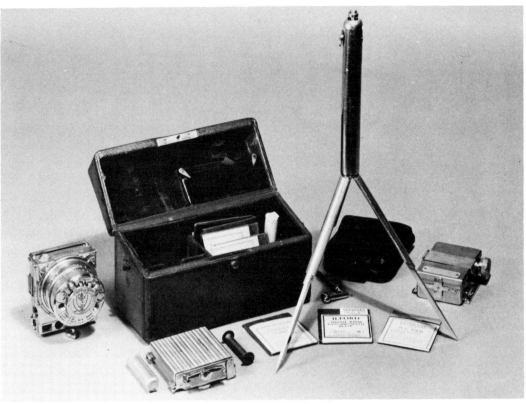

182 Compass outfit includes carrying case, tripod, camera pouch, accessory roll film and plate backs, and extra cut and roll film. Value, $1,200.

under the hinges, and in the front, just under the carrying handle, is the opening for reading the number of exposures. This is a charming item, of which there are not many more than a dozen known to exist in photographica collections.

Another camera, even more difficult to find, was designed for female "private eyes" and is called the English "handbag" camera. It, too, was made in the 1920s. This is a quality woman's purse, fully leather lined, which concealed an Ensign folding roll-film camera. Although it was patented in the United States, the only known examples in the United States are in the George Eastman House and Isenberg collections.

One of the most remarkable miniature cameras ever made and a delight to all collectors is the Compass. Designed by an Englishman, Noel Pemberton-Billings, this amazingly complex camera was built by the Swiss watchmakers Le Coultre et Cie. for the London marketing firm of Compass Cameras, Ltd. Within its brushed-metal body, measuring only 1¾ inches high, 2⅛ inches wide, and 1¼ inches in thickness, are the

following incredible features: coupled range finder, exposure meter, f/3.5 lens, a shutter with twenty-two speeds from 4½ seconds to ⅟₅₀₀ of a second, a spirit level on the top, a magnifier for focusing on ground glass, three built-in filters, two threaded tripod receptacles, and stereoscopic and panoramic heads.

The image size, 1 by 1½ inches, is the same size as a standard 35-mm negative, but the Compass used either specially prepared cut film or glass plates, or a six-exposure roll of film with an accessory roll-film back. A complete Compass outfit included a leather carrying case fitted with a tripod, plate and film backs, and space for film storage.

The Compass was introduced in 1937, and its manufacture was discontinued around the beginning of World War II. Although not considered particularly rare, this technical tour de force is one of those items of photographica that every collector feels he or she must own.

There is a modern group of subminiature cameras ideally suited to the purpose of taking clandestine photographs. Among these, the Minox is generally considered to be the ultimate "spy camera." The Minox was invented by Walter Zapp, a Latvian engineer, and was first made in Riga around 1937. Measuring only ¹⁹⁄₃₂ by ¹¹⁄₁₆ by 3⅛ inches, the original model had a stainless-steel case, an f/3.5 lens, shutter speeds from ½ second to ⅟₁₀₀₀ of a second, and used a special cassette of unperforated movie film 9.5-mm wide, containing enough film for fifty 8-by-11-mm pictures. By a push-pull action on the camera body, the film was advanced and the shutter cocked for the next exposure.

Until production stopped at the beginning of World War II, the Minox gained increasing acceptance among serious and amateur photographers and, presumably, most of the world's intelligence services. Since the Minox could be focused as close as 18 inches, it was ideal for the covert copying of documents, and the film cartridges were easily concealed. After the war, the Minox was produced in Germany, and later the Japanese made adaptations of the basic design. Among collectors, however, it is the original Latvian-made models that are sought. These are most easily identified by

183

Original model of Minox "spy camera" made in Riga, Latvia, c. 1937. Stainless-steel body 3⅛ inches long with f/3.5 lens; shutter speeds to 1/1000 of a second. Cassette contained enough film for fifty 8-by-11-mm photographs. Value, $450.

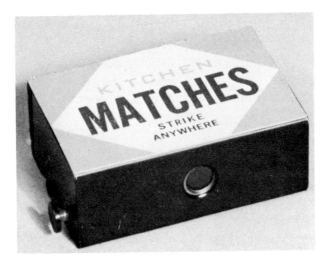

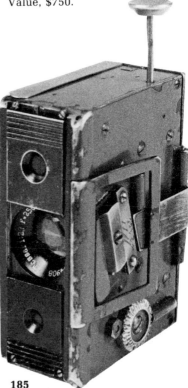

their stainless-steel bodies, which are much heavier than the later aluminum models and have serial numbers not exceeding approximately 22,000.

During World War II, both the Eastman Kodak Company and an unidentified German camera manufacturer developed almost identical "spy cameras." These cameras were about the size of a small box of wooden matches with the lens opening in the middle of one of the narrow sides of the box. Exposures were made on both cameras by depressing a plunger-type release at the top of the body which also advanced the film in the miniature cassette. The German camera was technically more sophisticated and had adjustable shutter speeds, lens opening, and focusing.

Other recent subminiature cameras of importance to collectors are the Steineck wristwatch camera made in Germany, and the Echo cigarette lighter camera and the Petal, both made in Japan. The Steineck appeared around 1950 and looks and fits on the wrist like a watch except that instead of a watch face it has a lens for taking the photograph and an opening at the center for direct viewing with the camera off the wrist and held directly to the eye. Viewing with the camera on the wrist is accomplished by means of a section of the case polished to a mirror surface which reflects the image to the operator's eye and is centered by means of a gunsightlike pointer. The camera requires a special template and cutting device for making the 25-mm round film on which eight 3-by-4-mm photographs can

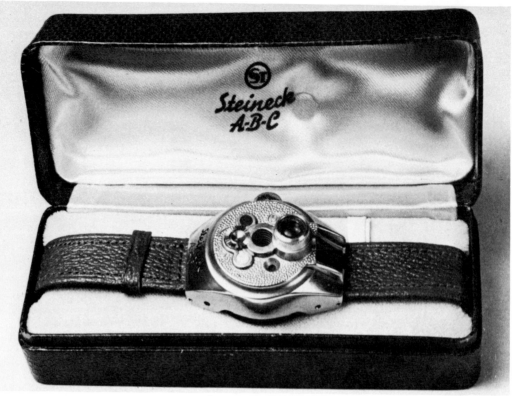

186

Steineck A-B-C wristwatch camera made in Germany around 1950. Took eight 3-by-4-mm photographs on a sheet of round cut film very similar to system used in Stirn's Vest Camera sixty years earlier. Value, $500.

be made. It is a type of item that is somewhat on the border between high-precision technology and sheer novelty.

The Petal is one of the more interesting cameras produced in Japan shortly after World War II. It is not much larger in diameter than a 50-cent piece and, like the Steineck wristwatch camera, used specially cut round film. Because they were made before the end of the American occupation of Japan, in June 1952, the Petal cameras imported into the United States all bear the mandatory mark *Made in Occupied Japan*. Most Petal cameras offered for sale at photographica shows have a round body similar to that of an ordinary pocket watch. A great deal rarer, however, is the octagonal-shaped model found in the Isenberg collection.

In 1954, the Japanese began producing the Echo 8, a camera which resembled a Zippo lighter and actually worked as both a camera and a cigarette lighter. The Echo 8, as the name implies, takes eight pictures on 8-mm movie film.

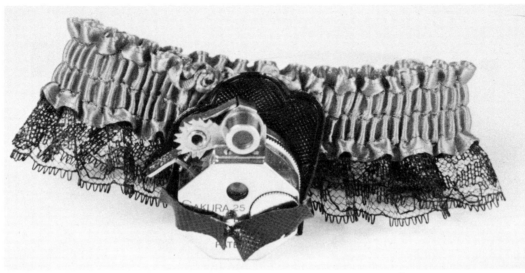

187 Petal, a Japanese subminiature camera, c. 1949. Made for American export, it is marked *Made in Occupied Japan*. Most Petal cameras were round and about the diameter of a half-dollar. This is a rarer octagon-shaped Petal attached to a lady's garter. Value, $100.

Two novelty cameras in the collection from the early 1950s and 1960s are a combination of camera and portable radio. The earlier model is a tube-type radio housed in a simulated leather case with a cheap twin-lens reflex 127-size roll-film camera. The radio was made by the Automatic Radio Company of Boston, Massachusetts, and this particular outfit was called the Tom Thumb Camera-Radio. Almost identical models of this novelty in other collections have different trade names.

The other camera-radio is a pocket-size Japanese transistor-type radio combined with a fairly sophisticated miniature camera. The camera used twenty exposure film cassettes, has variable shutter speeds from 1/50 to 1/200 of a second, an exposure counter, an optical viewfinder and an f/3.5 lens. This particular model is called the Bell Kamra, an obvious contraction of camera-radio.

Still being sold today is the Swiss Tessina camera, which gained considerable publicity at the time of the Watergate scandal. This is the camera allegedly lent by the Central Intelligence Agency to E. Howard Hunt, who furnished it to the people who broke into the office of Daniel Ellsberg's psychiatrist. Although the Tessina straps to the wrist, it is bulkier than a watch, but can be concealed by a sleeve. It is a precision camera with an f/2.8 lens and adjustable shutter speeds

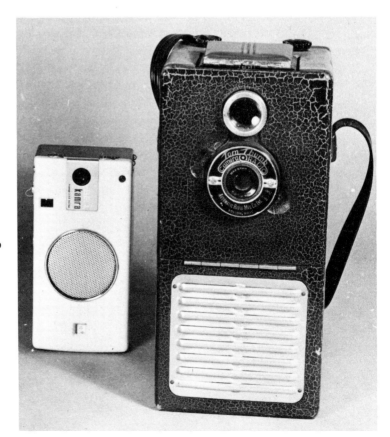

188

Japanese Echo 8 subminiature camera resembles a Zippo lighter and worked as a cigarette lighter as well as a camera that takes eight pictures on 8-mm film. Made around 1954. Value, $200.

189

Two camera-radio combinations. *Left:* Japanese six-transistor radio housed camera with f/3.5 lens, adjustable shutter speeds, and cassette for twenty exposures. Made about 1960. *Right:* American Tom Thumb Camera-Radio, c. 1950. Tube-type radio and reflex camera using 127 roll film. Value $80 to $100.

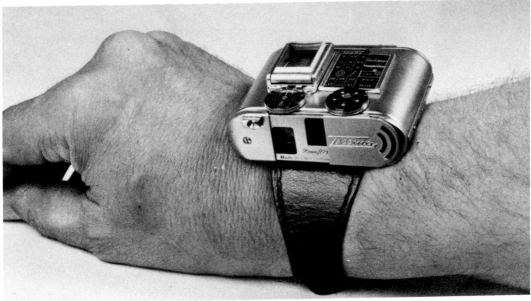

190 This Swiss-made Tessina wrist camera is the type allegedly furnished by the CIA to Watergate burglars. Spring-powered motor permits burst of five to ten 14-by-21-mm exposures on 35-mm film. Value, up to $250 with accessories.

capable of taking quality photographs. Its value to collectors has undoubtedly been enhanced by its recent notoriety.

In the span of slightly more than a hundred years, portable cameras, concealed cameras, and cameras made to simulate other devices have evolved from the ideas behind Nicour's binocular camera and Schmid's detective camera. Cameras have been given the appearance of matchboxes, lighters, watches, radios, and books. Amazing miniaturization has been achieved, and the photographer can be conspicuous or not as it suits his or her particular purpose. Collecting the equipment that has made this transition possible is a very fruitful area and one in which many collectors have specialized.

⑥

Early Color Photography

One of the truly revolutionary developments in photography over the past quarter of a century has been the almost universal adoption of color photography by the millions of casual picture takers. The introduction and perfection of easy-to-use color film and cameras suited to its use has led most amateurs to abandon black-and-white photography completely. Color film can be exposed in the most simple Instamatic or most sophisticated cameras, sent to a processing laboratory, and be returned as color slides or prints. In the Polaroid and more recent Eastman processes, full-color prints are available in a few minutes after exposure, the development taking place in full daylight outside the camera. Color photography is now such a simple and available medium that many of us lose sight of the immense technical problems which had to be overcome before it became a popular reality.

The search for a practical means of making photographs in color began only a short time after Daguerre's process was announced. In 1851, an upstate New York minister, Levi Hill, who had taken up daguerreotypy, announed that he had succeeded in making full-color daguerreotypes. He was able to convince Samuel F. B. Morse and others of his sincerity and intelligence but was unable to duplicate his purported

results. It is presently assumed that Hill's claim was a hoax, and his daguerreotypes were colored by hand. But interest was so great in the possibility of being able to photograph in color that Hill was able to keep alive his contentions for several years by contributing tantalizing articles to *Photographic Art-Journal* and *The Daguerrean Journal.*

The first solid contribution to color photography was made in 1862 by a French worker, Louis Ducos du Harnon. He suggested that if a subject were photographed on three separate plates sensitive respectively only to red, yellow, and blue, developed to a positive dyed red, yellow, and blue, and then superimposed, a full-color image would result. This principle was soon proved in the field of color printing and lithography, and, by 1870, plates inked with two, three, or more colors were soon able to produce the accurate reproduction of artwork.

Progress in color photography did not proceed as rapidly as it did in printing. The three negatives required for color separation had to be exposed individually, and this required a static subject, so early efforts were confined mostly to the reproduction of paintings and other still-life subjects.

An example of an early attempt at this type of color photography in the Isenberg collection is a plate holder made by the English firm of Sanger-Shepherd around the turn of the century. It held three 2¾-by-3¼-inch glass plates, and almost any view camera could be adapted for its use. The plates were arranged so that after each exposure through a different-colored filter, the next plate could be moved into position in a manner smooth enough to assure the closest registration of one image on another. Positive transparencies made from these negatives could be viewed or projected through a second series of three filters to achieve a full-color image.

The first American camera to make three-color-separation negatives in a single exposure was covered by patents issued to Frederick E. Ives of Philadelphia between 1890 and 1899. Ives was a prolific and pioneering inventor of systems for color printing and photography, and he named his one-shot camera the Ives

191

Holder for three 2¾-by-3¼-inch plates which were successively exposed through a red, blue, and green filter. Made by English firm of Sanger-Shepherd in the 1890s. Value, $200.

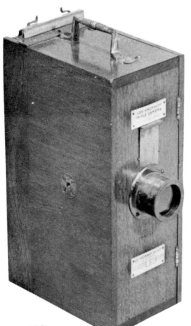

193

Patent label as it appears on
Krōmskōp camera.

192

Ives Krōmskōp Triple
Camera. Made in Philadel-
phia, Pennsylvania, in 1899.
This camera exposed three
plates in one exposure
through three different col-
ored filters. Value, $4,000.

194

Interior view of Krōmskōp
camera showing three filters
aligned vertically, the triple
plate holder at the right,
and the optical tubes which
direct a complete image to
each plate.

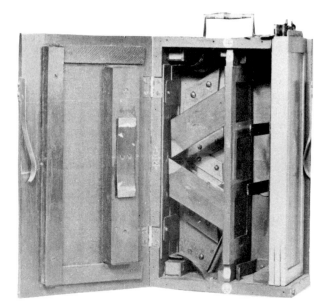

195

Schematic drawing of
Krōmskōp from manual
originally furnished with
camera.

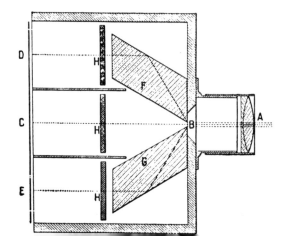

134

Krōmskōp Triple Camera. In the Krōmskōp, three sensitized plates are exposed simultaneously through an arrangement of prisms and three filters (red, green, blue) placed in front of each of the plates. Stereo photographs could be made with the Krōmskōp by inserting a second set of three plates in the camera and making another exposure after the camera was shifted laterally about two inches.

196 Krōmskōp monocular viewer. By an arrangement of filters and mirrors, three transparencies were superimposed and viewed in color. Value, $1,000.

197
Stereo version of Ives Krōmskōp viewer. Value, $1,200.

As part of his color, or Krōmskōp, system, Ives developed both monocular and stereo viewers in which, through an arrangement of mirrors and filters, a set of three positive transparencies made from the Krōmskōp negatives could be seen in color. In the Isenberg collection is an Ives Krōmskōp one-shot camera, one of five known examples, and both the monocular and stereo viewers in addition to a large number of Krōmskōp mono and stereo views made by Ives to promote the sale of the viewers.

Each of the Ives items is quite rare, as is the first Hess-Ives Hi-Cro three-color camera in the collection, which is one of only two known to exist. The other was in the collection of the Minnesota Mining and Manufacturing Company which acquired it when the company purchased the collection of the American Museum of Photography in Philadelphia in 1959. The 3M Collection has since been acquired by George Eastman House.

198

Hess-Ives Hi-Cro color
studio camera, c. 1911. This
is one of only two known
examples. Value, $750.

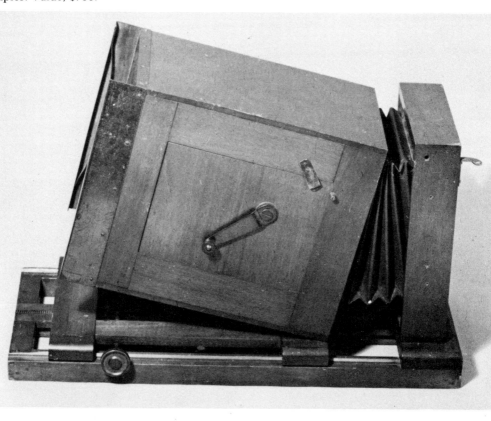

This first Hi-Cro was patented in 1911 and was an early attempt to market a one-shot, three-color, wooden studio-type camera for commercial photographers. The image size was 5 by 7 inches and used a HiPack, which consisted of three sensitized surfaces in a single holder. It required considerable manipulation of the dark slide, levers, tilting of the camera, and movement of a filter-mirror to get the three plates into position in the camera before an exposure could be made. After the picture was taken, the steps had to be reversed in order to reassemble the plates within the HiPack. Hess-Ives leather-covered Hi-Cro cameras of a slightly later date are considerably more common and worth less than $100. Suggested exposure in bright sunlight for the Hi-Cro with an f/6.3 lens was as fast as 1/6 of a second. This is in contrast to the Ives Krōmskōp Triple Camera, which had a recommended 10-second exposure.

An absolutely unique color camera dating from around the turn of the century came to the Isenberg collection in a rather interesting manner. In most areas of antiques collecting, there are individuals known as "pickers," who travel about ferreting out items that would appeal to certain dealers and collectors. A picker who specialized in photographica came to Isenberg and asked what he would pay for an old wooden box camera. Isenberg replied that he would probably be willing to give $50 for it no matter what it was. He was then asked, "What would you pay for a detective camera?"

"I'd pay a hundred dollars for any detective camera," Isenberg responded.

"Well, how much would you pay for a wooden color camera?" was the picker's next question.

"I guess I'd pay two hundred dollars for a wooden color camera, regardless of what it was."

"Okay," said the picker. "That makes three hundred and fifty dollars for this wooden detective color camera I just found. I never saw anything like it and didn't know what to charge for it."

The camera he produced was indeed as he had described it, and appeared to be a handmade prototype of

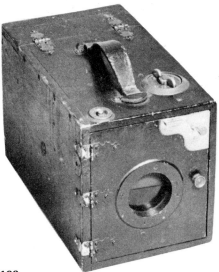

199

One-shot color camera
made in United States be-
tween 1900 and 1910.
Entirely handmade, it is a
remarkable example of
Yankee ingenuity. Value,
$1,000.

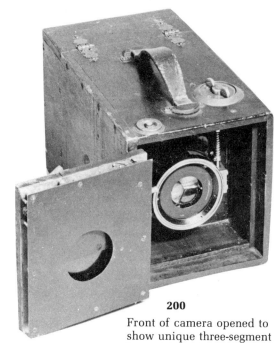

200

Front of camera opened to
show unique three-segment
lens which directed three
images through filters to a
different portion of a single
plate.

a color camera which some Yankee mechanic had
been trying to develop. The overall design was similar
to a Blair camera of around 1891. Its most unusual fea-
ture was the lens, which was made up of three wedge-
shaped lenses, each of which made up one-third of the
regular circular configuration of an ordinary lens. Each
segment produced a separate image which passed
through a different color filter and focused on its own
area of a single 3¼-inch-square plate. It would seem
that someone ingenious enough to work out the optics
of this system would have been satisfied merely to
adapt an existing camera and shutter mechanism to ac-
commodate it. This was not the case, as the box is
handmade and the shutter is also of original design and
construction. Although this three-segment lens was an
apparently simple means of doing away with the elab-
orate prism-and-mirror system employed by Ives and
others, for some reason it was never produced com-
mercially, and this is the only example of this design
ever found.

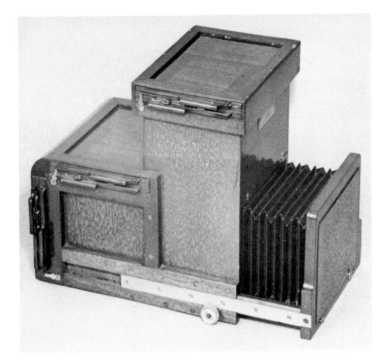

201
Butler one-shot color
camera, British, c. 1906.
Made one exposure on three
separate plates through an
arrangement of pellicle mir-
rors and filters. This exam-
ple is pristine, with
lensboard uncut. Value,
$3,000.

This same picker was instrumental in the acquisition
of another rare color camera now in the collection. He
reported to Isenberg that an old man in New Jersey had
an unusual camera which from the description ap-
peared to be a Butler, an English one-shot color camera
first patented in 1906 and of which there are less than a
handful of known examples.

Isenberg asked the picker how much the camera
would cost, and the picker said that he didn't know but
that the owner liked Graflexes and might trade for a
few of those and some additional cash. Isenberg sent
the picker off to buy the color camera with a signed
blank check and three Graflexes worth about $200.
The situation was complicated, however, by the fact
that another collector knew about the camera and was
hoping he could eventually own it. When the negotia-
tions began, the owner called the other collector, and
the transaction became an auction between him and
Isenberg. What started out as the picker's offer of $350
plus the Graflexes plus a $315 finder's and expense fee

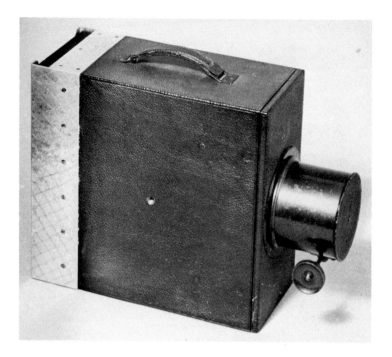

202
Sanger-Shepherd "one-plate one-exposure" color camera made in London, c. 1907. Similar in design to Ives Krōmskōp camera. This is the only known example of this camera. Value, $2,000.

to the picker, finally cost Isenberg $2,415. This is the way the transaction broke down:

$700 cash plus $200 worth of Graflexes to the owner;
$315 to the picker;
$1,200 (the value of a Kraus Photo Revolver) given to the other collector to withdraw from the bidding. From this it can be seen that collecting rare cameras is not always a simple buy-sell deal.

Another early English one-shot color camera in the collection was made in London around 1907 by Sanger-Shepherd & Company, scientific instrument makers. It is very similar in design to the Ives Krōmskōp and might even be considered by some to have infringed on the Ives patent. Although advertisements for this camera appeared in the *British Journal Photographic Almanac* for several years around 1910, this is the only Sanger-Shepherd to have surfaced so far, but it is felt that others will ultimately be discovered.

One-shot color cameras continued to be improved, and the collection contains two sizes of the German-made Jos-Pe camera produced in the mid-1920s and two made by Bernpohl, also in Germany, around 1935. A Devin camera, made in the United States from the late 1930s to the early 1950s, brings the collection of

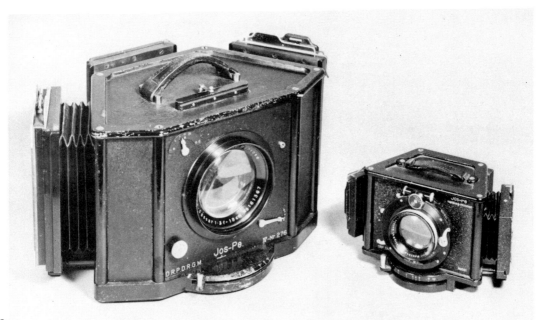

203
 Two sizes of the Jos-Pe, a German one-shot color camera made about 1925. Larger model takes 9-by-12-cm plates, and smaller version 4.5-by-6-cm plates. Value, $1,000 each.

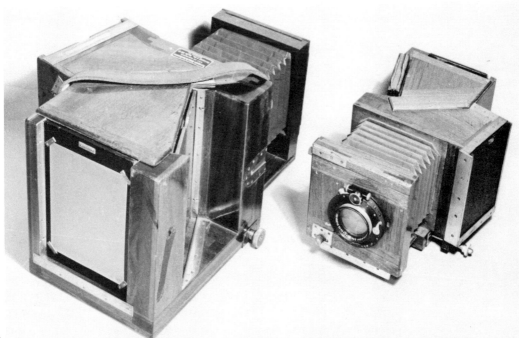

204
 Two models of German Bernpohl color camera made from about 1935 to 1950. Camera at left uses 13-by-18-cm plates; and smaller version, at right, 9-by-12-cm plates. Value, $1,200 each.

205

Devin one-shot color camera was made in the United States in various models and sizes from the late 1930s to the early 1950s. This example uses 2¼-by-3¼-inch cut film. Value, $450.

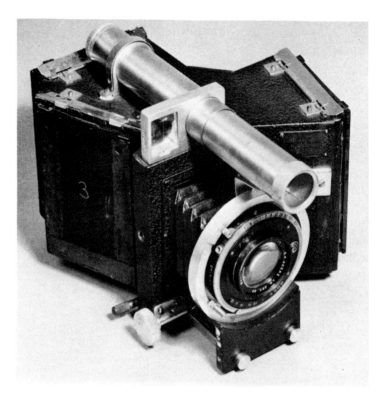

206

Mikut, a European apparatus for projecting three transparencies by means of three lamps and filters through a single lens to secure a color image. Since it appeared just prior to the introduction of 35-mm Kodachrome film in 1936, it soon became obsolete. Value, $400.

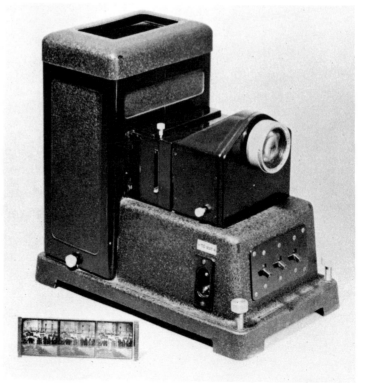

one-shot color cameras up to the point where the intro-
duction of Kodachrome film made the three negative
one-shot cameras obsolete.

There is a European color projector in the collection
that was made in the 1930s only up to the time Koda-
chrome film for slides became available. Called the
Mikut, it projected three horizontally mounted positive
transparencies through an arrangement of three lamps,
prisms, and filters and combined the images for projec-
tion through a single lens. Though quite sophisticated
in its design, it was made for a very short time and,
therefore, is rather rare.

As strong as the Isenberg collection is overall, the
color section tells the story of the progress of color
photography better than almost any other existing col-
lection. By itself, like so many other aspects of the col-
lection, it has achieved unequaled status for quality,
rarity, and historical significance.

7

The Leica

Matt Isenberg's first Leica held a special fascination for him and probably motivated to some extent the start of his photographica-collecting activities. For thousands of other collectors, there is enough equipment, history, and legend in the Leica to engage all of their collecting enthusiasm. Leica collectors form one of the largest single organized groups within the whole photographica-collecting fraternity. There are perhaps fewer than a handful of specialists in the United States with more complete Leica collections than Matt Isenberg's. However, his is the most comprehensive array of Leica equipment in any general collection in this country and is important enough to stand as a model for Leica collectors everywhere.

The Leica is a natural collectible for a number of reasons. While not the first 35-mm camera, it has been in continuous production longer than any other make, and for part of its history was the only one made in volume of any consequence. In the course of its more than fifty-year history, close to two million have been made in dozens of models and variations, and innumerable accessory lenses and other specialized equipment have been designed and produced for use in conjunction with the camera. Additionally, the Leica has

always been a relatively expensive, high-precision product which because of its intrinsic value and dependable performance was retained by its owners. This is in contrast to cheaper, less serviceable products, which are often discarded when their repair is considered impractical or uneconomical.

Another boon for the collector is that from its inception Leica production is unusually well documented with consecutive serial numbers starting with number 100 in 1923 up to seven-digit numbers at present. Thus, the year when a particular camera was made and how many were produced can be ascertained with greater accuracy than with most photographic collectibles.

The inventor of the Leica was Oskar Barnack, an optical worker who came to the Leitz Optical Works in Wetzlar, Germany, in 1910. At that time, Leitz had been engaged in the manufacture of precision optical products, most notably microscopes, for more than sixty years. Barnack was an amateur photographer and became interested in making a small camera that would use 35-mm perforated motion-picture film and

207
Photo of part of the Isenberg collection of Leica cameras, lenses, and accessories.

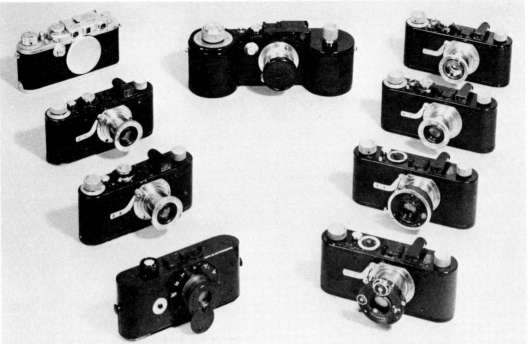

208

To emphasize the importance of the Leica, these nine Leica cameras have a total value of about $30,000 on the collector market.

209

Oskar Barnack's first camera, the Ur-Leica, was made in 1912. The camera illustrated here is one of over a hundred copies made by Leitz over the past thirty years. Value, $650.

make use of the advanced optics that Leitz was capable of producing.

In 1912, Barnack built two prototypes, one for himself and one for Ernst Leitz, of what was eventually to become the entire lineage of Leica cameras. This camera is now referred to as the Ur-Leica, *Ur* being the German word for "ancestor." Recognizing its historical importance, Leitz has made more than one hundred reproductions of the Ur-Leica over the past thirty years, and two of these copies are in the Isenberg collection.

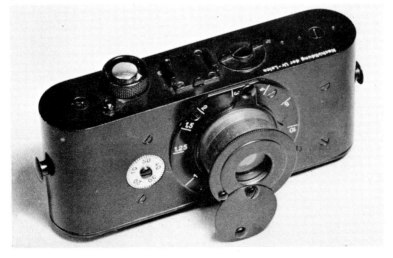

World War I postponed any plans to produce the camera commercially but did not prevent Barnack from refining and improving its design. A preproduction run of the thirty-one Leicas called the Model 0, or Nul, series was made in 1923 and serially numbered from 100 to 130. Like Barnack's first camera, it had a nonself-capping focal-plane shutter. Photographers found this to be a disadvantage, as it meant that a cap had to be placed over the lens as the film was advanced, and the shutter automatically cocked for each successive exposure.

The first cameras were offered to the public in 1925 and were known as the Leica I or Model A. This model had a self-capping shutter, and the lens, as on the Nul series, was a Leitz f/3.5 five-element Anastigmat. After the first few hundred, the lens formulation was changed briefly to the five-element Leitz Elmax, and by 1926 the formula of the lens was changed again and standardized as the four-element Elmar. Leicas with Anastigmat and Elmax lenses are rare. Isenberg has two Model A cameras with serial numbers 515 and 944, both with Elmax lenses placing them well within the company's first year of manufacture. Early unmodified examples of the Model A Leica should be instantly recognizable to the knowledgeable collector by the shape of their shutter-release button. Up to approximately serial number 17,000, the shutter release was a wide, flat, mushroom-shaped button. A little less than halfway through the run, the mushroom developed a dimple in its center. Subsequently, it was redesigned in a taller shape and made to accept a screw-on cable release.

No doubt the easiest to recognize and most sought after variations of the early Leicas are those equipped with Compur shutters. Instead of the standard focal-plane shutter, which is a slotted curtain which passes just in front of the film at the rear of the camera body, the Compur is a leaf-type shutter mounted at the front of the camera between the glass elements of the lens. Two of the reasons presently put forth for the introduction of the Model B Compur are: shutter speeds were as slow as 1 second, rather than 1/20 of a second on the standard Leica, and production costs were lower.

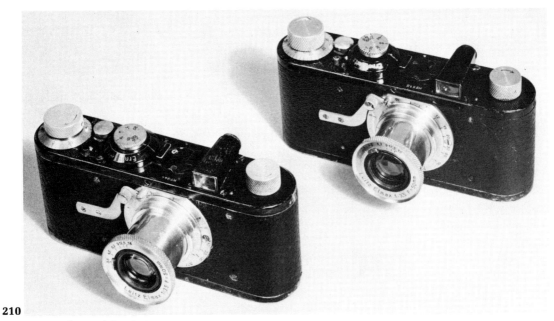

210

Two early Model A Leicas, serial numbers 515 and 944, equipped with rare Leitz Elmax f/3.5 50-mm lens. Note flat, mushroom-shaped shutter-release button. Value, $6,000 each.

211

Three Model A Leicas showing how shutter release button changed from flat, mushroom shape at left to mushroom with a dimple, and after the first 17,000 cameras to the button which would accept a cable release.

In any case, the Compur-type Leicas could not have been too much of a sales factor, as only a total of about fifteen hundred were made at various times in two styles between 1926 and 1930. The first Model B's used a Compur shutter on which the speed was set on a dial positioned directly above the lens opening. These dial-set Compur Leicas are about twice as rare as those made in 1929 and 1930 with a later rim-set Compur. On

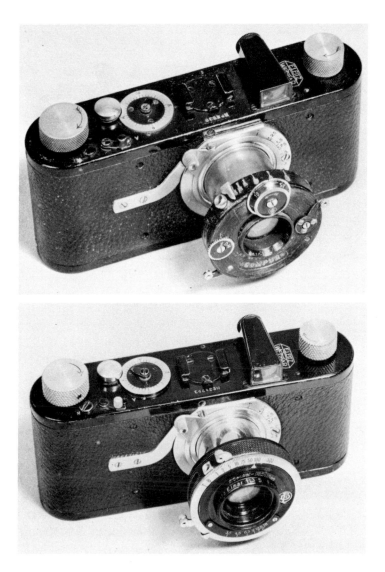

212

Model B Leica with dial-set
Compur shutter with speeds
from 1 to 1/300 of a second.
Made from 1926 to 1929.
Value, $5,000.

213

Model B Leica with rim-set
Compur shutter, 1929–30.
All Model B Leicas are very
rare, as probably less than
fifteen hundred were made.
Value, $4,500.

the rim-set, the shutter speed can be adjusted by
rotating a ring on the outer perimeter of the lens on
which the various speeds (from 1 second to 1/300 sec-
ond) are designated. Since the number of Compur-
equipped Leicas is so small in relation to the total of
considerably more than a million Leicas made, it is no
wonder that they now fetch from $4,000 to $5,000 in
the collector's market.

Another distinguishing feature of the Model B Leicas
was that the dial-set Compur models had the mush-
room-shaped shutter-release button, while the rim-set
Compurs had the dimpled button. This button design

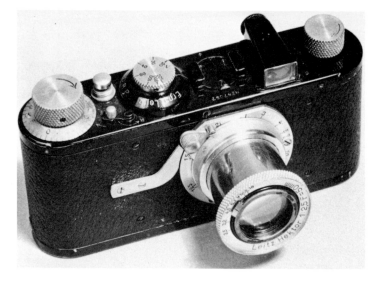

214

Model A Leica, serial number 47097, made in 1930. It is equipped with an f/2.5 50-mm Hector lens, Leitz's first attempt at a higher-speed lens. Value, $3,500.

was retained because the cable release was threaded directly into the Compur shutter.

It should be mentioned that the noninterchangeable lenses had to be individually calibrated to the cameras with which they were used on approximately the first sixty thousand Leicas sold. Any additional lenses subsequently purchased had to be adjusted at the factory for the owner's Leica. Leitz first attacked this problem by offering a set of lenses matched to a particular camera. The set of standard and accessory lenses tailored to a particular camera was engraved with the same number as the last three digits of the camera's serial number. This change converted the Model A to a non-standardized Model C.

215

The Model C Leica in this outfit is the nonstandardized type which required that the accessory lenses be individually calibrated to the camera at the factory. Each lens bore the last three digits of the camera serial number. Value, $2,000.

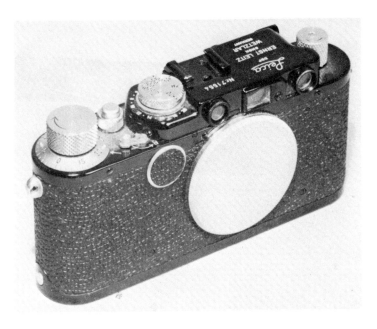

216
Although this Model D Leica was modernized to a model IIf by Leitz in the 1950s to accept flash synchronization, it still retains its original serial number, indicating that the camera was made early in 1932. Value, $450.

This system was superseded in 1931 by the introduction in that year of the Standardized Model C, which would accept without modification all lenses made after that date. These cameras and lenses can be identified by the presence of the letter "O" engraved at the top center of the lens flange on the camera body as well as on the lens itself. C models are similar to A models except for the absence of the nickel-plated infinity-stop spring-clip mounted on the front of the camera. Leicas equipped with this clip, which was needed to lock each lens at infinity, are commonly referred to among collectors as the "hockey stick" model.

First models of interchangeable normal and wide-angle lenses lacked an infinity-release button, which appeared in the second generation of Leica lenses, made to fit the C models which did not have the spring-clip stop. The third-generation infinity release took on the much more familiar conical shape with concentric rings machined into its surface.

Simple interchangeability of lenses spurred the development of new lenses for various purposes, and by 1931 four lenses in addition to the standard f/3.5 50-mm Elmar were being made. They were the f/3.5 35-mm Elmar wide-angle, the f/4.5 135-mm Elmar telephoto, the higher-speed f/2.5 50-mm Hektor, and the medium telephoto f/4 90-mm Elmar. The early version

of this 90-mm lens is referred to by many collectors as the "fat barrel" Elmar.

Since the collection includes over two hundred Leica cameras, most of which, although excellent, are not uncommon, this description will be confined to the rarest or most unusual models. While some of the oldest Leica cameras are among the rarest, there are several models or variations of more recent production that are at least as valuable and certainly as difficult to find.

In this category is the Leica 250, or Reporter, which is a modified version of a Leica E with a coupled range finder and shutter speeds as slow as 1 second. The 250, as the name suggests, was made with an oversize film chamber to hold 27 feet of film on which 250 exposures could be made. Special film cassettes were supplied with the camera which permitted the exposed film to be removed without the tedious task of rewinding the entire length. Although production of this model began as early as 1934 and was continued in small batches up to 1942, only about a thousand were made. This small quantity in relation to the total of all Leica production makes the 250 one of the most desirable collector's items.

From 1939 through 1945, most of the cameras made by Leitz went to the German armed forces. These Leicas can be identified in a number of ways as wartime models, the most obvious being gray-enameled metal parts instead of chrome or black, and the gray

217

Leica 250, also known as the FF or Reporter. Specially built to take 250 exposures on a 27-foot roll of 35-mm film. First manufactured in 1934 and made in small amounts until discontinued during World War II. A total of less than a thousand was produced, making the 250 a desirable collector's item. Value, $3,500.

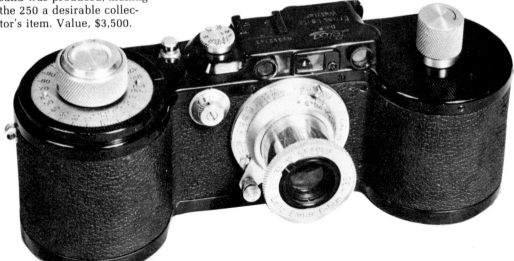

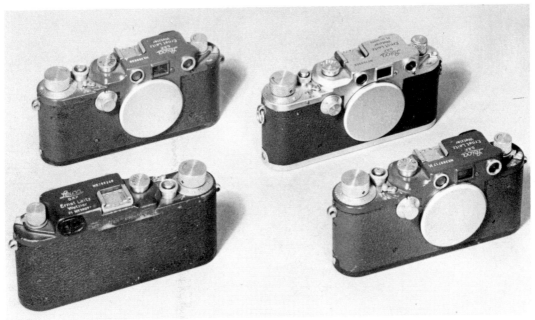

218 Four World War II Leica cameras. *Upper left:* gray paint, gray leather, serial number 388826. *Upper right:* grayish leather, chrome body, has German armed forces procurement order designation FL No. 38079. *Lower left:* all-gray, marked *Luftwaffen Eigentum. Lower right:* all-gray with letter "K" after serial number. "K" stood for *Kugellager,* or ball bearing," a special wartime construction for cold-weather use. Value, all gray models $1,000 each, model at top right, $800.

pebbled covering on the camera body instead of the usual black vulcanite. Some of those made for the German Air Force are stamped *Luftwaffen-Eigentum* on the back of the camera body. On some wartime cameras, the serial number is followed by the letter "K," which stands for *Kugellager,* meaning "ball bearing." This indicated that ball bearings had been used in certain parts of the mechanism in order to improve its reliability in cold weather. Other military cameras bore the designation "FL 38097" in addition to the serial number. FL 38097 is thought to refer to a purchase or procurement order number and helps identify military Leicas in the absence of other typical characteristics such as the gray-painted finish.

Postwar rarities in the collection include a Standard model similar to the Leica C which lacks the slow shutter speeds and the range finder. Less than a thousand were made in 1947 and 1948, probably in an effort to resume commercial production as rapidly as possible and to use up parts already on hand in the factory. All of these postwar standard Cs had serial numbers starting with 355 as the first three digits, usually a prewar number.

In 1949, Leitz's French distributor, Triant et Cie., ordered a limited number of Leica IIIa bodies to be assembled in the Saar region of Germany, which was

219

The Model C Leica standardized to accept interchangeable lenses was first made in 1931. Although obsolete, about 650 of these postwar standards were made by Leitz in 1947 and 1948 in a effort to resume commercial production. This example is fitted with an excessively rare f/2 Summicron lens mounted in a Compur shutter. That was done so that nonflash- synchronized cameras could be used with flash attachment. Value of camera body $1,500; lens, $3,000.

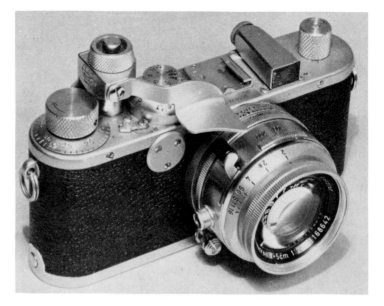

220

In 1949 Leitz's French distributor ordered a small quantity of Model IIIa Leica parts, which were assembled in the French-occupied Saar region. These cameras were the first to be built outside of the Wetzlar, Germany, factory. Marked *Monté en Sarre*, they are very rare. Value, $5,000.

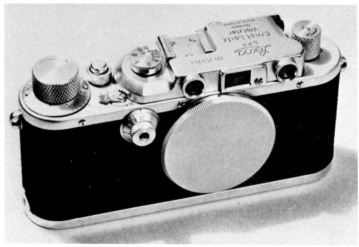

221

Only about two hundred of these seventy-two-exposure half-frame Leicas were made in Leitz's Canadian plant in Midland, Ontario, in 1954 and 1955. Distinguishing features are half-frame mask over viewfinder, exposure counter numbered up to 75, and the marking *18 × 24* over the serial number. Very rare. Value, $8,000.

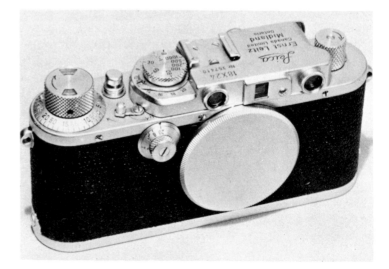

under French occupation at the time. These were the first Leicas to be built outside of the Wetzlar factories and are important to collectors for this reason and for the fact that so few can be found. These cameras can be identified by the legend *Monté en Sarre* etched into the top of the chrome camera body.

By 1954, Leitz had set up manufacturing facilities outside of Germany in an assembly plant in Midland, Ontario, Canada. It was only in this plant that the Canadian half-frame was made in a very short run of probably less than two hundred cameras. The 72 was basically a combination of a Model IIIa body with the IIIf model's flash synchronization. It was made to take seventy-two 18-by-24-mm exposures using the regular thirty-six-exposure film cartridge. It can be identified most readily by the front of the viewfinder window, which is masked vertically in the same format as the half-frame negative. Also, the numbers *18 x 24* appear on top of the camera body immediately above and dominating the serial number. Its value to collectors surpasses that of the Compur B, while the *Monté en Sarre* Leicas can be expected to reach that level shortly.

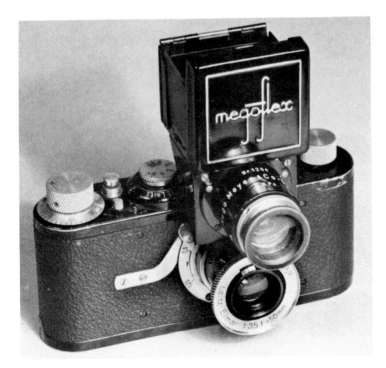

222

This device, called the Megoflex, was made by Hugo Meyer of Germany around 1932 to convert the non-range-finder-equipped Leicas into a twin-lens reflex-focusing camera. Value, Model A Leica, $450. Accessory viewfinder, $200.

Leica collectors aggressively seek not only the cameras, lenses, and accessories made by Leitz, but anything made to be used with or modify Leica equipment regardless of who manufactured it. Some of these items are quite ingenious, as two examples from the Isenberg collection will illustrate. The first is an adapter which converted early, non-range finder Model A Leicas into a twin-lens reflex-type camera. Called the Megoflex, it was made by the German optical firm of Hugo Meyer around 1932. Focusing was accomplished by adjusting the image transmitted to a horizontal ground-glass screen by a separate viewing lens which was coupled to the normal f/3.5 Elmar camera lens.

Another non-Leitz collectible accessory is a three-lens rotating turret fitted to a Model IIIa Leica of 1936 vintage. It was made for and marketed by the New York City photographic dealer and distributor Haber

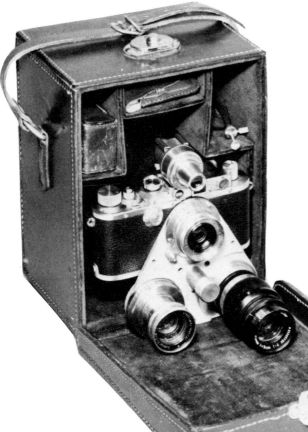

223
Leica IIIa fitted with a rotating turret containing 35-, 50- and 90-mm Leica lenses. Marketed around 1936 by Haber and Fink, New York City photographic distributors. Value, $500.

and Fink. The outfit in the collection is furnished with 35-, 50-, and 90-mm lenses mounted on the turret, and a universal viewfinder—all contained in a custom-made leather carrying case.

It must be emphasized that over the past fifty years Leitz has made just about every conceivable accessory or gadget that could possibly be of value to photographers working with Leica cameras. Some of these are quite ordinary, such as accessory viewfinders for special lenses, microscope attachments, copying and close-up devices, and even film-processing equipment such as developing tanks and enlargers. Other, more specialized equipment would include accessories for stereo photographs and a few for making color-separation negatives. The latter device was, of course, made obsolete by the advent of color film. This type of equipment was never made in large quantities, and therefore it is among the more desirable Leica artifacts.

There is one item, however, that deserves special note. It is a possibly unique accessory for making four-color-separation negatives. Called the OMAG, it consists of four different-colored gelatin filters mounted one above the other between two glass plates. This filter strip slides up and down in a special mount that can be fitted over the front of a normal 50-mm Leica camera lens. One exposure is made through each filter

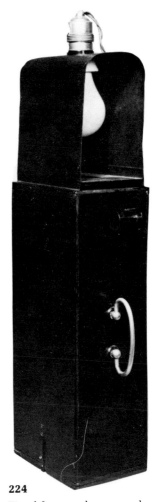

224

Fixed-focus enlarger made by Leitz around 1931. The 35-mm negatives were inserted in carrier under the lamp and projected through a 65-mm focal-length lens onto 3½-by-5½-inch printing paper at the bottom. Value, $500.

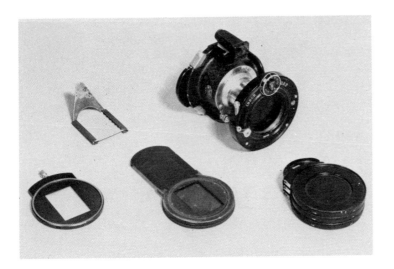

225

Accessory made by Leitz for making single exposures on cut film or glass plates has Ibsor leaf-type shutter and accepted Leica lenses. Shown with film holders, ground-glass screen, and (upper left) frame to hold film for developing. Made in 1936. Value, $2,000.

226

Accessories for taking or viewing stereo photographs with the Leica. *Top left:* Stemar stereo attachment with twin f/3.5 33-mm Elmar lenses. Made in Canada around 1960. Value $1,700. *Top center:* stereo viewer with 5x magnification, 1960. $300. *Top right:* Leitz stereo viewer, c. 1931. $400. *Bottom left:* f/3.5 50-mm stereo projector lens. Made in Canada. $350. *Bottom center:* pre–World War II Stemar stereo attachment with twin f/2.5 35-mm lenses. $1,500. *Bottom right:* stereo attachment for Leica Model D camera, c. 1933. $450. *Center:* stereo slide bar, c. 1931. $100.

227

The OMAG, a possibly unique attachment for making color-separation negatives through four different-colored filters which were shifted in front of the lens at each exposure. Early 1930s. Value, $500.

228

Two moderately long focal length Leica lenses with unusually large apertures. *Left:* f/1.5 85-mm Summarex, c. 1951. *Right:* f/2 90-mm Summicon, made around 1960. Both lenses are shown with lens hoods and accessory viewfinders.
Value, $400–$500 each.

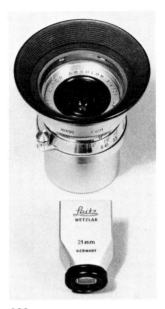

229
Super Angulon f/4 21-mm wide-angle lens with hood and viewfinder made around 1960. Value, $400.

230
Very rare f/2.2 90-mm Leica Thambar lens was ideal for portrait photography. When accessory disc (*bottom center*) was fitted to the lens, the center spot provided a soft focus effect. Value, $1,200.

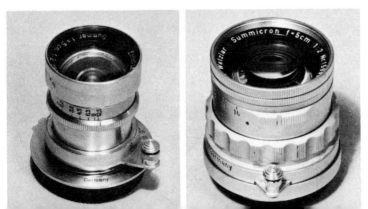

231
Leica f/2 50-mm Summar in rigid screw mount was made around 1936. Value, $1,800.

232
Leica f/2 50-mm Summicron in rigid bayonet mount. Made in 1960. Value, $350.

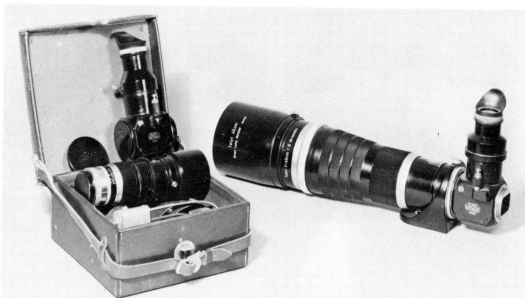

233

Two Leica telephoto lenses, both fitted with mirror reflex viewers. *Left:* 200-mm f/4.5 Telyt in fitted case, c. 1936. *Right:* 400-mm f/5 Telyt, postwar. Value, $200 and $400.

234

Japanese Canon camera, made in 1937, copied the Leica shutter and superstructure but used a Contax-style bayonet lens mount. Finder for normal 50-mm lens popped up for viewing. This example has f/4.5 Nikkor lens. Value, $400.

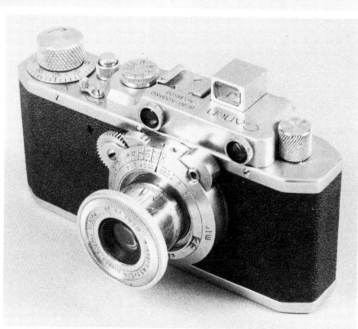

in succession, and from the color-separation negatives, color prints could be made. This filter strip and mount have their own leather-covered case which is marked "OMAG" FOUR COLORFILTER *for Leica Camera* E. LEITZ. *Inc.* NEW YORK. These markings may indicate that the OMAG was made only by or for the American branch of Leitz, and by the nature of its function it is obviously earlier than 1936, when Kodachrome became available for 35-mm cameras.

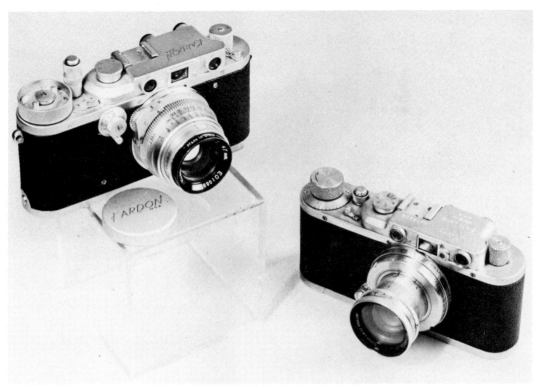

235 Left, Kardon, a Leica copy made in the United States around 1953, had Kodak f/2 47-mm lens. Value, $150.

236 Right, part-for-part copy of the Leica Model D, made in the Soviet Union around 1937. Known as the Counterfeit Leica. Value, $200.

Practically the entire range of lenses made by Leitz and other manufacturers for the Leica can be found in the Isenberg collection, and many of the rare or important ones are illustrated in this chapter.

Naturally, any successful product is bound to have its imitators, and the Leica is no exception. Therefore, any well-rounded Leica collection includes Japanese copies made by Canon, the American-made Kardon camera, and a Leica counterfeit made in the U.S.S.R. bearing full Leica markings which is a part-for-part knockoff of a Model D (chrome) Leica.

A factor which will probably influence the future value of collectible Leica cameras and accessories is the price at which current models are sold. A new Leica camera with a basic lens sells for more than $1,000 and each accessory lens is worth at least $300 to $500. Under these circumstances, a collector with modest means can invest perhaps $200 in a 1950s vintage Leica that will still give outstanding photographic results and have the added bonus of possible appreciation in value.

8

The Development of the 35-mm Camera

Although the Leica occupies a commanding position in the history of photography and is certainly among the premier collectibles, it was far from being the first commercially produced camera to use 35-mm film. The products of four other camera makers were marketed at least ten years prior to the commercial introduction of the Leica in 1925.

The consensus among photo historians is that the impetus to develop 35-mm still-cameras was caused by the availability of huge amounts of surplus 35-mm movie film. It was found that the motion-picture makers would accumulate short ends of unexposed film, generally up to fifty feet in length, which they were eager to sell at roughly one-third of the price of full rolls. It is not surprising, therefore, to find that the design of the earliest 35-mm cameras was influenced to some degree by the shutter and film-advance mechanism and the image size and format of ciné cameras.

In the time span between 1912 and 1915, at least four cameras were patented, manufactured, and sold commercially which represent the origin of 35-mm photography. Two of these were American-made, one was French, and the other German. The French camera, the

Homeos, differed from the others in that it was designed primarily to take stereo pictures but could take single photographs if desired. Also, the Homeos was normally held in a horizontal position, as was the Leica and almost all subsequent 35-mm cameras. The other three were usually held vertically, and the perforated film was fed from an upper full spool to a lower take-up spool or magazine. Except for the Homeos, the image size was the same as for motion pictures, 24 mm wide and 18 mm high, or half the Leica and subsequent 35-mm camera format of 24 by 36 mm. The size of the Homeos picture was 19 by 25 mm.

The first commercially produced 35-mm camera for which a patent was applied is the Tourist Multiple. The patent application was dated October 19, 1912, and on March 31, 1914, a patent was granted to Paul Deitz of Brooklyn, New York. It was made by the New Idea Manufacturing Company and marketed by Herbert and Huesgen Company, photographic distributors in New York City. The literature accompanying the Tourist Multiple stated that it used "Eastman Standard Perforated Film in Daylight loading Magazines" on which 750 photographs could be made—enough, it was claimed, to photograph for an entire summer or even on a world-encircling trip.

The camera was offered with a choice of three lenses: an f/3.5 Tessar, an f/3.5 Goerz Hypar, or a faster f/2.5 Steinheil Triplar. All could be focused from two feet to infinity, and the shutter speeds ranged from 1/40 to 1/200 of a second plus Time. The lensboard could be moved up or down to adjust for perspective, a most unusual feature for a small-format camera. Also available from Herbert and Huesgen was a projector with which the rolls of 750 exposures, made into positive black-and-white transparencies, could be shown. The camera and projector sold as a package for $250, and the camera alone for $175.

To secure the Tourist Multiple camera, the projector and original Tourist Multiple literature, Matt Isenberg made the most spectacular trade of his collecting career. In all, he traded thirty-one very desirable cameras, including a Kodak Ektra and many others

237
The first patent for a commercially produced 35-mm camera was applied for in October 1912 for this American-made Tourist Multiple camera. It took 750 half-frame pictures on a roll of Eastman motion-picture film.

with a value of from $200 to $300, for his Tourist Multiple outfit. The range of serial numbers on the few Tourist Multiple cameras that Isenberg has been able to examine leads him and other photo historians to believe that considerably fewer than a thousand of these cameras were made. This was partly due to the impact on travel caused by the advent of World War I.

The effect of World War I probably limited the production of the other pioneer American-made 35-mm camera, which was first advertised in February 1914. This was the Simplex camera and was made by the Multi-Speed Shutter Company on Long Island, New York. This company, which was in the movie camera and projector business, changed its name to the Simplex Photo Products Company shortly after introducing the Simplex camera. The Simplex shared many design and mechanical features with the ciné camera, which had been the company's principal business.

When loaded with about thirty-five feet of 35-mm sprocketed motion-picture film, the Simplex could take eight hundred half-frame 18-by-24-mm photographs or four hundred full-frame 24-by-36 mm pictures. In this regard it is important to note that the Simplex was the

first production camera designed to take a full-frame-size photograph on 35-mm film. This is the size that has become standard for all subsequent 35-mm cameras.

The Simplex was originally priced at $50, was raised to $65, and then dropped to $25 for a cheaper model which did not have the 800 half-frame option. The first version of these cameras offered an f/3.5 Bausch and Lomb 50-mm Tessar lens and a shutter with eight speeds from 1 second to 1/300 plus Time. Presently, the collection does not contain a Simplex, but Isenberg does own some of the first advertisements and original literature pertaining to the camera. From these sources and by examining a few specimens in other collections, Isenberg has been able to reconstruct the history of the manufacturer and the specifications of the camera.

The first German-made 35-mm camera appeared in 1915 and was made by Levy-Roth in Berlin. This was the Minnigraph, the smallest of these early 35-mm cameras; measuring only 5 inches high, 2 inches wide, and 2½ inches deep, it was also the simplest. It has an f/3 lens and only one shutter speed of 1/30 of a second plus Time. Exposure of the fifty half-frame-size pictures could be controlled only by varying the lens aperture. Fastened to the side of the leather-covered body was a metal plate with three tables to consult in figuring proper exposure. One table gave a numerical value for the month and hour of the day, to which was added a value from the second table listing subject matter (architecture, landscape, portrait, and so on) and a value for the atmospheric conditions. The sum of these numbers was translated in the third table to the recommended lens opening and shutter speed. Any exposure longer than 1/30 of a second, of course, had to be timed by the operator. Like its American counterparts and the French Homeos camera which will be discussed next, the Minnigraph was not produced in huge quantities. As far as can be determined, only about three thousand were made.

The patent application date of the Homeos, September 20, 1913, gives it the distinction of being the second commercially produced 35-mm camera and the first to use that size film to make stereo photographs. It was

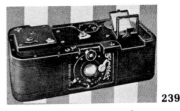

239

Illustration of the Simplex 35-mm camera from a sales display card supplied to dealers around 1914. Simplex took either eight hundred half-frame or four hundred full-frame pictures on a single roll.

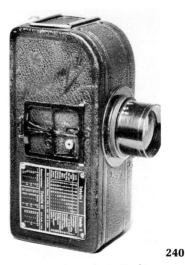

240

Minnigraph made in Berlin, Germany, about 1915. It took fifty half-frame photographs. Exposure was computed by referring to three tables attached to camera body. Value, $1,200.

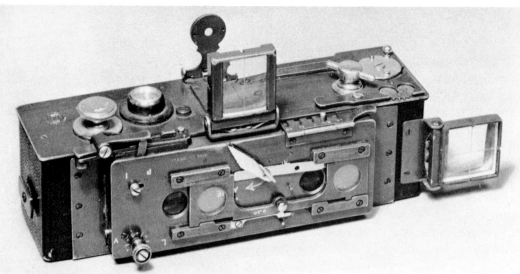

241

Homeos, first camera to take stereo photographs on 35-mm film. Made in Paris by Jules Richard from 1914 to about 1921. Could be held vertically or horizontally and was also capable of taking single photographs. Value, $2,000.

manufactured by Jules Richard of Paris, who had made other stereo cameras and viewers and who was partially responsible for the design. The Homeos produced twenty-seven pairs of 19-by-25-mm stereo pictures or fifty-four single photographs of the same size. The exposed metal parts of the leather-covered body had a silver-blue, oxidized finish. The camera was equipped with a pair of fixed-focus Krauss f/4.5 Tessar lenses plus a pair of close-up lenses which could be shifted into place in front of the regular lenses. This allowed photographs to be taken as close as eighteen inches. The shutter had six speeds, adjustable from 1/10 to 1/142 of a second plus Time. Lens apertures were controlled by a series of graduated-size holes punched into a metal strip which was moved horizontally behind the lens and the shutter. The perforated 35-mm film was wound on metal spools furnished with a paper leader in order to permit daylight loading of the camera.

A particularly sophisticated feature of the Homeos was that it could be disassembled into practically all of its component parts without the use of any tools. This allowed easy access for cleaning, service, or replacement of a defective part. A reference advertising the Homeos for sale appeared in a 1921 copy of the *British Journal Photographic Almanac*, which offered the camera for £50, or about $250. This would indicate that the Homeos, of the four original 35-mm cameras,

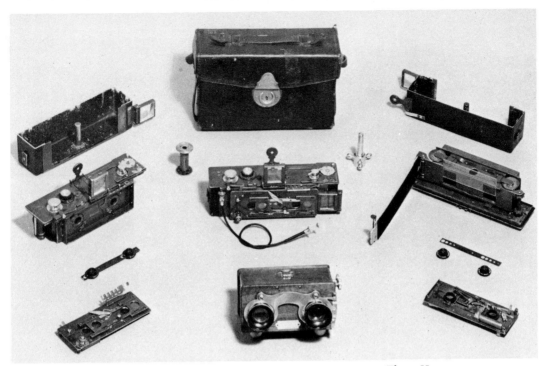

242 Three Homeos cameras, with two on either side broken down into their major components. This could be done without tools. *Lower center:* stereo viewer for pictures taken with this camera.

had survived after World War I and that manufacturing was resumed. However, it must have been discontinued shortly thereafter, and various authorities have put the total production of the Homeos camera at less than a thousand.

Although all of these landmark 35-mm cameras are very rare, Isenberg does own two Tourist Multiple cameras, one a complete outfit in its original case—a Minnigraph—and three Homeos, plus a stereo viewer for the latter. The absence of a Simplex in the collection and the hope of acquiring one is one of the things that maintains Isenberg's interest in collecting.

From the mid-1920s and the success of the Leica, millions of 35-mm cameras have been made by hundreds of manufacturers in just about every technically competent country in the world. Many of these were copies of existing designs, such as the knockoffs of the Leica, and very few were truly innovative. While Isenberg owns scores of these 35s from the 1920s through the 1950s, most of them have been relegated to a basement showcase or to attic drawers. The few that he does prize from this period are some of the rarities and

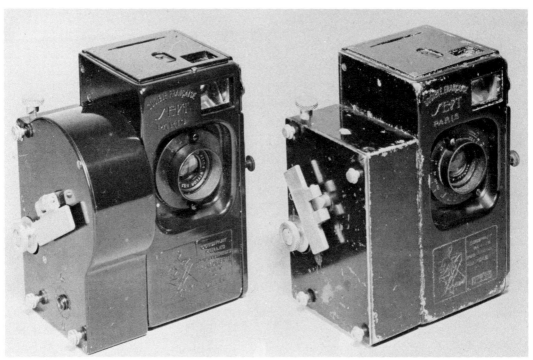

243

Two models of the Sept, a French camera employing a spring-wound motor to advance half-frame 35-mm film automatically. Could be used as motion-picture camera or single-exposure. *At right:* original type first made in 1922. *At left:* 1925 model with larger spring motor. Value, $150.

the cameras that have contributed significantly to the advance of photographic technology.

The 1920s marked the appearance of several 35-mm. cameras other than the Leica that are of interest to collectors. One of these is the French Sept camera, which was introduced in 1922. It was made to take a cassette which held enough perforated 35-mm film for 250 18-by-24-mm or half-frame photographs. Essentially a motion-picture camera in concept, the Sept had a spring-wound motor which permitted photographs to be made in rapid succession. However, it could also be used as a still camera for single exposures. Its versatility was somewhat limited by a shutter which operated at only 1/60 of a second, requiring exposure modification by adjustment of the lens aperture.

To its credit in terms of flexibility, by opening the back of the camera and introducing a suitable light source, the Sept could be used as a projector for positive images or as an enlarger for making prints from negatives.

The camera was equipped with an f/3.5 lens and both waist- and eye-level optical viewfinders. In 1925, the Sept was modified to accept a larger, more power-

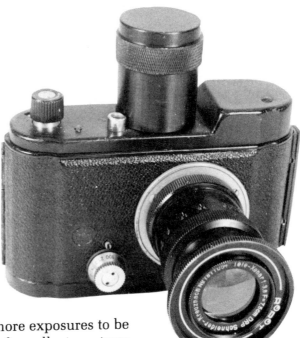

244
Wartime model of German Robot camera made for the Luftwaffe. Larger than usual spring motor at top of camera body permitted forty 24-by-24-mm photographs to be taken in rapid succession. Made around 1943. Value, $200.

ful spring motor which permitted more exposures to be made before rewinding. Its interest for collectors stems from the fact that the Sept was the first 35-mm camera to use an automatic film advance and was the forerunner of the Robot and all other 35-mm spring or battery-powered film-advance and shutter-cocking systems.

The Memo was an American-made 35-mm camera introduced by the Ansco Company of Binghamton, New York, early in 1927. For the low price of $20, the Memo offered an f/6.3 lens, five shutter speeds from 1/5 to 1/100 of a second, plus Time and Bulb, an optical eye-level viewfinder, and a counter which indicated the number of half-frame exposures taken on the fifty-exposure film cassettes. All of these features were contained in a compact 2⅛-by-2⅝-by-4½-inch leather-covered wooden body. Later models came with an f/3.5 Agfa Anastigmat lens and can further be identified by a metal guard next to the shutter release which prevented tripping the shutter accidentally. A popular variation of the Memo is the Boy Scout model, which had an olive-green finish to the case and was sold through the Boy Scouts of America's marketing operation.

Around 1932, the prestigious optical firm of Carl Zeiss made its entry into the 35-mm camera market. Zeiss had been a precision optical instrument and lens

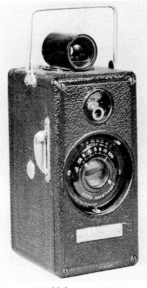

245
Memo, half-frame 35-mm camera first made by Ansco of Binghamton, New York, in 1927. This is a slightly later model with an f/3.5 lens and a guard to protect shutter release from tripping accidentally. Value, $50.

maker for at least as long as E. Leitz, but waited until then before introducing its Contax line of cameras. Although some collectors feel that in certain technical respects the Contax was superior to the Leica, Zeiss was never able to achieve a sales figure much greater than 15 percent of the total number of Leicas sold during the 1930s.

The Contax employed an all-metal tamboured focal-plane shutter which opened and closed vertically like a window shade and permitted shutter speeds faster than 1/1000 of a second on later models. It was the first popular 35-mm camera to introduce quick-changing bayonet-mount lenses, and the first to build an exposure meter into a 35-mm camera and combine the range finder and viewfinder in a single viewing window. It was also the first to offer the ultrafast f/1.5 Sonnar lens. A full line of accessories was also available to Contax users. None of these innovations seemed to make any appreciable difference in the sale of Leicas or enhance

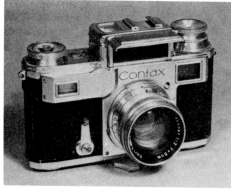

246

Contax III, 1938 model of the Contax line of 35-mm cameras first made in 1932 by Zeiss Ikon to compete with the Leica. This model has built-in exposure meter at the top of the camera. Value, $100.

247

Telephoto lens, 180-mm f/2.8, made for Contax camera by Zeiss Ikon for use at 1936 Olympics held in Berlin. Shown with reflex mirror housing and fitted leather case. Value, $400.

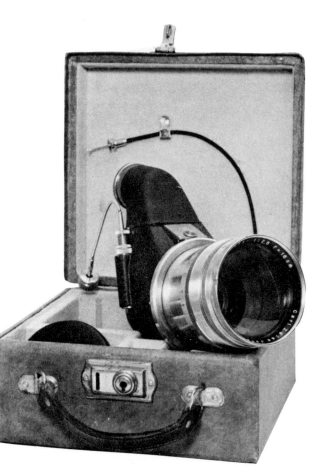

the appeal of the Contax to collectors to any noticeable degree.

Zeiss did make one particularly glamorous 35-mm camera in the mid-1930s that most collectors are eager to own. This was the Contaflex, a 35-mm twin-lens reflex camera. Obviously patterned after the Rollei design, it used the Contax shutter and could accommodate, in special mounts, the full range of lenses that Zeiss had developed for the Contax. One of the main reasons the Contaflex is considerably rarer than the Contax is its high original selling price; so, obviously fewer were sold in those economically depressed times.

A Contaflex can presently be bought in the collectors' market for perhaps $300 to $500. This is for the camera body equipped with what is generally thought of as its standard lens, an f/2 50-mm Zeiss Sonnar. In the Isenberg collection are three Contaflexes, all of the optional accessory lenses including a 35-mm wide-angle f/3.5 Tessar, an f/3.5 50-mm Tessar, an f/1.5 50-mm Sonnar, an f/2 85-mm Sonnar, an f/4 85-mm

248

Three Contaflex 35-mm twin-lens reflex cameras. Camera at right is shown with accessory back for single exposures. Included in photograph are all of the seven lenses Zeiss Ikon supplied for the Contaflex. Made in mid-1930s. Value, camera with 50 mm lens $450. Camera with seven lenses, plate back, and carrying case $1,500.

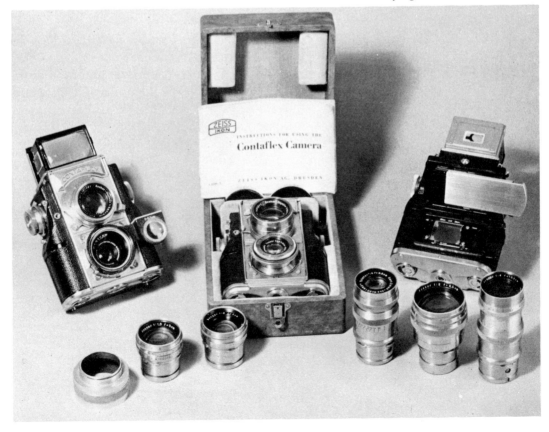

Triotar, and an f/4 135-mm Sonnar. There is also an accessory viewfinder for the wide-angle lens, a ground-glass viewing back for making single exposures on plates, plus an original carrying case and instruction booklet.

The Contaflex is a most impressive-looking piece of photographic machinery, but its acceptance by amateur and professional photographers lagged in comparison with the easier-to-use, less-conspicuous range finder 35-mm cameras.

During the 1930s other German 35-mm cameras appeared, such as the Peggy in 1933, the Super Nettel and Tenax cameras made by the Zeiss Ikon conglomerate, and the line of Retina 35-mm cameras made by Kodak at their works in Stuttgart. The unusual feature of the Peggy was that its pop-out bellows front had to be squeezed in slightly toward the camera body in order to cock its Compur shutter. It required special 35-mm film cassettes and was equipped with a built-in knife to cut the film at any point and process the exposed portion, which wound into a lighttight receptacle.

The Super Nettel could be thought of as a folding version of the Contax in that it had the same focal-plane shutter and a coupled range finder, but it lacked the facility to accept interchangeable lenses. The Tenax was a square format (24-by-24-mm) camera making fifty exposures on a standard thirty-six-exposure cartridge. It was a rigid-body range finder–focusing camera equipped with a lever at the side of the lens which, when depressed in a single stroke, advanced the film and cocked the shutter.

249

Peggy, German 35-mm camera, c. 1933. Compur shutter is cocked by squeezing front of camera inward. Film could be cut with built-in knife, and exposed portion of roll developed without wasting the balance of the fifty-exposure cartridge. Value, $350.

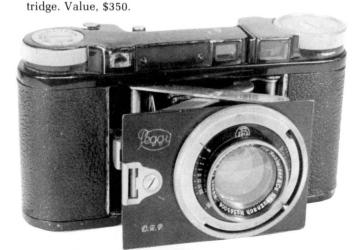

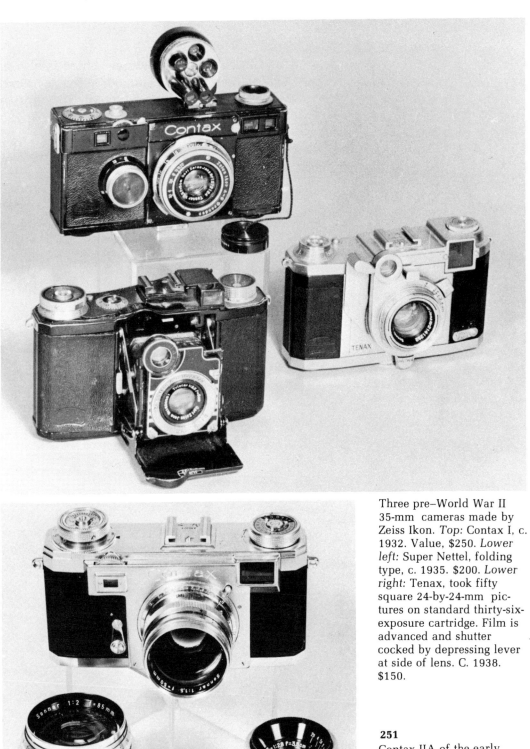

250

Three pre–World War II 35-mm cameras made by Zeiss Ikon. *Top:* Contax I, c. 1932. Value, $250. *Lower left:* Super Nettel, folding type, c. 1935. $200. *Lower right:* Tenax, took fifty square 24-by-24-mm pictures on standard thirty-six-exposure cartridge. Film is advanced and shutter cocked by depressing lever at side of lens. C. 1938. $150.

251

Contax IIA of the early 1950s fitted with f/2 50-mm Opton lens and showing f/2 85-mm Sonnar lens at left and f/2.8 35-mm Biogon lens at right. Value of outfit, $300.

252

Contarex, single-lens reflex 35-mm Zeiss Ikon camera made in the 1960s. Exposure meter at top center of camera is coupled to lens. *Left:* f/4 135-mm Sonnar lens. *Right:* f/4.5 21-mm Biogon lens. Value, $400.

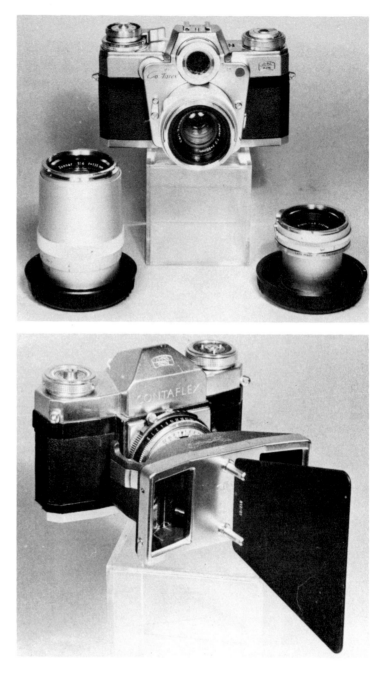

253

Contaflex I of the mid-1950s fitted with Zeiss Steritar stereo attachment. Value, camera and attachment, $100.

The Foton is a fairly unusual camera made in the United States by Bell and Howell starting in 1948. Bell and Howell were best known for their amateur movie cameras and projectors, and the Foton was their attempt to market a still-picture photographic system. When this effort failed, Bell and Howell undertook the

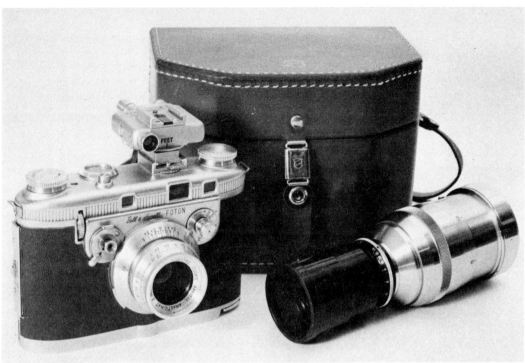

Foton, made in United States by Bell and Howell, c. 1948. This 35-mm camera featured a spring-wound film advance and was equipped with an f/2 British-made Cooke lens. At right is very rare f/5.6 216-mm Cooke telephoto lens which was also supplied for the Foton. Value of outfit as shown, $650.

United States distribution of the Japanese-made Canon cameras in which they were successful for a number of years.

The body of the Foton is slightly taller than a Leica to house its spring-wound film advance. It has a coupled range finder, and the focal-plane shutter has speeds from 1 to 1/1000 of a second, plus Bulb. The lens is an English-made 50-mm f/2 Cooke Amotal. What is especially rare about this Foton outfit is the 216-mm f/5.6 lens that very few collectors know was made for the camera. This telephoto lens is accompanied by an accessory viewfinder which can be calibrated for parallax compensation.

By the early 1950s, the Japanese camera industry had begun to make inroads on the sale of German-made precision miniature cameras. One of the 35-mm cameras responsible for this drastic turn-around was the Model SP Nikon. Introduced in the mid-1950s by Nippon Kogaku, the SP evolved from Nikon cameras first made in 1951 that were obvious copies of the Contax design. With the SP, however, Nikon entered the world market with a fully integrated photographic system offering as wide a choice of fine lenses and accessories as

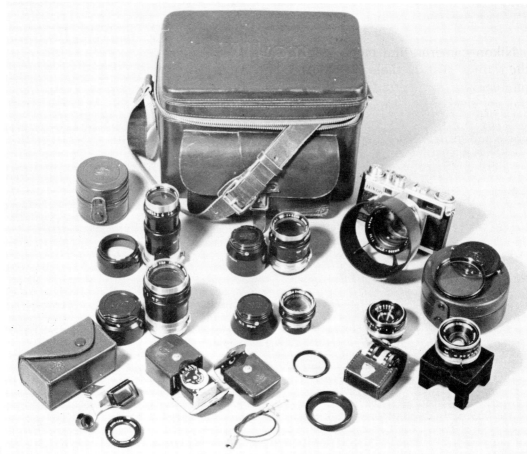

255

All of the Nikon equipment in this photograph can be stored inside Nikon carrying bag. The camera is a Nikon SP, made around 1954. It is a precision adaptation of the Contax design. Value of outfit, $1,000.

anyone, and selling, at that time, for considerably less money.

The SP was a range-finder camera with speeds from 1 to 1/1000 of a second and could be fitted with an incredibly fast f/1.1 Nikkor lens. The full range of other lenses of varying focal lengths were all highly acclaimed for their superior optical characteristics.

The Nikon SP is not an especially rare camera, but as more collectors begin to specialize in Nikon equipment, its value is likely to rise quickly. The SP in the Isenberg collection is accompanied by many of the lenses originally available with it, plus most of the other accessories such as a clip-on exposure meter, extra viewfinders, filters, and a leather Nikon carrying case into which the SP, seven lenses with sunshades and cases, and about a dozen other accessories could be fitted.

Nikon cameras first came into prominence during the Korean War, in the early 1950s. Combat and news photographers passing through Japan on their way to the conflict bought the cameras, and their enthusiasm was quickly transmitted to the rest of the professional and amateur market. The year 1959 marked the beginning of Nikon's dominance of the 35-mm field with the appearance of the Nikon F, its first single-lens reflex camera. Subsequently refined by Nikon, and the design adapted by almost every other maker of small cameras, the single-lens reflex is today the most popular of all 35-mm camera types.

The 35-mm cameras described here are some of the more important items in this part of the collection. Such popular makes and models as the Argus A and C series, the 35-mm Exaktas, Bolseys and the Voigtlanders all sold in great numbers and contributed significantly to the popularity of miniature photography. While examples of these cameras and many more are in the collection, they are not discussed here because the supply is still far too plentiful to place them among the more desirable collectibles. A separate chapter has been devoted, of course, to the Leica, and the rare Kodak Ektra and more common Retinas have been included in the discussion of the products of the Eastman Kodak Company.

256
Swiss-made Alpa Reflex appeared about the time of World War II. Focused either with waist-level ground-glass viewer or range finder. This model has a French-made f/2.9 50-mm Angenieux lens in an interchangeable bayonet mount. Value, $125.

Single- and Twin-Lens Reflex Cameras

Some historians place the origin of the camera obscura in its box form as early as the middle of the sixteenth century. Thus the optical principles involved in designing a reflex-type photographic camera had been around for about three hundred years before Daguerre's announcement in 1839. However, it was more than forty years after that date before any reflex camera was built and sold in commercial quantities.

Like the camera obscura, the lens of a single-lens reflex camera focuses an image on a mirror tilted at a 45-degree angle. The mirror, in turn, projects the image rightside up, but transposed laterally, to a ground-glass viewing screen. In order for this system to work photographically, the mirror must be removed before a shutter is opened to allow the image to reach the sensitized film or plate. This is a more complicated arrangement than the twin-lens reflex camera, in which there are separate lenses, one above the other, for viewing and taking the photograph. This makes the camera section mechanically independent of the viewing system and allows the mirror to remain in a fixed position.

Therefore, it is somewhat surprising that the earliest reference to a reflex camera is of the single-lens vari-

ety. This camera was patented in 1861 by Thomas Sutton, an English inventor, and described by him in a paper delivered in 1865. No examples of Sutton's camera have yet been found, and it is assumed that few if any were ever made.

The earliest commercially produced American single-lens reflex camera is the Patent Monocular Duplex, patented in 1884 by Calvin Rae Smith of New York City. Advertisements for the Monocular Duplex appeared as early as December 1884 and listed the distributor as E. W. Smith, possibly a relative of the inventor, of 42 John Street, New York City. The camera was subsequently patented in England and France, and later advertisements and brochures refer to it as the "artist's camera."

In the Monocular Duplex the mirror which transmits the image to the ground-glass focusing screen is attached to a curved metal blind, part of which is cut away to form a horizontal slit. When the shutter is released, the mirror swings upward and carries the blind with its open portion past the rear of the lens.

257 Only known example of C. R. Smith's Patent Monocular Duplex, the first commercially produced single-lens reflex camera, originally introduced in 1884. Made to take film plates and also the Eastman-Walker roll-film holder. Shutter is attached to reflex mirror, and film is exposed as mirror is raised. Value, $6,000.

258
Maker's plate on rear of lid of Monocular Duplex camera.

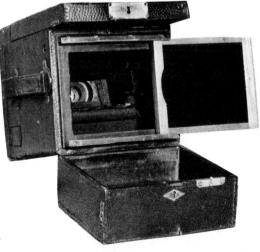

259
Rear view of Monocular Duplex, showing mirror raised and shutter open. Chamber behind plate holder stored extra plates.

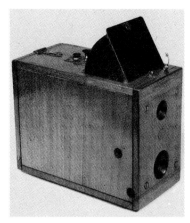

260 Simplex-Magazin camera designed by Dr. Rudolph Krugener of Germany around 1890. Viewing lens on this twin-lens reflex did not focus. Film plates stored in a magazine could be changed internally. Value, $1,500.

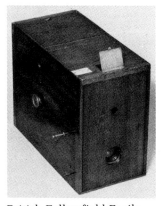

261 British Fallowfield Facile, made around 1890, though not a true reflex can be viewed through large reflex viewing window. Value, $1,000.

This allows light to reach the film before the blind is moved farther upward and the exposure terminated.

The Patent Monocular Duplex was first made for dry plates but between 1887 and 1890, when it would seem that the camera was discontinued, it was also available with a forty-eight-exposure-capacity Eastman roll-film holder. At its original retail price of $55, the Monocular Duplex was very well made, with a good-quality leather covering over the wooden body which was stitched along all the edges of both sides of the camera instead of being completely glued. Interior surfaces of the front and rear panels were velvet-lined. Two keys were furnished with the camera: one locked the lid to the plate-holding chamber at the rear; and the other, inserted in the side of the camera, reset the mirror, cocked the shutter, and governed the tension of the spring-loaded shutter.

Although C. R. Smith's Monocular Duplex was manufactured for at least six years in four sizes and was widely advertised in the United States, England, and France, the only known existing example is in the Isenberg collection. This Monocular Duplex takes 4-by-5-inch plates and is thought to have been made around 1885 or 1886. It was found by a dealer-collector in a New York flea market, where it had been lying around unnoticed for three days before being discovered. The thrill of coming upon such rare photographic treasures in unexpected places keeps many collectors in the chase. However, it is the knowledgeable collector who recognizes the important items when he or she is fortunate enough to find them.

In Europe, most of the early development of reflex cameras appears to have been concentrated on the twin-lens type. In the late 1880s, the prolific German inventor Dr. R. Krugener brought out his Simplex-Magazin camera. This was a twin-lens wooden box camera in which the lens taking the picture could be focused, while the viewing lens could not. It was loaded with a magazine holding twenty-four plates which could be changed inside the camera body. About the same time, an English twin-lens camera, the Fallowfield Facile, appeared which was similar to the Sim-

262
The Facile could be carried and operated concealed inside a paper sack.

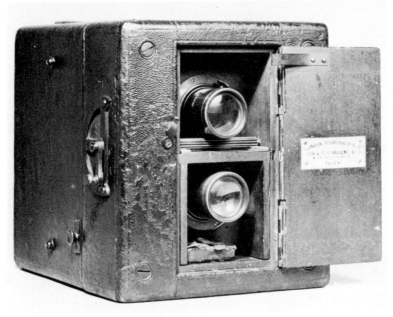

263
Le Cosmopolite was made in Paris in the late 1880s. This example was sold in England by the London Stereoscope Company. Value, $800.

plex but was more oriented to the detective style in its use. The top-opening reflex viewer was quite small, did not provide the same size image as the film size, and was meant to be carried inside a paper wrapping to conceal its function.

Before 1890, a French twin-lens reflex camera, Le Cosmopolite, appeared which provided 1:1 viewing-and-taking images with coupled focusings. It was marketed in England by the London Stereoscope Company, which was active in the last decade of the nineteenth century in promoting the sale of twin-lens cameras for both mono and stereo purposes. Two British twin-lens reflex cameras of this period sold by the London Stereoscope Company were the Carlton and the Ross. The Ross in the Isenberg collection is equipped with a Thornton-Pickard shutter and bears the label of Robinson and Company, a Singapore dealer. Thus it can be surmised that British cameras found their way to all parts of the empire.

At the turn of the twentieth century, American camera makers were still refining the single-lens reflex camera, and in 1890, C. R. Smith, who invented the Monocular Duplex, patented another camera which was known as the Patent Reflex Hand Camera. Actual

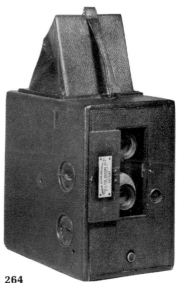

264
British-made Carlton twin-lens reflex of the early 1890s. Value, $750.

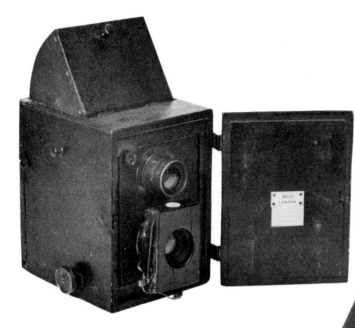

265

This British Ross twin-lens
reflex is equipped with a
Thornton-Pickard shutter.
Camera bears label of a
Singapore dealer. Made
around 1890. Value, $750.

266

Patent Reflex Hand Camera,
made around 1898. De-
signed by C. R. Smith, in-
ventor of the Monocular
Duplex. Made in Yonkers,
New York, by the Reflex
Camera Company. Value,
$550.

manufacture of this camera began several years later
in Yonkers, New York, by the Reflex Camera Com-
pany, and it continued to be made in various models
until about 1912. The demise of the Patent Reflex and
the Premo single-lens reflex camera made in Rochester,
New York, was hastened by the popularity achieved by
the Graflex, the ultimate American single-lens reflex
camera.

The Graflex was a product of the Eastman Kodak
Company from 1907, when Eastman acquired the Fol-
mer and Schwing Company, until the mid-1920s, when
it was forced to divest itself of this division as a result

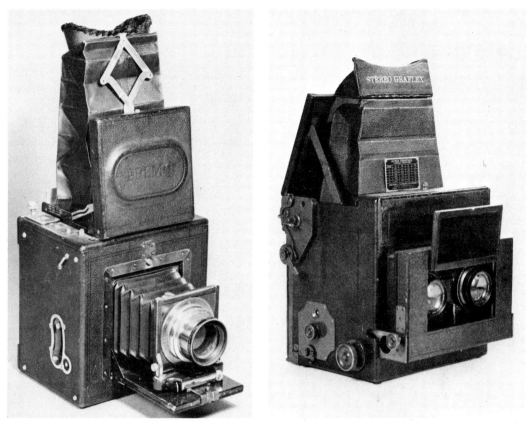

of a federal antitrust suit. Besides the enormous marketing resources of Eastman Kodak, the Graflex had the advantage of a superior focal-plane shutter designed by Folmer and Schwing and a more compact and serviceable focusing arrangement. Its acceptance by press, professional, and serious amateur photographers was overwhelming and left little room for other cameras of this type.

It was the British, however, with a heritage of superior craftsmanship in the marriage of brass to wood, who produced the most beautiful specimens ever made of single-lens reflex plate cameras. This perfection can be seen in the Soho Reflex and the Adams Minex cameras in the collection. Both are tropical models—that is, made mostly with clear-coated teakwood or other hardwood bodies, with high-grade leather used only in the bellows and viewing cones. Brass parts are brightly polished and lacquered, and the manner in which the

267
Premo single-lens reflex, c. 1906. Made by Rochester Optical Company, a firm more noted for view cameras, this type was made for only two years and is thus quite rare. Value, $600.

268
Rare stereo version of the Graflex, a camera that was the accepted standard of American press and professional photographers from 1910 to 1930. This camera has twin f/4.5 Bausch and Lomb Tessar lenses and a rising and falling front. Front cover pops open when camera is racked out. Value, $1,750.

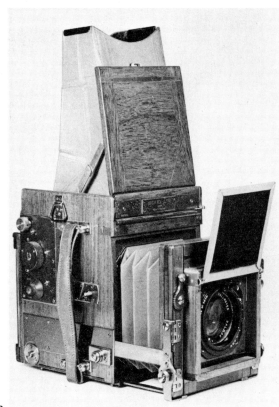

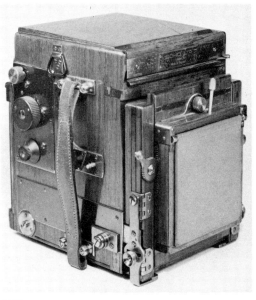

270
Soho camera closed for
storage or carrying.

269

One of the finest examples
of British camera craftsman-
ship is this tropical-style
reflex camera made by
Soho, Ltd., around 1930.
Value, over $2,500.

cameras focus or the way the viewing hoods extend or
store bespeaks careful design and precision construc-
tion. Cameras of this type and quality were made in
England from about 1905 until shortly after World War
II.

By the late 1920s, Zeiss Ikon had made its entry into
the single-lens reflex market with the Miroflex. This
was a flat-folding camera with a long viewing hood
which unfolded from the top of the camera. For less
critical work, the hood remained closed and the
photograph was framed by the use of a rear metal sight
aligned with a wire-frame finder which pulled out of
the front panel of the camera. The Miroflex was quite
successful on the European continent until it went out
of production in 1936.

Early in the 1920s, before its merger into the Zeiss
Ikon complex, the Ernemann Camera Works in Ger-
many produced a stereo camera for 45-by-107-mm
plates. The unusual feature of this camera was that it
used a single-reflex system for focusing one of the

271
Adams Minex, c. 1930,
impeccably finished tropical
folding reflex camera in the
tradition of the best of
British-made cameras.
Value, over $3,000.

272
Viewing hood folds out
elegantly 180 degrees from
stored position.

273
Typical German stereo
reflex camera of the mid-
1920s, made by Ernemann
before merger with Zeiss
Ikon. Lens without reflex
viewer has wire-frame
direct viewfinder. Value,
$600.

274
The Miroflex, made by Zeiss
Ikon in the late 1920s, was
a very popular European
press camera. With hood
folded, it could also be used
with wire-frame direct
viewfinder. Value, $200.

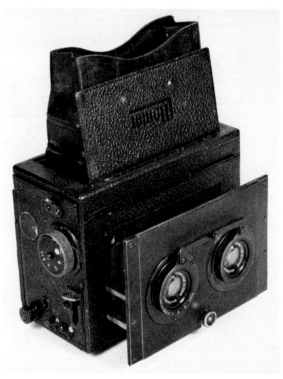

275

Operator of the German Mentor stereo reflex of the mid-1920s could view both images. Value, $450.

lenses. Obviously, if one lens was in focus, the other, mounted in the same plane, would also focus at the same distance. This arrangement was no doubt practical, but it made for an awkward, unbalanced-looking camera.

This Ernemann stereo camera was a simplification of the viewing system of the Mentor stereo reflex camera that was made in Dresden a few years prior to the Ernemann. By looking down into the reflex-focusing hood of the Mentor, the operator saw both images produced by the pair of stereo lenses. Apparently, the Ernemann engineers did not feel that this dual-image capability was necessary.

A third type of reflex viewing system for stereo cameras being marketed prior to 1920 was to have an enormous influence on the design of subsequent twin-lens reflex cameras. This was the triple-lens stereo camera with two lenses for taking the stereo photograph with the third lens in the middle for focusing. This concept developed from the Verascope, a French stereo camera made by Jules Richard before 1900. In the Verascope, the center-mounted reflex viewing lens acted as little more than a waist-level finder. It remained for the German Voigtlander Stereflektoskop of

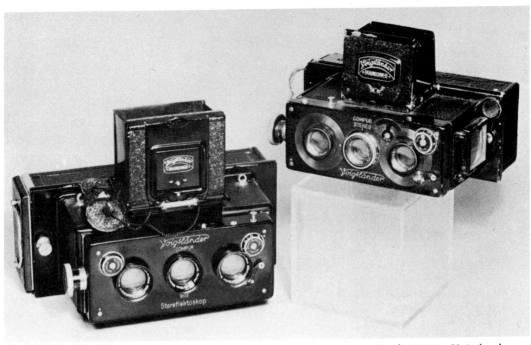

276

1913 and the later Franke and Heidecke Heidoscop to
provide almost full-size images through the reflex
focusing system of their stereo cameras.

Both these cameras were made primarily for glass
plates held in metal holders, and it was not until 1926
that Franke and Heidecke modified their Heidoscop
stereo camera to accept roll film. This new stereo
camera was called the Rolleidoscop and took pairs of
6-by-6-cm photographs on 120 roll film. One year later,
in 1927, a smaller Rolleidoscop using 127 vest-pocket-
size roll film appeared. By doing away with one of the
stereo lenses and placing the viewing lens above the re-
maining picture-taking lens, the Franke and Heidecke
designers transformed the stereo Rolleidoscop into the
world's most popular twin-lens reflex camera, the Rol-
leiflex.

The first Rolleiflex cameras were made in 1929 and
took six 2¼-inch-square photographs on 117 film. In
1931, a smaller model, the Baby Rolleiflex, for 127 film
appeared, and certain refinements were added. Most
important of these was a handle on the right side of the
camera body which, when cranked rapidly, advanced
the film for the next exposure. The basic Rollei design
has remained the same for almost fifty years and has

187

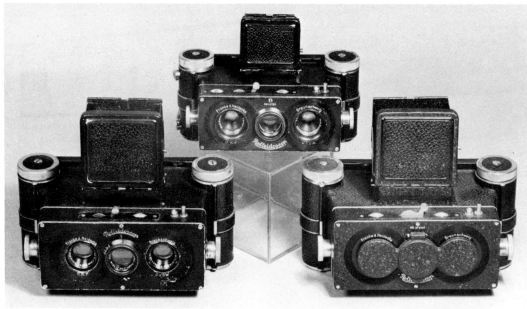

277

These three Rolleidoscop cameras were late 1920s roll-film adaptations of earlier Heidoscop stereo reflex cameras made by the same company, Franke and Heidecke of Braunschweig, Germany. *Top center:* rare "baby" Rolleidoscop for 127-size film. Values, $800 to $1,500.

been the prototype for dozens of other makes of twin-lens reflex cameras produced all over the world.

The Rollei line of twin-lens reflex roll-film cameras maintained its popularity after World War II and prompted copies by many other manufacturers. Kodak's entry, the Kodak Reflex, lacked refinement, but Ansco tried to compete with its Automatic Reflex camera. Made from about 1948 to 1952, the Ansco twin-lens reflex had an automatic film-advance crank similar to the Rolleiflex's, an f/3.5 lens, and shutter speeds to 1/400 of a second. It was a well-made American camera that is still appreciated by collectors.

The Ikoflex marked Zeiss Ikon's entry, in 1934, into the twin-lens reflex market. For an organization as technically competent as Zeiss, the first Ikoflexes were remarkably unpretentious. They were equipped with a slow f/6.3 Novar lens and a Derval shutter with speeds only as high as 1/100 of a second. Three years passed before the Ikoflex was available with a Zeiss Tessar lens and a Compur shutter. Apparently, Zeiss must have put all of their engineering skill into the development of the Contaflex, the supreme 35-mm twin-lens reflex camera, which appeared about 1935.

In the 1930s, some odd variations of the twin-lens design appeared which employed a bellows type of

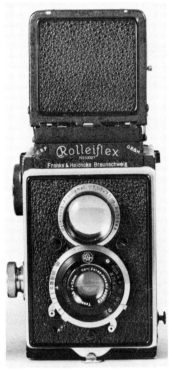

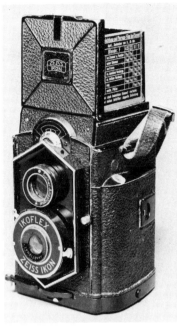

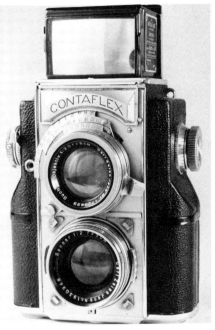

279

First model of Zeiss Ikon's Ikoflex, c. 1934. Although made to compete with the Rollei, it was far less technically sophisticated. Film was advanced from right to left, rather than vertically, an unusual design departure for this type of camera. Value, $100.

280

Although commercially unsuccessful, the Zeiss Ikon Contaflex twin-lens reflex 35-mm camera was an engineering triumph. One operating drawback was that it was almost impossible to take a picture with a vertical format. Value, $450.

278

The Rolleiflex, the first of what was to become an enormously influential line of twin-lens reflex cameras. This 1929 model took six 2¼-inch-square pictures on 117 roll film. Value, $125.

281 Four models of the baby Rolleiflex for 127 vest-pocket-size film. *Right to left:* 1933 model, 1939 model with internal shutter and accessory flange on lens mount, post–World War II gray-finish Rollei, black baby Rollei of the 1950s. Gray-model value, $60; black cameras, $100 and up.

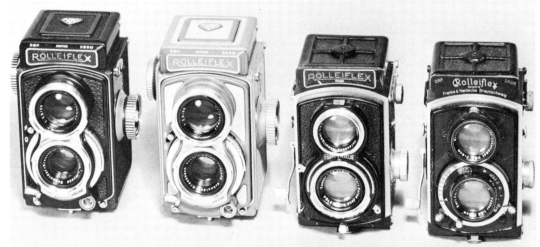

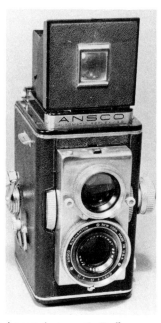

282 Ansco Automatic Reflex, made around 1947. Well-made American version of Rollei-style twin-lens design. Value, $150.

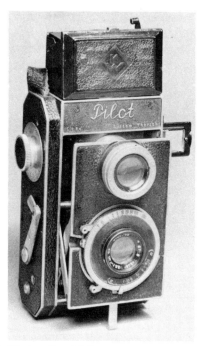

283 Pilot, a flat-folding bellows-type twin-lens reflex camera. Made in Germany around 1931. Camera took 127 roll film and offered a wide range of lenses as fast as an f/2 Zeiss Biotar. Value, $300.

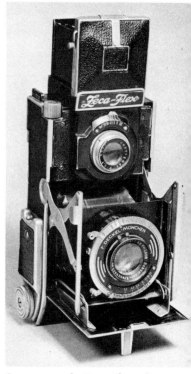

284 German-made Zeca-Flex of the mid-1930s used 120 film for twelve 2¼-inch-square pictures. Design appears awkward. Value, $350.

folding camera with a reflex focusing viewing lens. Their only advantage was that since the bellows could be compressed into the camera body, these cameras were less bulky than the boxy Rollei bodies. In this group was the Pilot, a compact camera which used 127 roll film and offered a range of lenses from an f/3.5 to an f/2 Zeiss Biotar, all mounted in Compur shutters.

A less common folding twin-lens reflex of the 1930s was the Zeca-Flex. Like the Pilot, it was made in Germany, but it was much bulkier. This was due to its

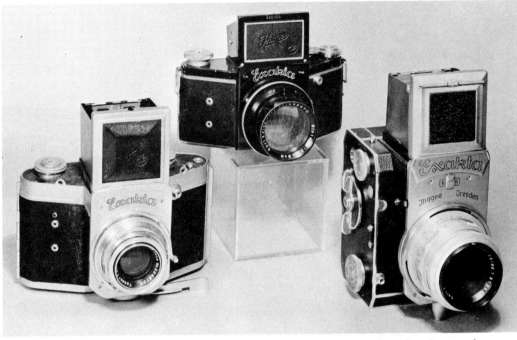

Three less frequently seen single-lens reflex Exakta roll-film cameras made by Ihagee of Dresden, Germany. *Top center:* Night Exakta took 127 film and had f/2 Zeiss Biotar lens, c. 1936. Value, $250. *Left:* post–World War II large-format Exakta took 120 film. Value, $250. *Right:* 1950s Exakta; 120 film is advanced vertically rather than horizontally in typical Exakta cameras. Value, $250.

larger film size, 120, and its focusing arrangement, which separated the viewing lens mounted in the body from the picture-taking lens which was attached to a bellows. It gives the appearance of a camera designed by a committee.

Another important manufacturer of reflex cameras both before and after World War II was the Ihagee firm of Dresden, Germany. Their Exakta line of compact single-lens reflex cameras sold extremely well both in their "vest-pocket" models for 127 roll film and in the Kiné Exakta series for 35-mm film. Less common variations are the prewar vest-pocket Night Exakta with a Zeiss f/2 lens and the larger models using 120-size roll film for 2¼-inch-square pictures. Significant in this latter group are the large 120-size Exakta in which the film travels horizontally in typical Exakta fashion, and the postwar model for vertically advanced 120 roll film. This vertical-style Exakta works very much like the popular Swedish-made Hasselblad and the Kowa and Bronica cameras which are made in Japan. Reflex-focusing cameras have been in popular use for almost a hundred years.

10

Twentieth-Century Stereo and Special-Purpose Cameras

 There is so little activity in stereo photography today that it is difficult to understand how popular this system became in the latter half of the past century and the first quarter of the present one. In the nineteenth century, professional photographers toured the world taking stereo views of exotic and historic places. These were reproduced and sold by the thousands to a public eager to see what the ruins of ancient Rome, the pyramids of Egypt, or the Holy Land actually looked like. The equipment used by these photographers a century or more ago was cumbersome, the daguerreotype and wet-plate processes were tedious, and, prior to the introduction of reliable dry plates and roll film, simply did not lend themselves to amateur use.

This antique daguerreian and wet-plate stereo equipment has already been discussed in Chapter 2, in which British, French, and American stereo cameras of the 1850s and 1860s were described. George Eastman's first stereo camera, the box-type No. 2 Stereo of 1901, was illustrated in Chapter 4, devoted to Kodaks. A Stereo Graflex and several German cut- and roll-film stereo cameras of the 1920s were included in Chapter 9 in the discussion of reflex cameras. These cameras

were placed in those chapters because their major significance was other than the fact that they took paired stereo photographs.

Toward the end of the last century, photographic plates and film were made commercially that were more uniform in their results and in sizes suited to a compact, hand-held stereo camera. Initially, the French designer and manufacturer Jules Richard of Paris was very active in this area, and around 1895 he produced the Verascope. This was an all-metal twin-lens camera for taking stereo photographs on 45-by-107-mm glass plates. As many as twelve of these plates could be stored in a magazine attached to the back of the camera, and were changed by manipulating the plate-changing mechanism built into the magazine. Richard continued to make the Verascope in numerous styles and sizes and it was responsible, in part, for the development of the Homeos. The Homeos, it will be recalled, was the first stereo camera made for 35-mm film and is a direct descendant of the concepts involved in the design of the Verascope.

Other French manufacturers, and the Germans as well, produced dozens of small stereo cameras using magazine-loaded glass plates and cut film until the mid-1930s, when the popularity of stereo photography

286

Three portable stereo cameras made by Jules Richard of Paris between 1905 and 1920. *Left:* Verascope for 4.5-by-10.7-cm plates. *Right:* Verascope for larger, 6.5-by-13-cm plates. Value, $175 each. *Center:* Le Glyphoscope, very popular stereo camera which could be converted to stereo viewer. Value, $50.

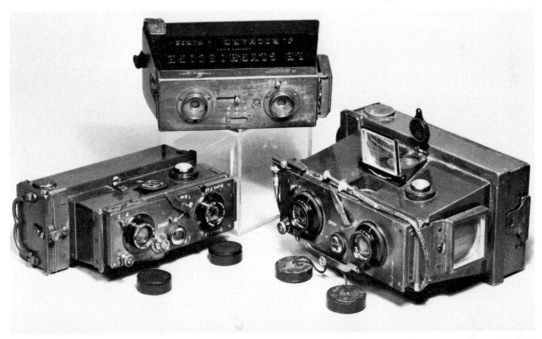

287
Le Stereocycle, a French
stereo camera, c. 1898.
Unusual in that it used
separate right- and left-hand
plates. Value, $375.

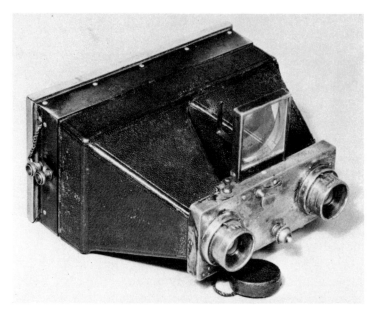

288
Rear view of Le Stereocycle,
showing directions for com-
plicated plate-changing
operation.

came to an end. Among the French makes were Le
Stereocycle by Bazin and Leroy of about 1898, Leroy's
Le Stereo-Panoramique of 1903, the 1907 stereo cam-
era by H. Bellieni which used separate plates for each
image, and the Monobloc by Jeanneret and Company
of Paris, made in the mid-1920s. In 1905, Jules Richard
brought out a cheaper version of the Verascope called
Le Glyphoscope, which in terms of the quantity sold

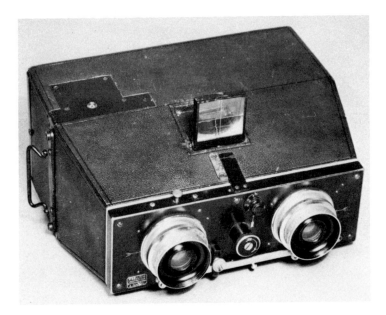

289
Stereo camera made by H. Bellieni of Nancy, France, around 1907. Uses magazine-loaded film plates. Value, $250.

was the "box Brownie" of stereo cameras and remained popular into the 1930s.

The Ica Polyscop was a typical 1920s German stereo camera with a plate-changing magazine and all-metal construction. It followed the Ica Stereo Ideal 651 folding-bellows-type stereo camera which that company made about 1910. This bellows style of stereo camera can be found in American examples from the turn of this century in such cameras as the Blair Stereo Hawkeye. The Blair Camera Company was absorbed by Eastman Kodak about that time, and when the Blair name was dropped around 1905, the Stereo Hawkeye evolved into a Kodak line of folding-bellows Stereo Brownie cameras. To satisfy what demand there was for larger stereo equipment for professional use, the Graflex division of Eastman Kodak produced Stereo Graphic view cameras and Stereo Graflex reflex cameras into the mid-1920s.

There are a number of cameras that are either too specialized or too limited in popularity to categorize conveniently. A few of these will be discussed in order to assess their significance and familiarize collectors with their appearance, function, and value.

For a period of about thirty years between 1880 and 1910, camera manufacturers endeavored to market

290

Le Stereo-Panoramique, made by Leroy of Paris around 1906. By rotating right-hand lens to center position, camera could be converted to take a single wide-angle photograph rather than a stereo pair. Value, $175.

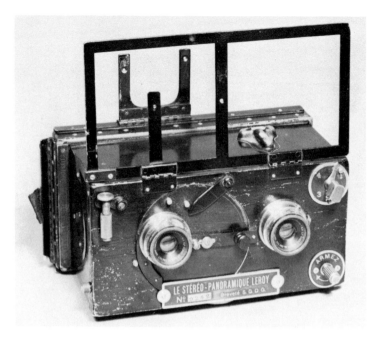

291

The French stereo Monobloc, c. 1920, could also be adapted to single panoramic photographs. Value, $150.

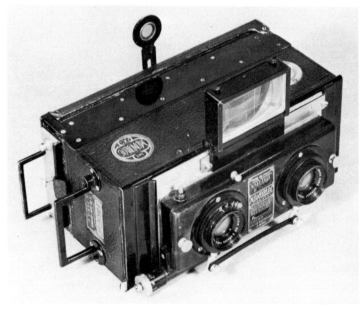

products that would be compatible with two popular hobbies, bicycling and photography. Whether compact or relatively bulky, cameras were advertised as being eminently suitable for transport on a cycling journey. Even the Lucidograph, a view camera for 5-by-8-inch pictures, was advertised in 1885 as "adapted for the use of 'cyclists and instantaneous work.'" This might

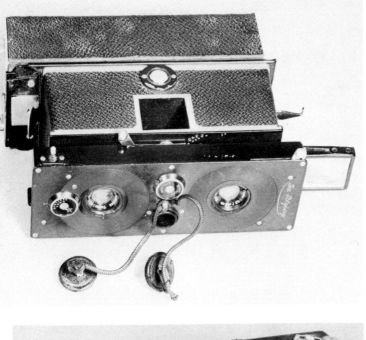

292

Ica Polyscop, typical German stereo plate camera of the 1920s. Value, $150.

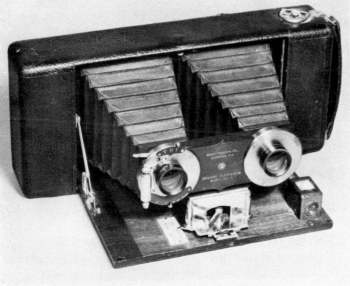

293

Blair Stereo Hawkeye, folding bellows-type stereo camera for roll film made just after the turn of the twentieth century by the Blair Camera Company, soon a division of Eastman Kodak. Value, $125.

stretch the truth somewhat, as the Lucidograph, made by the Blair Tourograph and Dry Plate Company of Boston, Massachusetts, measured 9½ by 6½ by 4¼ inches when closed, and required a tripod for use. The front panel of the Lucidograph was hinged on one side and swung open like a door, after which the bellows track folded down and the camera lens racked out

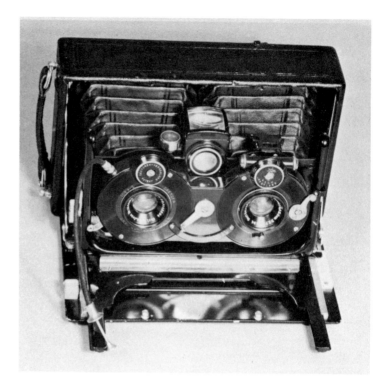

294
Ica Stereo Ideal 651, German folding stereo camera for 6-by-13-cm plates. Made around 1910. Value, $125.

along its bed. Shortly thereafter, in folding cameras, the bellows guide became part of the front panel, which folded down to become the camera bed. This is the type of arrangement we find in the Graphic view cameras made by Folmer and Schwing in the early 1900s, which eventually became the Speed Graphic, the standard camera for press photographers until the 1950s.

About 1910, Folmer and Schwing, then a division of Eastman Kodak, introduced the No. 0 Graphic. The No. 0 was a ruggedly built leather-covered camera, much bulkier than it needed to be since it took relatively small 1⅝-by-2½-inch pictures on 127 vest-pocket-size film. The lens was an unspectacular fixed-focus f/6.3 Kodak Tessar, but the camera was equipped with the superior Folmer and Schwing focal-plane shutter with speeds from 1/10 to 1/500 of a second.

Much more practical for the bicyclist or any other photographer desiring a truly compact camera was the Pocket Kozy, patented in 1892 and made and sold by

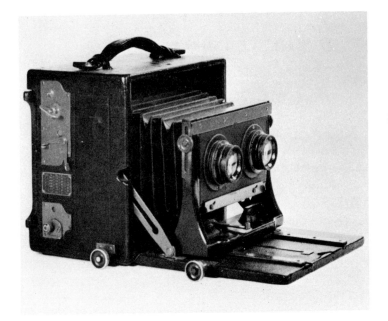

295
Stereo version of Graphic view camera made by Folmer & Schwing division of Eastman Kodak, c. 1910. Value, $800.

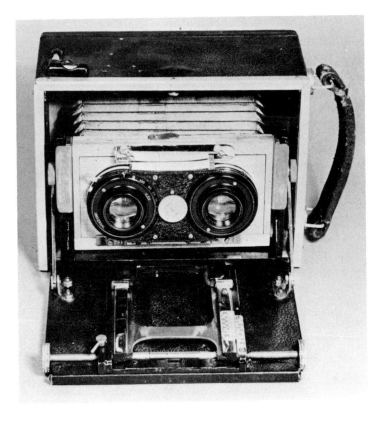

296
Nonproduction stereo camera owned and used by the Keystone View Company of Meadville, Pennsylvania, one of the largest producers of stereo view cards in the United States. Made around 1920. Value, $250.

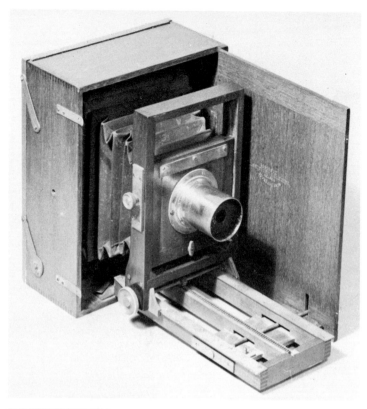

297

Lucidograph, made by the Blair Tourograph and Dry Plate Company of Boston, Massachusetts, and patented May 10, 1887. This view camera requiring a tripod was advertised as being suitable for bicyclists. Value, $400.

298

When folded into its box, the Lucidograph measured 9½ by 6½ by 4¼ inches.

the Kozy Camera Company of Boston, Massachusetts. The Kozy was a flat-folding roll-film camera of unusual design. Measuring only 1⅞ by 4½ by 5¾ inches when folded, the Pocket Kozy opened by extending a bellows which became one side of the camera. In appearance it is similar to the Swiss Vega camera shown in Chapter 3 except that the bellows of the Vega forms the rear section of the camera. Unlike the Vega, which uses cut film, the Kozy took twelve or eighteen 3½-inch-square photographs on roll film.

As an independent camera maker, the Kozy Camera Company evidently had difficulty in competing with the ever-more-powerful Eastman Kodak Company. In 1898, Kozy was offering its potential customers such inducements as a ten-day free trial and credit terms which could extend the payment of the $10 cash price over five months with an additional $3 for carrying charges. By 1900 and 1901, the Kozy was discounted to $6, and the company's ads read: "We are not in the camera trust and therefore we can sell you direct from the factory."

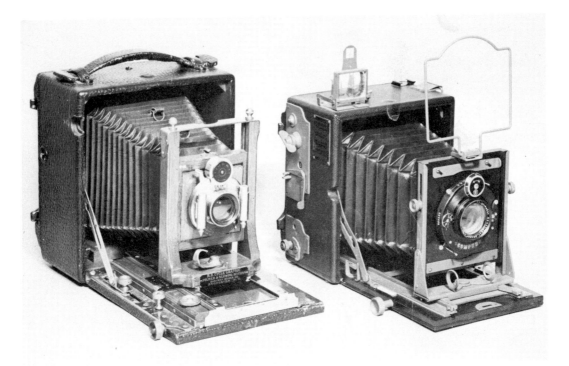

299 *Left:* revolving-back Cycle Graphic made by Folmer and Schwing, a division of Eastman Kodak, for 4-by-5-inch cut film or film pack. Made around 1907. *Right:* preanniversary Graphic of the early 1930s became one of the most widely used press cameras in the world. Value, $100 each.

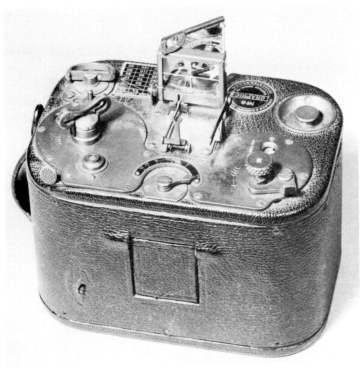

300
No. 0 Graphic, c. 1913. Made by F. & S. division of Eastman Kodak. Flap in front covers f/6.3 fixed-focus Bausch and Lomb lens. Camera is equipped with Folmer and Schwing focal-plane shutter. Value, $200.

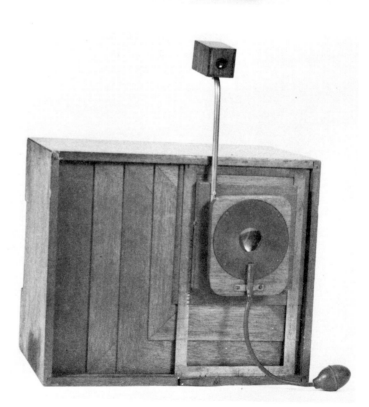

301

Pocket Kozy Camera, a
flat-folding roll-film camera
which unfolded in an
unusual manner. Most of
the advertisements for this
camera, made in Boston,
Massachusetts, appeared
around 1898. Company
tried to compete with Kodak
by selling direct to customer
and offering discounts and
time-payment plans. Value,
$700.

302

Gem wet- or dry-plate
camera made by Simon
Wing of Charlestown,
Massachusetts, around
1900. By shifting position of
the lens, camera made fif-
teen separate 1-by-1¼-inch
"gem"-size pictures on a
single 5-by-7-inch plate.
Periscope-type viewfinder is
distinctive feature. Value,
$800.

At the beginning of the twentieth century, Simon Wing, who had been a manufacturer of wet-plate cameras as early as 1860, was still in business, making both multiple-image and regular view cameras. Among the more interesting of the former type was the Wing Gem camera, made around 1901. The lens and shutter assembly of the Gem was mounted to a front panel constructed of overlapping wood panels which permitted the position of the lens to be shifted vertically and/or horizontally after each exposure. This allowed fifteen pictures, five on each of three rows, to be taken on a single 5-by-7-inch wet or dry ferrotype plate, or glass or film. The "Gem" in the camera's name refers to the size of the 1-by-1¼-inch pictures made by this apparatus. In appearance, the Wing Gem camera is immediately recognizable by its periscope-type viewfinder which extends above the camera body to leave clearance when the lensboard is shifted to its lowest position.

A camera with a self-contained processing system which could produce a finished picture in a minute was made in the United States in 1899. This was about

303
This Simon Wing 4-by-5-inch view camera with original case and plate holders was never used; therefore, lensboard is uncut. Made around 1900. Purchased from grandson of Simon Wing. Outfit, $500.

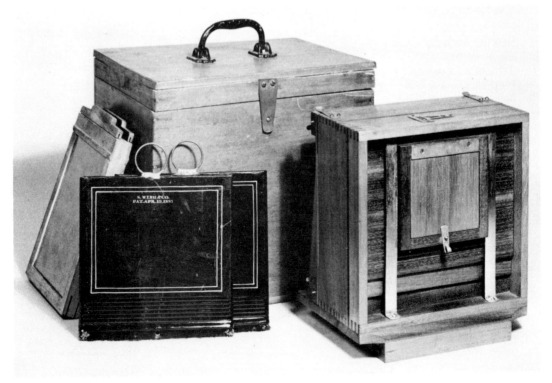

304

American-made Nodark
camera, 1899, took photo-
graphs on 2½-by-3½-inch
metal plates. Dial on side
indicates number of expo-
sures used from twenty-six
plate magazine. Value,
$500.

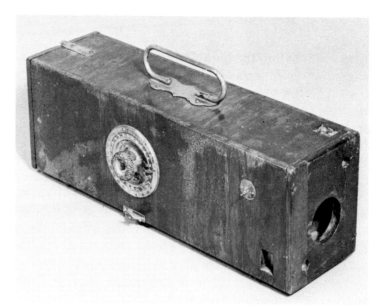

305

This street camera made in
Holland in the 1920s was
loaded with one hundred
button-sized plates. After
exposure, plate dropped
down supporting tube to
processing tanks in base.
Value, $800.

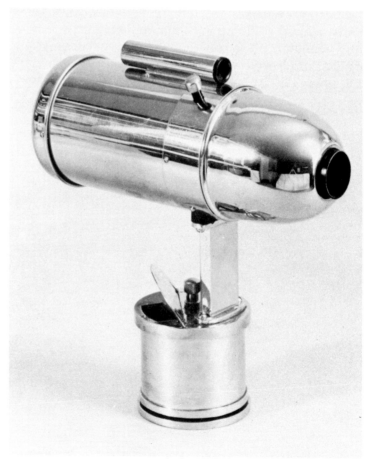

fifty years before the Land Polaroid camera offered the same feature in a much more easily used method. This early camera was the Nodark, a wooden box camera more than 12 inches long which housed, in addition to its lens and shutter, a magazine holding twenty-six 2½-by-3½-inch dry metal plates. Attached to the bottom of the Nodark was a metal tank for holding the processing chemicals into which each plate was dropped after exposure. Plate changing, development, and fixing were all carried out within the camera and processing tank.

Cameras of this type, which could quickly deliver a finished photograph without recourse to a darkroom, were especially appealing to photographers who tried to make a living photographing passersby on busy streets or at resorts. For that reason, cameras with built-in rapid-processing capability became known as "street" cameras. An interesting European street camera in the Isenberg collection, made in Holland about 1920, is a highly nickel-plated, bullet-shaped camera mounted on a flat, rectangular tube. This upright tube connects the camera with a circular processing tank which also acts as the camera base. The camera section could be loaded with a hundred circular metal plates about an inch in diameter. After exposure, the plate dropped down the tube and fell into a compartment containing developer. From that solution the plate could be moved to the fixer and then be removed to be mounted in a button and sold to the photographer's subject. It is called the Ente.

306

This European street camera of the 1920s is known as the Mirax. It is equipped with a French version of the Thornton-Pickard shutter and an f/4.5 lens by a Parisian optician. Most remarkable aspect of the Mirax is that it is constructed of over one hundred separate pieces of wood. Value, $1,000.

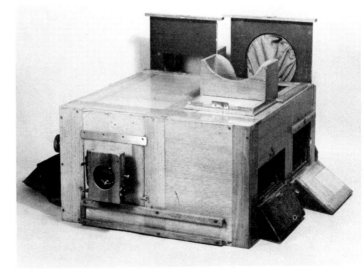

What Isenberg refers to as the "Rolls-Royce" of street cameras is the Mirax, a European outfit made in the 1920s. It is equipped with a French version of the British Thornton-Pickard shutter and a 135-mm f/4.5 lens made by Clement and Gilmer of Paris. The most remarkable aspect of the Mirax is that this camera is constructed of more than a hundred separate teakwood parts, all put together in a very craftsmanlike manner. Processing within the camera is not so simple as in some other types. It required the operator to insert his hand into the box through a lighttight sleeve in order to move his plates from the holders to each of the chemical containers.

Almost everyone who has had his or her picture taken as part of a school graduating class is familiar with the type of photograph made with a panoramic camera. These cameras for taking extra-wide pictures are another kind of special-purpose camera of interest to collectors. The principal distinguishing operating feature of the panoramic camera is that the lens is swung in an arc during the exposure to cover a field of view in some cases as wide as 180 degrees. In a few ex-

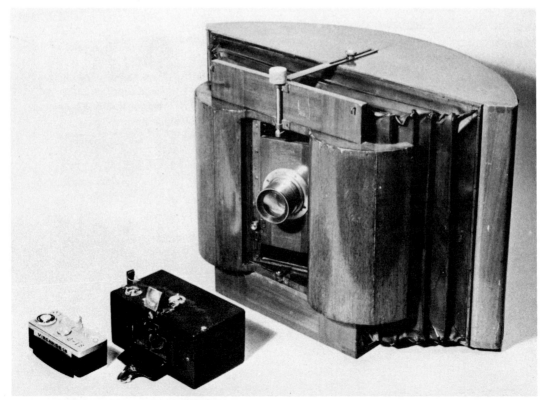

307

Three panoramic cameras of widely divergent sizes. *Right:* Star Panoram of 1905 is more than 12 inches high and 2 feet wide. It made its pictures on curved film plates. Value, $1,000. *Center:* Kodak No. 1 Panoram camera, of 1900. Value, $150. *Left:* modern Viscawide uses 16-mm film. Value, $200.

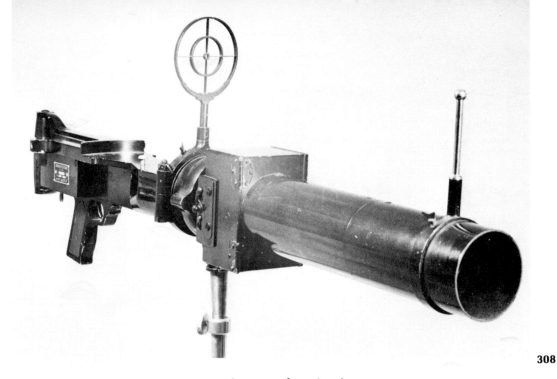

amples, the film or plate is moved in synchronization with the lens as it traverses its arc.

Early panoramic cameras were designed for professional use and were usually very large and ungainly. Eastman reduced the size to a practical 3½-by-12-inch format in his 1899 Kodak No. 4 Panoram, and still further in 1900 to 2¼ by 7 inches with the No. 2 Kodak Panoram. The Japanese Widelux panoramic camera of the 1970s using 35-mm film produces a 1-by-2⅜-inch negative, and smallest of all is the Viscawide made for 16-mm film. The swivel action of the lens is common to all of these cameras.

A true oddity in the collection in the area of special-purpose cameras is a World War II Japanese machine-gun camera. It is almost a part-for-part copy of a British machine-gun camera made during World War I by Thornton-Pickard and which Isenberg also owns. These deadly-looking cameras closely resemble real machine guns and were used to train aerial gunners in both wars. The Japanese model is equipped with a 285-mm f/11 Rokuoh-Sha lens made by a company now producing the Minolta brand of cameras and lenses.

Many collectors have specialized in one or more areas of special-purpose cameras and find that there is more than enough material available to encourage and reward their acquisitive fervor.

World War II Japanese machine-gun camera. It is a direct copy of British Thornton-Pickard made during World War I for training aerial gunners. Value, $600.

11

Images and Cases

Some of the most active and far-sighted photographica collectors are now engaged in pursuing not only rare cameras and equipment but important photographic images. Not too many years ago, daguerreotypes, ambrotypes, tintypes, stereo views, and other nineteenth-century photographs either lay neglected in trunks and bureau drawers or could be bought in box lots from antiques dealers or at auction for a few cents each. Presently, any reasonably preserved daguerreotype, no matter how mundane the subject, is worth at least $10, and important daguerreian and other early images sell into the thousands of dollars.

The more expensive items in this collectible category are full-plate (6½-by-8½-inch) daguerreotypes, daguerreotypes depicting groups, landscapes, genre or occupational scenes, military subjects, and portraits of notable nineteenth-century political, artistic, or scientific celebrities. Another factor that adds value for the collector is if a daguerreotype or other early photograph can be attributed to a prominent photographer of the period. For example, Mathew Brady is most commonly associated with photographs taken by him or his employees during the Civil War. Collectors know,

however, that as early as 1844, Brady was one of the most active and accomplished daguerreotypists working in New York City. The output of his studios, manned by operators under his direction, was huge and of a consistently high quality, but there were a number of less famous photographers whose work is considered superior. Most of these other daguerreian artists did not operate on such a large scale as Brady, and most of the work was performed either by themselves or under their immediate supervision. This tended to limit their production, so that examples of their work are rarer and more valuable than Brady's.

For the purists among image collectors, the daguerreotype holds the greatest fascination, not only because it is one of the oldest processes and the first to be commercially successful but for the innate quality of the image itself. The silvered surface of a properly prepared daguerreian plate was polished so finely that amazingly sharp images were possible. In addition, the development of the plate by the action of mercury fumes upon the silver iodide is molecular, not granular as in subsequent processes. This means that, theoretically, the resolution of the image upon the plate, or its clarity, is limited only by the resolving power of the lens. Even though modern lenses may be infinitely superior to antique lenses, their ability to render the finest detail is dependent upon the grain structure of

309

Full plate (6½ by 8½ inches) daguerreotype in typical oval mask. Value, $600.

310

Shown here is the relationship between the popular sizes of daguerreotype and ambrotype photographs and cases. *Clockwise, from top right:* full-plate, half-plate, quarter-plate, sixth-plate, ninth-plate, sixteenth-plate.

311

No image collection is complete without a photograph by Mathew Brady. Value, $75.

the film emulsion employed. When viewed side-by-side with an ambrotype, the daguerreotype sparkles, while the ambrotype seems dull and lifeless. The images from the Isenberg collection reproduced in this chapter should serve as a useful guide to the appreciation and understanding of what constitutes a collectible image and why their value has been increasing so rapidly.

Since the image size of early photographs is always referred to in terms of plate size rather than in inches or millimeters, it should be useful at this point to set down the measurements of the different size plates in general use. The size of the plate originally used by Daguerre in his first cameras measured approximately 6½ by 8½ inches. By referring to this size as a full, or whole, plate, all subsequent sizes after trimming bear an approximate relationship to those dimensions. Thus the sizes commonly found in daguerreotypes and in photographs made from wet plates have these measurements:

Full-plate	6½ by 8½ inches
Half-plate	4¼ by 5½ inches
Quarter-plate	3¼ by 4¼ inches
Sixth-plate	2¾ by 3¼ inches
Ninth-plate	2 by 2½ inches
Sixteenth-plate	1⅜ by 1⅝ inches

These are the sizes for which cases for storage and display were available shortly after the daguerreotype process was introduced. Some operators occasionally used larger-size plates up to 15 by 17 inches for life-size portraits or for groups, but these were very few and obviously are very valuable today.

The daguerreotypists whose work is especially prized are the Boston photographers Southworth and Hawes. This partnership was innovative in its methods, used advanced equipment, and the graceful composition and refinement of their photographs have rarely been equaled. In 1853, Jeremiah Gurney was considered the foremost daguerreotypist in New York City and was awarded prizes for excellence that had previously been won by Mathew Brady with dependable

312

313

These two sixth-plate daguerreotypes are by Southworth and Hawes of Boston, Massachusetts. They are distinguished by the strength of the poses, the grace of the composition, and the clarity of the images. Value, $1,000. each.

regularity. Anson was another New York photographer who, according to an account in Taft's *Photography and the American Scene,* was still using the daguerreian system in 1862. This was at a time when most photographers had shifted almost exclusively to ambrotypes or paper prints.

Around 1850 there was such a great demand for daguerreotype portraits that photographers resorted to some ingenious methods in order to increase production. One of these was to mount one camera above another, fixed so that they both focused at the same point. The top camera was used just for composing the picture on the ground glass, and the bottom camera just for taking the photograph. This meant that the ground glass and plate holder did not have to be interchanged for each exposure.

Some photographers advertised the capacity for producing five hundred or more daguerreotypes daily "by a new German Invention and Machinery." Probably, in addition to using the dual-camera setup, the machinery referred to was power-driven plate-polishing and-cleaning equipment, normally a very time-consuming and exacting process.

314

The half-plate daguerreotypes by Jeremiah Gurney of New York City are famous for their sharpness. Most of Gurney's best work was done in this size. Value, $300.

315 Advertisement by early prizewinning Philadelphia daguerreotypist.

316
Quarter-plate daguerreotype of a mother and child by Anson of New York City. Baby's eyes apparently blinked during long exposure. Reproduced in several publications. Value, $300.

317

Beautiful sixth-plate tinted daguerreotype of a young girl is also by Anson, who was noted as a superior photographer of children. Value, $150.

318

Very clear daguerreotype of an American sailor by W. and W. H. Lewis of New York City. Important because it is the product of the same people who made so many of this country's early cameras. The tinting is exquisite, the subject compelling, even though it is only sixth-plate in size. Value, $150.

Two important pioneer photographers were M. A. Root of Philadelphia and Robert Vance of San Francisco. Root was principally engaged in making studio portraits, while Vance, in addition to his portrait trade, produced a series of three hundred full-plate daguerreotypes depicting scenes of California. These were exhibited in New York City in 1851 to great critical acclaim, but after passing through several hands are now, unfortunately, lost.

Practically all daguerreotypes of outdoor scenes depicting commercial and residential structures are highly collectible as they are the earliest accurate

319

Postmortem daguerreotype of a child with a newspaper clipping of the obituary notice. Value, $40.

320

This Boston photographer claimed to produce five hundred daguerreotypes a day. The "new machinery" probably refers to power-driven plate-polishing equipment.

record we have of how towns or buildings actually appeared in the 1840s and 1850s. Especially prized, however, are daguerreotypes of California gold-mining operations. These seem to have a mystique for the photo historian, since upon close inspection they and any other good landscapes yield an incredible amount of information. Building signs, tools, machinery, modes of dress can be studied, and a clear appreciation of frontier life can be ascertained.

Ambrotypes, made by placing a glass negative against a black backing, while not usually so valuable as daguerreotypes, still provide considerable informa-

321

Quarter-plate daguerreotype by M. A. Root of Philadelphia. Root was also the author in 1864 of the first history of American photography. Value, $125.

322

Quarter-plate daguerreotype by Robert H. Vance, who worked in San Francisco in the early 1850s. Value, $125.

323 Incredibly clear
daguerreotype of a young
couple mounted in an oval
case. Note detail in man's
vest and woman's lace col-
lar. Value, $100.

324 The steady gaze and
freckled complexion of this
elderly gentleman is con-
veyed compellingly in this
well-lighted sixth-plate
daguerreotype. Value, $75.

325 Twenty-one young ladies in a studio setting are
shown in this sixth-plate daguerreotype. Note accom-
panying this photograph informs us that it is the June
1855 graduating class of the Packer Collegiate Insti-
tute in Brooklyn. New York. "the first class graduated
from the new building." Value. $400.

326 Miniature daguerreotypes
were frequently mounted in
pieces of jewelry. This is a
lady's gold locket. Value,
$75.

327

Half-plate daguerreotype of a gold-mining scene. This important image was formerly owned by Zelda McKay, a noted case and image collector. Her hand-written description reads: "Panorama of Grizzly Flat famous gold rush town 33 miles south of Hangtown (Placerville) California. In the foreground is Jacob Phillips who came from Elizabeth, N.J. to California in 1849." Value, $2,500.

328

Half-plate daguerreotype of an entire riverfront town. Most probably a school-house or meeting house dominates the landscape. Note extensive use of white-painted wooden fencing. Value, $800.

329

Many commercial enterprises can be seen in this half-plate daguer-reotype of the main street of this mid-nineteenth-century agricultural community. Value, $750.

330

This amazingly detailed sixth-plate daguerreotype shows us the appearance of a typical New England factory about 1850. Given to Isenberg by the Carroll family, direct descendants of the original owners of this mill located in Norwich, Connecticut. Value, $750.

331

Full-plate ambrotype of a Civil War Union officer in original frame. Value, $375.

332

Quarter-plate ambrotype showing a group of carriages and a milk wagon beside the Boston Common in the late 1850s. Value, $150.

333
Advertisement for ambrotypist working in Providence, Rhode Island, around 1860.

334
This case is typical of those used to frame ambrotype family portraits.

tion and interest for the collector. At this point, they are all at least a hundred years old, and ambrotypes of landscapes and occupational or military subjects are in strong demand. Paper prints such as *cartes de visite* and the metal tintype were produced in such large quantities that their subject must be exceptional to command any appreciable value.

Due to the great volume published and sold in the latter half of the nineteenth century, stereo views printed on photographic paper and mounted on cards have been a long-neglected item of photographica. Currently, however, some of these images are achieving fine collectible status. One might have to leaf through box after box of stereo cards at a flea market or at a dealer's shop before coming upon any but the most pedestrian subjects. Among these common items would be foreign travel views, nonphotographic printed views of American Indians, the Grand Canyon, and other natural phenomena, and many with religious themes.

What the discerning stereo collector tries to find are the earlier stereo cards published by the Anthonys in New York or the Langenheim brothers of Philadelphia, or views that have important historical or architectural associations. An exciting area for the photo historian are those cards containing interior or exterior views of photographers' studios or those that show any early photographic equipment or photographers at work. Since stereo daguerreotypes and ambrotypes were less easily reproduced, most of these are one-of-a-kind items from an earlier period than paper prints and are obviously valuable regardless of content.

335

Tintype of military subject framed in ivory case in the form of a book. Since this was a direct positive process, like the daguerreotype, the image is reversed. Value, $50.

336

Portion of stereo card of the late 1860s showing a photographer carrying a stereo wet-plate camera while riding a mule. Taken in Yosemite Valley, California, by C. L. Pond of Buffalo, New York. Value, $90.

337

Portion of a stereo card of the late 1850s, showing wet-plate equipment and a dark tent. Value, $40.

338
Kitten at play with what appears to be a Lewis-type full-plate camera with Waterhouse stop inserted into a C. C. Harrison-type lens. Photograph is enlarged from one-half of a stereo card. Value, $60.

339
Portions of stereo cards made in the 1860s, showing a photographer's gallery on the Eastern seacoast and in a Western frontier town. Value, $45 each.

340

341
In the 1850s, a photographer named Babbitt had a monopoly on the photographic business on the American side of Niagara Falls. Sign over his pavilion reads: "Photographic and stereoscopic views of the Falls." This full-plate albumin print is valued at $40.

342
Half-plate ambrotype taken from Babbitt's Point on the American side of Niagara Falls. Note that subjects are back lighted and therefore silhouetted. Value, $100.

222

Daguerreotype and ambrotype views of Niagara Falls are of interest to the collector especially in relationship to a commercial rivalry between an American and a Canadian photographer in the 1850s. In 1853, Platt D. Babbitt was granted sole rights to take photographs of tourists on the American side of the Falls. He constructed a pavilion, or gazebo, to shelter his equipment at a spot which became known as Babbitt's Point. Babbitt enjoyed a very lucrative trade selling photographs to tourists who were happy to have a picture of themselves with the Falls as a background as a souvenir of their visit. Babbitt's one disadvantage, however, was that, except in the early morning, his subjects would be backlighted and their pictures would be rendered almost in silhouette.

A Mr. Hollister, who apparently had a similar photographic monopoly on the Canadian side of the Falls, capitalized on this by advertising: "This is the only place where a likeness can be taken with a view of the Falls, and the features nicely delineated, and taken light. At all other points the shadow is on the face, and the features dark." Photographs taken from the Canadian side frequently show Babbitt's Point and the structure he maintained there.

343
Hollister, a photographer on the Canadian side of Niagara Falls, took advantage of the lighting conditions by advertising that the features of subjects taken on his side would not be in shadow.

344
Half-plate ambrotype of Niagara Falls taken from the Canadian side. Babbitt's pavilion is visible at upper left. At top center are some of the large tourist hotels. Note that face of subject is lighted so that features are discernible. Value, $100.

The delicate surface of a silver-coated copper daguerreotype plate or the glass ambrotype required some means of protection from handling, oxidization, or breakage. For that reason, an industry rapidly expanded for supplying suitable cases to store and display these images. The earliest cases were made of leather or embossed paper and held the daguerreotype in an enclosed, glass-covered frame. By the mid-1850s, the thermoplastic hard case had come into vogue, and it remained popular until the advent of the paper print—which brought with it the necessity for photograph albums, which were first patented in 1861. The thermoplastic case, formed in a die from a mixture of sawdust, shellac, and resin under heat and pressure, was made in hundreds of different styles, patterns, designs, and sizes. Manufacturers vied with one another to develop cases with artistic scrollwork, geometric patterns, and historical, classical, or allegorical motifs. So varied were the patterns and types of thermoplastic cases that some collectors specialize in just this one area.

The earliest United States patent for a daguerreotype case was granted on January 22, 1850, to Ann F. Stiles of Southbury, Connecticut. In her patent she states:

> The nature of my invention consists in the manufacture of a glass tube or case in which the picture can be conveniently secured and seen through a magnifying lens and at the same time protected from dust and interfering reflections from other objects.

To fit a Stiles case, a daguerreotype was cut into a round shape and cemented to the bottom of a cone-

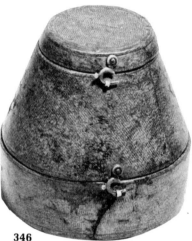

345
The first U.S. patent for a daguerreotype case was granted to Ann F. Stiles of Southbury, Connecticut, on January 22, 1850. This label is attached to inside of bottom cover of case.

346
Stiles case as it appears closed.

347
Stiles case opened. At right is magnifying viewing aperture. Daguerreotype was fitted to round opening at base. Glass ring around daguerreotype admitted light. Value, $1,200.

shaped glass tube. The upper or narrow end of the tube contained a magnifying lens, and a ring of clear glass surrounded the image at the lower end. Between the magnifier and the band of translucent glass, the interior of the cone was darkened with black paint. This entire assembly, which was made of glass, was enclosed in an external protective case which opened at the top and bottom for viewing. Aside from being ex-

348

Copy of J. F. Mascher's 1853
patent for a stereoscope
daguerreotype case.

349 Stereo daguerreotype in a
thermoplastic Mascher case.
Value, $500.

350

Stereo daguerreotype in
case patented by John Stull
of Philadelphia, February
27, 1853. Value, $1,500.

351

The Scovill Manufacturing Company of Waterbury, Connecticut, was one of the first and most important suppliers of daguerreotype plates in the United States. They were also engaged in the manufacture of thermoplastic cases.

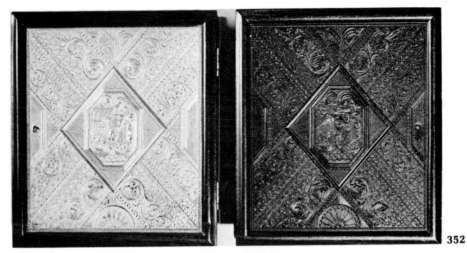

352

Two styles of sixth-plate thermoplastic case. To make case on right, a sheet of gold paper was laid over mold before pressing. Subject is referred to as "Lady in the Daguerreian Gallery."

353

Close-up of center portion showing lady examining daguerreotype frames and cases. Large building in background with U.S. flag at top is the 1853 New York Crystal Palace. Value, $100.

227

354

This half-plate case with the title "Country Life" contains an amazing amount of detail. Value, $150.

355

"Gypsy Fortune Teller," quarter-plate case made by A. P. Critchlow and Company, c. 1857. Value, $65.

A. P. CRITCHLOW & CO.,

Manufacturers of

Daguerreotype Cases.

A. P. C. & CO.

Are the **Original Inventors** of the **Composition** for the UNION CASE, (so called,) including all the various shades of color and fineness of texture peculiar to their manufacture and of the EMBRACING RIVETED HINGES, thus securing them from breaking out as do others that are inserted with or without a metal brace.

Hinge Patented
OCT. 14, 1856, & APRIL 21, 1857.

356
Critchlow label as it appears inside the case.

357 Sixth-plate case known as "Scroll, with Constitution and the Laws." Made by Littlefield, Parson and Company, around 1862. Value, $40.

Littlefield, Parsons & Co.,

MANUFACTURERS OF

Daguerreotype Cases.

L., P. & Co., are the sole Proprietors and only legal Manufacturers of UNION CASES, with the Embracing Riveted Hinge. Patented October 14, 1856, and April 21, 1857.

358 Label from Littlefield, Parsons case.

359

Thermoplastic cases with scalloped edges are relatively rare. Value, $100.

360

This unusual "window" case contains an ambrotype made on milk glass. Value, $100.

230

ceedingly rare, the Stiles case is historically important from the standpoint of its patent date.

A case for storing and viewing stereoscopic daguerreotypes was patented by J. F. Mascher on March 8, 1853. Mascher cases are prized collector's items. This is equally true of the stereo case patented by John Stull of Philadelphia two years later. The Stull case is much more striking visually than the Mascher, as the green front bears an eagle embossed in gold, along with trailing vines. Also stamped in gold is the maker's name and address, the patent date, February 27, 1855, and the message: "Orders furnished to any part of the United States or in Europe."

The sheer magnitude of the quantity of daguerreotypes, cases, and wet-plate photographs made in photography's first fifty years still leaves vast opportunities for the discovery of valuable items. Obviously, dealers and collectors are actively engaged in digging out this material, but even the novice collector is practically on an even footing with the experts. Many families still retain as heirlooms old photographs and cases that may have been forgotten for generations. In fact, anyone whose ancestors lived in this country in the middle of the past century is likely to possess some photographic record of that period. The potential historical importance of these artifacts and their present value should amply reward the patient and persistent collector.

Bibliography

Auer, Michel. *The Illustrated History of the Camera.* Boston: New York Graphic Society, 1975.

Auer, Michel. *The Michel Auer Collection.* (privately printed) Switzerland: 1972.

Burgess, N. G. *The Photograph Manual.* New York: D. Appleton & Co., 1862.

Daguerre, L. J. M. *An Historical and Descriptive Account of the Various Processes of the Daguerreotype and the Diorama.* Intro. by Beaumont Newhall. New York: Winter House, Ltd., 1971.

Darrah, William Culp. *Stereo Views.* Gettysburg, Pa.: Times and News Publishing Co., 1964.

Delamonte, Philip H. *The Practice of Photography for Students and Amateurs.* London: Joseph Cundall, 1853.

Eder, Josef Maria. *Die Photographische Camera und die Momentapparate.* Halle: Druck und Verlag von Wilhelm Knapp, 1892.

Eder, Josef Maria. *Jahrbuch Für Photographie und Reproductionsverfahren.* Halle: Von Wilhelm Knapp, 1921.

Gernsheim, Helmut and Alison. *L. J. M. Daguerre.* New York: Dover, 1968.

Gernsheim, Helmut and Alison. *The History of Photography.* New York: McGraw-Hill, 1969.

Gilbert, George. *Collecting Photographica.* New York: Hawthorn Books, 1976.

Gilbert, George (Ed.). *Photographic Advertising From A to Z.* Vols. I, II, III. Yesterday's Cameras, New York: 1970, 1972, 1976.

Grossmark, D. C. *The Leica Collectors Guide.* Hove, United Kingdom: Hove Camera Foto Books, 1976.

Hardwick, T. Frederick. *A Manual of Photographic Chemistry.* New York: Scovill Manufacturing Company, 1896.

Heath, A. S. and A. H. *Photography, A New Treatise.* New York: Heath and Brother, 1855.

Holmes, Edward. *An Age of Cameras.* King's Langley, England: Argus Books, Ltd., 1974.

Holmes, Oliver Wendell. *The Stereoscope and Stereoscopic Photographs.* New York: Underwood and Underwood, 1899.

Humphrey, S. D. *A Practical Manual of the Collodion Process.* New York: 1857.

Hunt, Robert. *A Manual of Photography.* London: Richard Griffin & Co., 1854.

Lager, James L. *Leica Illustrated Guide.* New York: Morgan and Morgan, 1976.

Lahue, Kalton C., and Bailey, Joseph A. *The American 35 mm. Camera.* New York: Amphoto, 1972.

Lahue, Kalton C., and Bailey, Joseph A. *Glass, Brass and Chrome.* Norman, Okla.: University of Oklahoma Press, 1972.

Londe, Albert. *La Photographie Moderne.* Paris: C. Masson, 1896.

Lothrop, Eaton S., Jr. *A Century of Cameras.* New York: Morgan and Morgan, 1974.

Moss, George H., Jr. *Double Exposure.* Seabright, N.J.: Ploughshare Press, 1971.

Newhall, Beaumont. *The Daguerreotype in America.* New York: Duell, Sloan and Pearce, 1961.

Newhall, Beaumont. *The History of Photography.* New York: Museum of Modern Art, 1964.

Permutt, Cyril. *Collecting Old Cameras.* London: Angus and Robertson, 1976.

Rinhart, Floyd and Marion. *American Daguerreian Art.* New York: Clarkson N. Potter, 1967.

Rinhart, Floyd and Marion. *American Miniature Case Art.* New York: A. S. Barnes, 1969.

Rogliatti, G. *Leica, The First Fifty Years.* Hove, United Kingdom: Hove Camera Foto Books, 1975.

Sipley, Louis W. *A Half Century of Color.* New York: Macmillan, 1951.

Smith, R. C. *Antique Cameras.* Newton Abbott, England, David and Charles, Ltd., 1975.

Snelling, Henry H. *The History and Practice of the Art of Photography*. New York: C. P. Putnam, 1849.

Spencer, D. A. *Color Photography in Practice*. 3rd ed. New York: Pitman, 1948.

Stokes, I. N. Phelps. *Catalog of the Hawes-Stokes Collection of American Daguerreotypes by Albert Hawes and Josiah Johnson*. New York: Metropolitan Museum of Art, 1939.

Taft, Robert. *Photography and the American Scene*. New York: Macmillan, 1938.

Welling, William. *Collectors Guide to Nineteenth Century Photographs*. New York: Collier-Macmillan, 1976.

Willsburger, Johann. *Fotofaszination*. Berlin: Bertelsman, 1974.

Wolf, Myron. *Directory of Collectible Cameras*. Lexington, Mass.: Privately published, 1972.

JOURNALS

Athenaeum, Journal of Literature, Science and the Fine Arts. London: January 1839 through December 1842.

Daguerrian Journal. Vol. I, Nov. 1850 through Nov. 1851. New York, S. D. Humphrey.

Journal of the Photographic Society of London from 1854 to 1864. London: Taylor and Francis.

Liverpool Photographic Journal. Liverpool: Vol. II, 1855, through Vol. IV, 1856.

Philadelphia Photographer. Philadelphia: Benerman and Wilson. Vol. 4, 1867; Vol. 5, 1868; Vol. 6, 1869.

Photographer's Friend. Baltimore: Richard Walzel. January 1871 through November 1873.

Photographic Art Journal. New York: W. B. Smith. Monthly, January 1851 through July 1853.

Photographic News. London: Cassell, Petter and Galpin. Weekly, Sept. 10, 1858, through December 1860.

Photography, the Journal of the Amateur, the Profession and the Trade. London: Iliffe & Son. November 1888 to December 1889.

Plain Directions for Obtaining Photographic Pictures. Philadelphia: A. Hart, 1853.

Index